The Curator's Egg

Karsten Schubert

The Curator's Egg

The evolution of the museum concept
from the French Revolution to the present day

Ridinghouse

Third Edition:
Published in 2009 by
Ridinghouse / Karsten Schubert
5-8 Lower John Street
Golden Square
London WIF 9DR
www.karstenschubert.com

Distributed in the UK and Europe by
Cornerhouse
70 Oxford Street
Manchester MI5 5NH
www.cornerhouse.org

Distributed in the US by
RAM Publications
2525 Michigan Avenue Building A2
Santa Monica CA 90404
www.rampub.com

First published 2000, reprinted 2002 by One-Off Press and distributed by Christie's Books

British Library Cataloguing-in-Publication Data
A full catalogue record of this book is available from the British Library
ISBN 978-1-905464-20-3

Designed and typeset by Richard Hollis and Christopher Wilson
Printed and bound in the United Kingdom by Short Run Press, Exeter

The cover shows:
Karl Friedrich Schinkel
drawing of the Alte Museum, Berlin 1823 – 30
Inset:
Benjamin Zix
Napoleon and the Empress Marie-Louise
visiting the Salle Laocoon of the Louvre by night 1810
and Tate Modern, London 2008

Note to the new edition: *The Curator's Egg* was first published in English in 2000; a second edition was printed in 2002. Since then the book has been translated into Turkish, Japanese and Italian, and a Spanish translation is forthcoming. The text of this new English edition follows that of the original, except for a few minor corrections and the addition of a new epilogue, 'Democracy of Spectacle: The Museum Revisited'. This was originally written as an afterword to the Spanish translation; it has been revised and updated for publication here. The new chapter was copy-edited by James Beechey. The third edition was overseen by Doro Globus and the production was coordinated by Marit Münzberg.

Foreword

Ever since childhood, museums have held an irresistible fascination for me. I have always thought of them in terms of places of never-ending instruction and entertainment, as a source of bottomless knowledge and wonder. That is to say, even at my most critical, I am writing as one who has never for a second questioned the institution's vital importance or doubted its ultimate benignity. I have spent many happy hours in the museums that I have made the subject of my analysis. To say that I am partial would be an understatement.

My project has been helped by too many people to acknowledge all of them by name. I have been thinking about museums and discussing the issues that surround them for many years, long before I considered writing a book on the subject. Many people have talked to me about aspects of this volume and shaped my thinking, without them – or me, for that matter – being aware at the time of what our discussions were leading to. To all of them I owe a debt of gratitude and extend my warmest thanks.

The first book, I am told, is always the most nerve-racking. I have been fortunate enough to be able to rely on the help of many friends who have repeatedly read drafts of individual chapters or the whole volume. Their advice and encouragement has been invaluable. I am particularly grateful to Christoph Becker, Isabel Carlisle, Gill Hedley, Richard Howard, John Rowe, Richard Shone, Nikos Stangos, Camilla Wallrock, Jo Walton and Alison Wilding who have all helped me at various stages of writing. Judith Gray has been a great editor.

The title of the book, *The Curator's Egg*, a variant of an eighteenth-century English saying, was coined by the London art dealer Anthony Reynolds for a group exhibition at his gallery a few years ago. Thanks to him for allowing me to use it in such a different context.

Introduction

We are today in the midst of a new golden age of the museum. There are more museums than ever before, with new ones opening at short intervals, and they are playing an increasingly central and popular role in cultural life. One might therefore reasonably expect that their institutional self-esteem is high, and that their finances – encompassing both public and private contributions – are issues of no great concern. As a matter of fact, the exact opposite is true. The present is marked by a deep uncertainty about how museums and their role in society should be interpreted, and lack of money for running costs and purchasing budgets threatens to derail the objectives of even the most prominent institutions.

How this strange contradiction should have arisen is a question occupying museum directors, curators, art historians and administrators alike, and the literature on the subject, especially over the last decade, has grown exponentially.

Of course every author tends to look at the issue from his own particular perspective: the director analyses the problem from an institutional point of view; the curator approaches it in terms of exhibition and display practice; the art historian concerns himself with institutional evolution and questions of political and institutional interplay; and the administrator attempts to translate anecdotal evidence into a statistical formula that will allow him to predict future developments with at least a modicum of authority.

Some writers are concerned with specific institutions and others are dedicated to particular countries or periods in time. Some authors look at the issue from definite, tightly focused points of view, analysing questions such as the museum's uneasy relationship with artists, or the thorny issue of museum architecture. Sometimes, authors are deeply biased and harbour great resentment, painting a dark picture of the museum as the linch-

pin at the centre of some vast establishment conspiracy set on distorting or suppressing the historical record, or as the wicked usurper and neutraliser of artistic power. Others write from within specific institutions and clearly find it difficult to gain a neutral perspective. On occasion it is hard to recognise the same museum from one description to the next.

While these accounts often contain many interesting facts as well as a great deal of truth, as a rule the majority fail to reflect the full picture. By trying to reduce the museum to a simple formula instead of acknowledging that there are a great number of contributory factors, any chance of gaining a true sense of the intricacy of the situation is forgone.

The museum is one of the most complex cultural constructs, based on a great many historic assumptions. Many of these are still deemed operational, surprisingly even by those who criticise the museum most harshly. It is an amalgamation of many diverse, often contradictory external influences: the product of its own past and the personalities of all those involved – curators, donors, politicians, artists and the audience – and an often distorted reflection of their opinions, needs and assumptions. With so many voices, such diverse and partisan input and so much historical baggage, it is surprising that museums have managed to function so successfully for so long, and little of this extraordinary achievement is reflected in the literature.

Rather than concentrating on specific aspects of particular institutions, types of institutions, or particular chapters in museum history, I have tried to draw a more complete picture of the various influences by encompassing curatorial, scholarly, political and economic spheres alike.

The museum concept's own history has greatly contributed to the complexity of the picture: much of what constitutes today's museum is based on past record and institutional precedent. Without a look at history, today's museum would be virtually indecipherable, and in order to reflect this, it has been necessary to split my account into two parts.

The first part gives a brief outline of the evolution of the museum idea from just before the French Revolution to the building of the Centre Pompidou, covering a period of a little more than 220 years, from about 1760 to 1980.

The second part offers an in-depth look at subsequent developments and covers the last two decades of our century, a period of exceptional activity following a rather fallow mid-century.

In the light of detailed analysis, today's crisis in museums appears less puzzling. It quickly becomes clear that the tensions between unprecedented success, financial turmoil and self-doubt are not contradictory but are intimately connected, and that the present situation is an up-to-date variant of an old theme. From the outset the museum has been the subject of close scrutiny and perpetual critique and revision.

It could be said that one of the greatest myths about the museum is that it is an oasis of calm untouched by the storms of politics and history. Nothing could be further from the truth. Over time, the museum has responded to political and social shifts with seismic precision. Its very success is the result of exceptional flexibility and capacity to adapt – a capacity other cultural institutions do not share.

I

1.

Beginnings

The museum is changing. In the past it was a place of absolute certainties, the fount of definitions, values and education in all matters artistic, a place not of questions but of authoritative answers. Today, the museum is at the centre of a heated debate about its nature and methodology. At the most extreme, its very purpose is questioned – and denied.[1] It is a perpetually inconclusive discussion, yet it profoundly affects the way museums are perceived and run.

The following is an attempt to chart how the debate has progressed over the years and how changing curatorial attitudes,[2] over the course of time, have revolutionised institutions in both Europe and North America.

The idea of the museum plays such a central and important role in the way Western culture is defined and understood that it is generally forgotten how relatively new – and complex, as well as fragile – a concept it is. Instead we have come to believe that the museum is a place beyond reproach: neutral, objective and rational. 'Rationality' in this context is understood as something that is self-evident and that needs no further explanation – or indeed justification. As a matter of fact, the museum concept is a 'rational myth', one of the most persistent and powerful: a widely shared and applied set of beliefs that hardly withstands any critical analysis. It took nearly 200 years before the assumptions at the core of the museum's definition were subjected to close scrutiny, setting off the latest round of soul-searching about the museum's role and its true *raison d'être*.

The present crisis is, on the one hand, the outcome of a belated realisation that the museum is not quite as straightforward a place as people were willing to believe for so long. On the other hand it is a faithful reflection of developments in post-industrial and post-modern society, a society that simultaneously craves and derides iconic symbolism. Of all cultural symbols the

[1]
When the institution of the museum is under violent attack it is worth recalling that at the outset of the Russian Revolution it was suggested that all museums and their contents be destroyed. Fortunately, the idea was dropped.

[2]
How the curator has evolved from eighteenth-century amateur to the university-taught professional of recent years is in itself a fascinating story but one that lies outside the scope of the present volume.

museum is both the most venerated and the most contentious, and therefore most vulnerable to sustained attack.

Yet, in a way, the present crisis is not the first. In different guises, the discussion about the nature and purpose of the institution has been virtually continuous from the moment the first museums began to open their gates to the general public during the eighteenth century. On each occasion, politics and social change have fundamentally affected the course and outcome of the debate.

Each generation has had its 'own' particular museum crisis, resulting, as political, social and economic circumstances evolved, from frequently contradictory demands and expectations. This perpetual call for reform, however diverse a form it took, was always focused around two central issues: that the museum be open and accessible to all and that its displays represent an adequate, fair and 'objective' reading of its subject. Ultimately of course, access can always be wider, and displays can be subjected to endless expansion, review and honing, a process that is insatiable and never conclusive. As a consequence, the museum has always been on the edge of its own ever-changing and ever-expanding definition, the object of savage critique and unending reform, yet in the end each crisis has miraculously reaffirmed its status and normative power in all matters cultural.

At different points in time, different museums, in different countries and continents, took the lead in this ongoing process and showed their sister institutions the way forward. Depending on one's perspective, the story begins either in London or in Paris.

2.

Paris and London 1760–1870

3
Another claimant is
the Ashmolean Museum
in Oxford, set up in 1683.
Its genesis is complex;
in any case it was not an
independent institution
but formed part of Oxford
University.

4
For a summary of
the development of the
precursors of the present-
day museum, beginning
with the Renaissance
Wunderkammer, see:
Eilean Hooper-Greenhill,
*Museums and the Shaping
of Knowledge* (London
and New York: Routledge,
1992). The evolution of
the museological mindset,
avant la lettre, is admiringly
charted in: Lorraine Daston
and Katharine Park,
*Wonders and the Order of
Nature 1150-1750* (New York:
Zone Books, 1998).

5
This tradition persisted
and it was not until 1931
that the British Museum
appointed its first non-
librarian director. Only
the British Library Act
of 1972 finally turned
the British Library and
British Museum into two
independent institutions.

6
Alma S. Wittlin,
*The Museum, Its History
and Its Tasks in Education*
(London: Routledge &
Kegan Paul, 1949), p 113.
Reprinted in 1970,
Alma Wittlin's book has
become one of the great
classics of museology and
is widely quoted to
this day.

The British Museum, founded in 1759, could be described as the oldest independent museum in the world, yet its claim is blighted by the fact that for roughly the first half-century of its existence it was not a museum in the sense we understand today.[3] At the start it was not a showplace for works of art but primarily a semi-public reference collection of books and manuscripts.[4]

Initially, the museum was set up as a repository for three collections which had recently become the property of the British nation: the manuscript collection of the Cotton family; the manuscript library assembled by the Earls of Oxford; and the collection partly bequeathed by Sir Hans Sloane and partly sold to the nation by his heirs in 1753. Sloane's was a natural history collection, with a comparatively small number of antique sculptures and stone inscriptions. It was really more in the spirit of a sixteenth or seventeenth century cabinet of curiosities, a model that was to set the tone for the museum until the turn of the century. There was initially no proper separation between the library and the natural history and archaeology departments, all run by a head librarian and two assistants.[5]

The museum was the domain of learned gentlemen and access was quite restricted. After a visit to London in 1785, the German historian Wendeborn complained that 'persons desiring to visit the museum had first to give their credentials at the office and that it was then only after a period of about fourteen days that they were likely to receive a ticket of admission.'[6] Until the turn of the nineteenth century access was governed by the rules of court protocol and aristocratic etiquette. Even after the access hurdle had been overcome, visitors were not allowed to peruse exhibits at their own leisure. Instead, reluctant staff guided small groups quickly and grudgingly through the galleries. Complaints about the hurriedness of such tours became a constant refrain in the reports of eighteenth-century visitors.

Although matters gradually improved, well into the next century those in charge continued to perceive the museum as an end in itself and not as a means of serving visitors. As a matter of fact, the notion that the museum was primarily for the visitors' benefit remained an alien concept for quite some time.

Arguably the first museum in the modern sense was the Louvre in Paris. Built as a palace for the kings of France, over the centuries it had become a repository for extensive royal collections. The idea of the Louvre as a public museum was not born with the French Revolution but in fact had been discussed during the dying years of the *ancien régime*. The project had been pursued with great diligence and true devotion by the Comte d'Angiviller, Louis XVI's director general of royal palaces. Paintings were purchased to fill gaps in the royal collections, architects were consulted to discuss changes to the Grande Galerie in order to make it more suitable for the public display of paintings, and artists were quizzed at length to establish the most appropriate curatorial concept for the new museum.

In the end, Angiviller's heroic fifteen-year effort came to nothing. Ultimately it was to take something as cataclysmic as the Revolution to propel the radical new institution into reality. Needless to say, Angiviller's important role in laying the groundwork for the future museum was never acknowledged by the revolutionaries, and he died, forgotten, in exile.

The monarchy fell on August 10, 1792, and only nine days later a decree was issued that turned the former royal palace into a public museum. From the outset it was intimately tied up with the aims and politics of the new Republic. The new museum was a symbol of revolutionary achievement and a programmatic statement of intent: it was to be the domain of the many rather than the few (aristocrats and learned gentlemen), promising all citizens a share of hitherto inaccessible private property of cultural value. Education and enlightenment were no longer limited to a privileged handful but were on offer to anybody who chose to enter the former royal palace. Past class and educational barriers were swept aside. The museum did not only symbolise the new order but was also an important tool in the implementation of its revolutionary agenda: it was through the arts that the public was to understand the Revolution's history, its purpose and aims.

The museum was to play a central role in the formation and development of the new society; yet when it opened to the public on August 10, 1793, the first anniversary of the Republic, none of this was obvious from the displays. They looked suspiciously pre-Revolutionary and resembled, in the words of the playwright Gabriel Bouquier, 'the luxurious apartments of satraps and the great, the voluptuous boudoirs of courtesans, the cabinets of the self-styled amateurs'.[7] A few months later Jean-Jacques David elaborated on this point: 'The museum is not supposed to be a vain assemblage of frivolous luxury objects that serve only to satisfy idle curiosity. What it must be is an imposing school.'[8] It seems that from the outset the museum and its critique went hand in hand.

The debate on how the museum, the 'school', should look was to rage for the better part of a decade, complicated by ever-moving goal posts. There were financial and space constrictions – part of the Grande Galerie remained under reconstruction for quite some time and the collection kept growing, especially as booty from Napoleon's conquests started arriving from all over Europe – and the ideological shifts and internal divisions of the Revolution added to the overall confusion.

When the Conservatoire came to power in January 1794, serious attempts were made to bring museum displays more in line with revolutionary goals, and paintings considered 'unsuitable' were taken off display. Most of Rubens' Medici cycle, for example, went into storage, with the exception of two canvases which, just to be on the safe side, had all symbols of royalty painted out. That this was not the way forward was quickly recognised. The conflict between the present revolutionary agenda and the retardataire message contained in many historical works of art was overcome by replacing religious or ideological interpretations with purely aesthetic and art-historical readings. This shift made it possible to display work that had previously been considered reactionary and unacceptable by the rather unbending, not to say priggish, standards of the new Republic. The full Medici cycle – *sans* editorial interventions – was back on view by 1815.

As the debate about the correct methodology for the new museum rumbled on, another administration took over in January 1797 and the Musée Français became the Musée Central des

7
Andrew McClellan, *Inventing the Louvre* (Cambridge: Cambridge University Press, 1994), p 108.

8
McClellan, op. cit., p 106.

Arts, to be renamed yet again, in 1803, the Musée Napoléon. Napoleon had appointed its director the previous November. Dominique-Vivant Denon was a rather surprising choice: diplomat, courtier, *bon vivant* and one-time pornographer, a jack-of-all-trades, he was not obviously qualified for the demanding job, yet his boundless enthusiasm and irresistible charm had clearly made an impression on the Emperor. The appointment had coincided with the arrival of Europe's greatest art treasures in Paris. In the wake of Napoleon's conquests, the royal collections of Belgium, Italy, Austria and Germany, as well as the Vatican, had been systematically stripped of their choicest exhibits and within a few years virtually the entire post-Renaissance canon of art was united in the French capital.

If there were any moral qualms about the wholesale plunder of other nations' artistic heritage they were quickly set aside. In a letter to Napoleon in 1803, the Minister of Justice suggested that 'the reclamation of works of genius and their safekeeping in the land of Freedom would accelerate the development of Reason and human happiness.'[9]

The argument of safekeeping has to this day remained a staple in debates about cultural restitution whenever the subject arises.[10] Apropos Benin bronzes in the British Museum, the museum's director, Sir David Wilson, as late as 1989, stated that 'our argument is [...] the sense of cultural responsibility, of holding material in trust for mankind throughout the foreseeable future [...].' In the same year the issue of the return of the Elgin Marbles was loftily dismissed as 'a long-running soap-opera' in an official British Museum publication outlining its policies.[11] Denon justified the plunder of Europe by declaring that 'the Romans, once crude, managed to civilise their nation by transplanting every product of vanquished Greece into their soil. Let us, following their example, use our conquest and bring [...] to France everything that may empower the imagination.'[12]

Denon wasted no time and set to work immediately. Only six weeks after his appointment he invited Napoleon to come to the Louvre and inspect his new installation of paintings by Raphael. The director was clearly pleased with the result: 'It is like a life of the master of all paintings. The first time you walk through this gallery you will find that this [new hang] brings a character of

9
Hooper-Greenhill, op. cit., p 174.

10
Annie E. Coombes, 'Ethnography, Popular Culture, and Institutional Power: Narratives of Benin Culture in the British Museum 1897-1992', in: Gwendolyn Wright (ed), *The Formation of National Collections of Art and Archaeology* (Washington DC: National Gallery of Art, 1996), p 154.

11
David M. Wilson, *The British Museum, Purpose and Politics* (London: British Museum Publications, 1989), p 114.

12
McClellan, op. cit., p 148.

order, instruction, and classification. I will continue in the same spirit for all schools...one will be able to have [...] a history course of the art of painting.'[13]

At the centre of the Raphael bay in the Grande Galerie was *The Transfiguration* (1518–20), flanked by *The Coronation of the Virgin* (1503) and *Holy Family of Francis I*. At the top left and right were two paintings by Raphael's teacher, Perugino. Also included in the installation were the *Portrait of Baldassare Castiglione* and some panels from the Baglione altarpiece. The paintings were chosen, Denon explained, so that 'one could see at a glance the extent of this artist's genius, the astonishing rapidity of his progress, and the variety of genres which his talent encompassed.'[14]

This one-wall retrospective, covering Raphael's career from beginning to end, was illustrated by some of his most admired paintings. Denon's installation of paintings recalls Giorgio Vasari's groupings of artists' drawings in his famous *Libro de' Disegni*[15] and in his taste and aesthetic judgements Denon was indeed greatly indebted to the Italian Mannerist.

As far as the installation of ancient art taken from the Vatican was concerned, there was little scope to apply the same methodology that had been so successfully adopted for paintings in the Grande Galerie. The antiquities collection, though it contained the entire eighteenth century canon of classical sculpture as set out by Johann Winckelmann, was much smaller and it was impossible to establish a reliable chronology because the dating of antique marbles on stylistic grounds was still in its infancy. To complicate matters further, it had just begun to dawn on scholars that the majority of sculptures Winckelmann had pronounced to be the pinnacle of Greek civilisation were, in fact, Roman copies. Winckelmann's system of classification and his proposed chronology, hugely influential at the time, was a wildly speculative stab in the dark based on little hard evidence. There was a knowledge vacuum that would take future generations to fill. Denon had to make do with an exclusively aesthetic approach by faithfully copying the layout of the Vatican Museum from where the majority of sculptures had been taken.

While perhaps not everything in the Grande Galerie and the rest of the museum was as cohesive as the Raphael bay, the overall

13
McClellan, op. cit., p 140.

14
McClellan, op. cit., p 141.

15
Three complete sheets are illustrated in: Michael Jaffé, *The Devonshire Collection of Italian Drawings, Tuscan and Umbrian Schools* (London: Phaidon Press, 1994) nos 36, 37 and 40.

effect was deemed a great success. Denon had concocted an installation that was based exclusively on chronology, artistic evolution and national schools. It was the first time that pedagogic aims and art-historical methodology had played such a central role in the display of works of art. In addition, he had single-handedly managed to shift the museum's agenda from the political-ideological to the historical-documentary.

Alas, Napoleon's dream of the universal museum did not last long and after the Battle of Waterloo in June 1815 and the Congress of Vienna in the autumn of the same year, most works of art were quickly returned to their rightful owners. For a blissful ten years Dominique-Vivant Denon presided over the greatest museum collection that ever was. To have made sense of this daunting assemblage was his supreme achievement and lasting contribution to museology.

Despite the fact that in many respects the Louvre and the British Museum developed in tandem, there were fundamental differences between the two institutions, reflecting their different origins. Unlike the Louvre, the British Museum had not usurped a former royal palace, nor had it appropriated royal, ecclesiastical or aristocratic property for its collections.

Both museums came into existence as the result of changing social circumstances and in order to satisfy the cultural needs of an emerging new bourgeois class. Whilst the methodological agenda was clearly set by the Louvre under the directorship of Denon – it was to remain a model for European and American museums well into the first decades of the twentieth century – its implicit political radicalism was too much for the rest of Europe. Its ideas had to be tempered so that they could be applied to emerging institutions in the capitals of countries that were still monarchies. Edmund Burke's *Reflections on the Revolution in France* (1790) fairly summed up widely-shared English attitudes towards the new Republic and towards the museum concept. For the English, it was very hard to embrace whole-heartedly an institution that was born out of what they perceived as the dreaded French catastrophe. Yet the museum concept had evidently caught the English imagination, particularly as it tied in with the cultural aspirations of the non-aristocratic elite that was emerging in the wake of the Industrial Revolution.

To overcome this impasse, the idea of the museum had to be depoliticised. The goal was achieved by playing down the institution's revolutionary birth and its essentially radical political nature[16] in favour of emphasising its educational and scientific potential. An equally effective device was simply to delay application of the concept until its uncomfortable connection with revolutionary events had receded safely into history. This would help to account, at least in part, for the fact that the National Gallery in London – really a twin institute to the British Museum – was not set up until 1824 and that for decades its development remained so fractious and protracted.[17]

Whatever qualms were initially felt about the revolutionary origins of the museum, they were soon sidelined by the realisation that it held great potential in the emerging rivalries between European nation states.

Britain and France were, for most of the nineteenth century, locked into a vicious race for imperialistic expansion and global domination. Both the Louvre and the British Museum became cultural symbols of this, belatedly joined by the Berlin museums when Germany entered the colonial fray in the 1870s.

Museums could make a variety of cultural claims for their nations. They facilitated the construction of a lineage which presented their countries as the latter-day incarnations of the great empires of the past, casting them in the role of political and moral heirs. Museum representatives, aided by diplomats, armies and navies, scoured cultural sites all over the globe.[18] France and England would often vie for the same archaeological objects: the Rosetta Stone, for example, was discovered by the French but ended up in London after Napoleon's defeat in the Battle of the Nile. The French tried every ruse to intercept the Parthenon Marbles on their long and risky journey from Athens to London; and Germans, English and French raced each other to reach and strip the Sumerian palaces before their rivals could get there.[19]

The museums presented their political masters as custodians of world culture, rescuers of what had been ignorantly neglected or even threatened with destruction in the countries of origin. In effect the museum became the handmaiden of imperialism, and to this day the fallout from this association haunts the great museums of the West.

16
Herein may lie an explanation for the fact that to this day political interference, as far as UK museums are concerned, is frowned upon. Margaret Thatcher's politically motivated appointment of trustees, for example, caused deep discomfort, while in France political interference in museum affairs is taken for granted and accepted without much comment.

17
See: Carol Duncan, 'Putting the 'Nation' in London's National Gallery', in: Wright (ed), op. cit., pp 101-111.

18
How this affected a particular country is chronicled in: Peter France, *The Rape of Egypt: How the Europeans Stripped Egypt of its Heritage* (London: Barrie & Jenkins, 1991).

19
For an account of this episode see: John Malcolm Russell, *From Nineveh to New York* (New Haven and London: Yale University Press, 1997) pp 17-51.

The most revealing, and best preserved, examples of this imperialisation of the museum are the Egyptian galleries at the Louvre, dating from the years of the Bourbon Restoration: unsurprisingly, the Louvre had by then changed its name yet again and was now known as the Musée Charles X. Planned by the Egyptologist Jean-François Champollion, and realised under his close supervision between 1826 and 1834, the mural cycle in the Egyptian galleries is a celebration of French cultural superiority. It linked the decidedly *nouveau* Bourbon dynasty to 4,000 years of Egyptian history, thereby claiming continuity and stability, and at the same time justifying French colonial conquests and white race supremacy. As with Denon's Musée Napoléon, it is interesting to note how yet again quite disconnected political and scholarly goals successfully coexisted in the same project.

During the first half of the nineteenth century the British Museum was never quite as overtly propagandistic as the Louvre. Maybe this is attributable to the fact that the British by then were much more assured in their imperialistic ambitions. They did not need such loud and self-congratulatory reassurance as the French, who were still in search of a national identity and political stability after the turmoil of the Revolution and the Napoleonic Wars.

As a true child of his age, the nineteenth-century curator at the British Museum brought a decidedly Darwinist approach to his profession. In spirit he was more a taxonomist than an art historian, and the concept of the chain of art dominated his thinking more than any other idea.

All art was considered just a stepping stone towards the pinnacle of Greek classicism, and the museum was a storehouse of 'specimens' to illustrate this lineage. As late as 1875 the official British Museum guidebook uses the term 'specimen' for man-made as well as natural history artifacts.

Aesthetic considerations hardly mattered: artworks were not looked at for their own merit but were interesting only as a way of measuring deviation from the perceived ideal of Greek high classicism as embodied by the Elgin Marbles.

Nineteenth-century photographs of the British Museum's galleries illustrate how displays mirrored the Victorian penchant for cluttered and dark interiors. Even by the 1870s the Graeco-

Roman galleries gave the impression not so much of an ordered display but of overcrowded and ill-sorted storerooms.[20] There was no sense that an attempt had been made to mediate the encounter between visitors and the works of art. The assumption was that those who entered the museum knew what they were looking for: the curator simply envisaged visitors in his own image. The former mode of exclusion by means of royal and aristocratic protocol had been replaced by that of knowledge.

Nineteenth-century museums were marked by an obsessive curatorial fixation on chronology that overruled all other considerations, and completeness of displays dominated to the point where perceived gaps in the collection would happily be filled with plaster casts. Plaster casts were an integral part of most museum collections during the nineteenth century: they were gradually phased out and, as a rule, had disappeared by the 1920s. Labelling was at best perfunctory, not to say patronising, but more often missing altogether.

As the century progressed the exhibition halls became increasingly crowded with objects. By 1857 the problem had become so acute that the freshly acquired parts of the Mausoleum of Halicarnassus from Asia Minor were stored in temporary wooden sheds – soon replaced with greenhouse-like structures – under the Great Russell Street Colonnade. The *Evening Standard* in 1860 jokingly wrote that 'if the Overcrowded Lodging House Act could apply to inanimate objects [...] the Trustees of the British Museum [would] come under the notice of the police. [The museum] continues to be besieged by fresh tenants, to whom it can only offer the doorstep or a shakedown beneath a temporary shed.'[21]

The image of the British Museum as a dusty and unwelcoming storehouse was probably born during the late Victorian age. So overcrowded were the galleries that it took a long time to make amends and instigate reform. Gradually, however, change set in: the natural history department moved to South Kensington in the 1880s, installations were thinned out and 'mixed' displays of originals and casts disappeared. Works of art were finally acknowledged as such – not just as 'specimens' – and were at last allowed some breathing space. However, the emphasis remained on historical rather than aesthetic issues and the Hellenocentric

20
Ian Jenkins, *Archaeologists and Aesthetes in the Sculpture Galleries of the British Museum 1800-1939* (London: British Museum Press, 1992) pp 132-3.

21
Marjorie Caygill, *The Story of the British Museum* (London: British Museum Publications, 1981) p 56.

concept of antiquity continued to rule unchallenged: at the British Museum the sculptures of the Parthenon were the apotheosis of ancient culture; the arts of all other civilisations were just stepping stones towards this supreme achievement.

As late as 1852 Richard Westmacott Junior, professor of sculpture at the Royal Academy Schools, testifying before Parliament, asserted that the Elgin Marbles 'are the finest things in the world; we shall never see anything like them again.' The Nineveh sculptures, he said, were 'objects of mere curiosity, certainly not of art', and, similarly, 'no man would think of studying Egyptian art. As for cultures on the fringe even of Oriental barbarism, such as the Chinese, the fewer artists who looked at their art the better.'[22]

As the British Empire expanded, the museum became the recipient of more and more art that did not fit into the narrow Hellenocentric concept: there was just too much new evidence which could no longer be ignored. The opening of the Chinese and Indian galleries in their grand Edwardian splendour in 1914 at long last signalled the arrival and full emancipation of Asian art. Ultimately African and Oceanic, as well as South American art, will also no longer be housed off-site but finally find a permanent place at the British Museum at the beginning of the twenty-first century, now that the British Library has vacated the Bloomsbury site and the central court is being redeveloped by Norman Foster.

The process of unprecedented growth and perpetual expansion of the great European museums effectively came to an end during the first decades of the twentieth century. The institutions were the product of an imperialist mindset, and only under imperialistic conditions was it possible to strip whole nations of their cultural heritage. By the beginning of the twentieth century the ideological climate had changed and such an approach was no longer feasible. The race for world domination between France, Germany and England came to an end: France reluctantly surrendered its fantasies, Britain set into slow and glorious decline, and Germany retrenched, with two catastrophic attempts at further expansion in the two World Wars.

The African and Asian nations that had so far been at the mercy of their occupying powers claimed their independence one after the other. Slowly they began to rebuild their national

22
Jenkins, op. cit., p 199.

23
The most famous case is Greece's ongoing battle for the return of the Elgin Marbles, see: William St Clair, *Lord Elgin and the Marbles* (second, revised edition, Oxford and New York: Oxford University Press, 1998).

24
Old colonial attitudes survived in the tradition of 'partage' between a museum-funded excavation and the host country. North American museums in particular owe many of their Egyptian collections to such divisions at the beginning of the century. Even as late as 1920 the Boscoreale Villa outside Pompeii was stripped of its wall paintings for division between the Metropolitan Museum in New York, the Louvre, and the museums of Naples, Brussels and Amsterdam.

25
Jenkins, op. cit., p 225.

26
John Russel Pope could be considered Duveen's in-house architect: he designed the Duveen Gallery at the Tate in 1929-1930. In 1931 Pope converted the Frick Mansion on Fifth Avenue into the Frick Museum. Duveen subsequently talked another of his big clients, Andrew Mellon, into employing Pope to design the National Gallery in Washington, on which work began in 1936. See: Part One, chapter 4.

identities that had been so callously destroyed. As the rediscovery of their own histories played an important part in this process, they were no longer willing to condone wholesale plunder by their former colonial masters but made valiant efforts to stem the flow of cultural artifacts leaving for foreign shores. Whenever possible, they even tried to reclaim what had already reached Berlin, London or Paris.[23]

As a result, the flood of objects reaching the Western museums turned into a comparative trickle, necessitating a shift from acquisition and expansion to scholarship and display.[24]

Although over the course of the second half of the nineteenth century slow progress had been made towards more visitor-friendly displays, these changes hardly registered when compared to the radical curatorial rethink that took place during the first decades of the new century. It was then that museology underwent a revolution.

'The Parthenon Marbles, being the greatest body of original Greek sculpture in existence, and unique monument of its first maturity, are primarily works of art. Their former decorative function as architectural ornaments [...] are by comparison accidental and trivial interests [...].'[25] This was the opening statement by three classical archaeologists, Bernard Ashmole, John Beazley and Donald Robertson, in their 1928 report to the Royal Commission on National Museums and Art Galleries on the question of the reinstallation of the Parthenon sculptures. Their report meant a radical reversal of 100 years of policy and practice, resulting, five years later, in John Russel Pope's[26] designs for the Duveen Gallery where the Elgin Marbles are displayed to this day. For the first time the sculptures were not seen as specimens – nor displayed together with plaster casts of segments left behind in Athens or held in other locations – but primarily as works of art. For the first time the Marbles were shown on their own, and all documentary and comparative material was banished to a side room.

This shift was by no means limited to the Parthenon sculptures. As far as displays were concerned, the emphasis shifted after the turn of the century. Museums gradually evolved into places where the focus was on an aesthetic-educational experience rather than exclusively on scholarly goals.

From the outset the museum's double potential as place of mass education and symbol of national glory was recognised both by curators and politicians. The resulting tension between educational and propagandistic goals continues to influence the methodology and definition of institutions, and this dichotomy still determines the structure and self-understanding of museums to a large degree.

If the complex ideological construct underlying the new institution was conveniently 'forgotten', this was not because of some vast conspiracy but was the indirect outcome of practical considerations. With hindsight, it was necessary to ignore the inherent contradictions and inconsistencies at the centre of the new institution in order to reap the full benefits of the methodology it offered. That the museum was far from being objective, but was shaped by political and social conditions, was too complex a notion to factor in so early in its history. Museology, the systematic enquiry into the nature and methods of the new institution, came into existence much later, after the museum itself had become historical. Yet for the first hundred years or so, the fundamental assumptions on which the museum was based were neither analysed nor queried. Only much later did self-analysis and -critique become an integral part of museum practice.

3.
Berlin 1900–1930

While the museums of Paris and London were being buried under the volume of acquisitions, Berlin had been lagging behind in both the scope and quality of its collections. The Prussian capital had always been a bit of a back-water as far as the European political landscape was concerned, but the proclamation of the German Empire in 1871 changed this situation and set off an unprecedented rush for political and cultural aggrandisement, Germany belatedly joining the race for a colonial 'place in the sun'. Its desire to catch up culturally with London and Paris led to curatorial activity on such a grand scale that only a few decades later the Berlin museums were rivalling their European sister institutions in every respect.

A considerable share of the credit for this is due to Wilhelm Bode who had been appointed assistant curator at the Prussian State Museums in Berlin a year after the proclamation of the German Reich. Thanks to his unflagging energy and scholarly brilliance, by 1880 he had become director of the paintings and sculpture department. Initially trained as a lawyer, Bode was a self-taught expert on seventeenth-century Dutch and Flemish paintings, on Italian Renaissance art and on the decorative arts, combining a refined aesthetic instinct with formidable analytical skills.

Bode was worldly, deft in his transactions with dealers and brilliant at soliciting major gifts from private collectors, bringing to the Berlin museums a unending stream of important acquisitions and donations. Despite the exceptional demands made on him as an administrator, he remained active as a scholar and researcher, his authority on Italian art rivalled only by the American expatriate, Bernard Berenson, who was holding court in Florence and was deeply unnerved by the German's competition. Between 1897 and 1905 Bode also published (in collaboration with Hofsteede de Groot) a full catalogue of Rembrandt's paint-

ings, the result of twenty-five years of intense and groundbreaking research which to this day informs our image of the Dutch painter.

By the turn of the century, Bode was universally acknowledged as the greatest museum expert and art historian of his age. In many ways his ability to harness political and ideological agendas for scholarly and aesthetic goals mirrored Denon's (and Champollion's) experience a century earlier.

Thanks to Bode's untiring efforts, the Berlin collections grew in great bursts, and by the end of the century the German capital could boast one of the most comprehensive assemblies of European painting, sculpture and decorative arts.

In the field of antiquities progress was equally swift. When the Pergamon Altar reached Berlin in 1878 it was not just an artistic triumph but also an event of great national importance. With the acquisition of the altar, the art historian Jacob Burckhardt rejoiced, 'Berlin had become one of the foremost art pilgrimages of the world.'[27] Other additions were Heinrich Schliemann's fabled finds from Troy ('Priam's Treasure'), the Ishtar Gate from Babylon, and major objects from excavations in Olympia and Amarna. The German Olympia campaign under Ernst Curtius in the 1880s was the first systematic excavation of a complete ancient site, and to this day remains an admired benchmark of archaeological exactitude. The Amarna finds revealed one of the most extraordinary chapters of Egyptian art and history: Egyptian civilisation could no longer be regarded as unchanging and monolithic. A new Islamic Department was set up in 1904, followed by one for Far Eastern Art in 1907.

By the turn of the century the Berlin museums had achieved universal scope. From Ethnographic (the Pacific as well as America and Africa) to Far Eastern (Japan and China), Egyptian, Near Eastern, Islamic, Greek and Roman, Early Christian, Medieval, Renaissance and post-Renaissance art: there was not a civilisation or period in the history of man that was not represented in the German capital.

One of the projects particularly close to Bode's heart was the Kaiser Friedrich-Museum which was built under his close supervision between 1897 and 1904[28] – it was renamed after Bode in 1956[29] – and it was there that he developed an entirely new and

27
Thomas W. Gaehtgens, 'The Museum Island in Berlin', in: Wright (ed), op. cit., p 68.

28
The building was designed by Ernst Eberhard von Ihne but it was in effect a collaboration between Bode and the architect.

29
One suspects that this was not primarily done to honour Bode but in order to remove of the name of the vilified Hohenzollern emperor.

groundbreaking way of displaying works of art. Objects were no longer shown by category – paintings with paintings, sculpture with sculpture, etc. – but grouped instead according to historical context. Renaissance paintings, for example, were exhibited alongside contemporary sculptures and furniture, French paintings with Louis XIV, XV and XVI furniture, and Dutch Baroque pictures were joined by medals and delicate fruitwood carvings from the same period.

The galleries often integrated contemporaneous architectural details, such as ceilings, fireplaces or doorframes. Objects from different categories informed each other and this gave a wider sense of the artistic and intellectual *Umfeld* in which they were created. Within a short space of time the Kaiser Friedrich-Museum became widely admired and its methodology was copied by curators the world over. Bode had demonstrated that it was possible to overcome the nineteenth-century taxonomic approach and create meaningful and informative displays without neglecting aesthetic considerations.

In 1905 Bode was appointed general director of all Berlin museums, a post he was to hold until his retirement in 1920. He immediately set out to apply the methodology he had developed at the Kaiser Friedrich-Museum to all the other institutions now under his care.

The master plan he submitted in 1907 (*Denkschrift betreffend Erweiterungs- und Neubauten bei den Königlichen Museen in Berlin*) was to turn the Berlin museums into the methodologically most advanced institutions of their kind. At the centre of Bode's plan was the Museum Island[30] with Schinkel's Alte Museum,[31] the model for museum buildings all over Europe in the nineteenth century, the Neues Museum,[32] the Nationalgalerie[33] and his Kaiser Friedrich-Museum.

To these Bode added a new building on the west side of the island: the Pergamon Museum complex. Its south wing was to house Near Eastern antiquities, the north wing German art and the central block the Pergamon Altar as well as Greek and Roman architecture and sculpture. The combination may appear strange but was by no means accidental. It subtly implied, in the imperialist spirit of the age, that German culture was on a par with its ancient Mesopotamian and Greek counterparts. The building

30
For a detailed discussion of the Berlin museums see: Michael F. Zimmermann et al., *Berlins Museen: Geschichte and Zukunft* (Munich and Berlin: Deutscher Kunstverlag, 1994); the Museums Insel is also discussed in: Thomas W. Gaehtgens, *Die Berliner Museumsinsel im Deutschen Kaiserreich* (Munich and Berlin: Deutscher Kunstverlag, 1992).

31
Designed by Friedrich Schinkel and built 1824–28.

32
Designed by Friedrich August Stühler. Built between 1843 and 1846, the interiors finished in 1855, it opened to the public the following year.

33
Designed again by Stühler and built between 1852 and 1862.

was designed by the architect Alfred Messel in 1907, but his sudden death in 1909 led to a number of subsequent revisions, and work progressed slowly, interrupted by the First World War and subsequent economic collapse, until the museum finally opened to the public in 1930.

The Pergamon Museum in its final incarnation marked an important advance in the display of Greek and Roman antiquities. Although Messel's building – as revised by Ludwig Hoffman – still harked back to classical models, these references were, at least in the interiors, more insinuated than actual. The drawn-out genesis of the building over a period of nearly a quarter of a century turned out to be beneficial, allowing for the incorporation of the latest in architectural thinking, and the outcome was a museum of almost Bauhaus-like clarity and restraint. There is a simplicity and airy spaciousness to the galleries that must have felt quite shocking at the time. A comparison between the Pergamon Museum and the British Museum antiquities galleries is revealing. Victorian gloom and overcrowding has given way to modernist simplicity and sparseness. There was no trace of added ornament and no attempt at decoration in the Pergamon galleries, the walls were pale, lighting was functional and pedestals were minimalist in their understated restraint. Marble sculptures and other works were judiciously placed to their best advantage. It was a new way of looking at classical sculpture: antiquities were no longer there primarily to illustrate some underlying narrative or chronology but were considered as works of art in their own right.

Not content with the Museum Island projects, Bode also envisaged a secondary museum cluster to be located in the Berlin suburb of Dahlem, with the aim of uniting all non-European collections there (Africa, Asia, the Pacific region, American archaeology, etc.). The buildings were designed by Bruno Paul and partly realised between 1911 and 1916. In the event, the complex was never completed and the finished parts served as depots until the outbreak of the Second World War. After the war the buildings became home for those parts of the Museum Island collections that had fallen into the hands of the Western Allies and were returned to West Berlin in the 1950s.

Bode was not only brilliant in the areas that interested him

personally but also had a knack of appointing the right person for fields that lay outside his own expertise.

In 1896 Hugo von Tschudi was appointed director of the Nationalgalerie, the museum for nineteenth-century art. Tschudi proved an inspired choice. Not only did he expand and rearrange the Nationalgalerie's collection (in the process shifting its focus from the shrill nationalistic to the aesthetic[34]); he was also the first German museum director to buy the works of the still-controversial Impressionists. In 1897 he purchased Cézanne's *Mill on the Couleuvre at Pontoise*,[35] the first painting by the artist ever to enter a museum collection.

Tschudi's progress was followed with suspicion and disapproval by the German emperor, Wilhelm II, who ominously declared that 'an art which forgets its patriotic mission and appeals solely to the eyes of the connoisseur did not at all exist'. When in 1908 Tschudi submitted a Delacroix painting to the emperor for approval – all Nationalgalerie purchases were subject to the emperor's final authorisation – Wilhelm II blustered that a 'director might show such a thing to a ruler that did not know anything about art, but not to me!'[36] Things finally came to a head and Tschudi was put on leave of absence. He resigned his Nationalgalerie post in 1909 and became director of the Alte Pinakothek in Munich. By the time of his premature death in 1911 he had purchased for the Bavarian capital more than forty paintings and sculptures by Gauguin, van Gogh, Toulouse-Lautrec, Rodin, Maillol, Bonnard and Matisse, as well as three oils by Cézanne and Manet's *The Luncheon in the Studio* (1868). Most of these works are still in Munich.

If Wilhelm II had hoped that Tschudi's successor would be more malleable he was sorely disappointed: Bode's choice as new director, Ludwig Justi, was even more up-to-date in his tastes than his predecessor. Without delay Justi began to purchase Post-Impressionists, Cubists and German Expressionists on an unprecedented scale.

By 1919 – the First World War was over and Wilhelm II in exile – the Nationalgalerie's collection had finally outgrown its home on the Museum Island. Justi spliced off two monographic museums devoted to Schinkel and the Prussian neoclassicist Rauch, and moved the twentieth-century part of the collection

34
On the genesis of the Nationalgalerie see: Françoise Forster-Hahn, 'Shrine of Art or Signature of a New Nation? The National Gallery(ies) in Berlin 1848-1968', in: Wright (ed), op. cit., pp 78-99.

35
Mill on the Couleuvre at Pontoise 1881, oil on canvas, 29in × 36in, Venturi 324, Rewald 483. The painting escaped Nazi 'de-accessioning,' survived the war, and is still in the Nationalgalerie.

36
John Rewald, *The Paintings of Paul Cézanne: A Catalogue Raisonné* (London and New York: Thames and Hudson, 1996) vol. I, p 325.

to the Kronprinzenpalais. The irony of this step could not have been lost on many. The very art Wilhelm II had detested so violently was now housed where he himself had grown up as a prince and where his son in turn had lived, in readiness for an office that he never attained.

Between the wars the Kronprinzenpalais became an international byword for the daring and committed collecting of new art, a home for the German and international avant-garde of the time. If it had not effectively still been a branch of the Nationalgalerie, it could claim to be the first museum devoted exclusively to present-day art, predating New York's Museum of Modern Art by nearly a decade.

The Berlin museums under Bode became a widely influential model for curatorial practice, their methods and techniques applied all over the world. Whatever the initial underlying political agendas, the Berlin museums' reputation was ultimately based on impeccable, standard-setting scholarship and on a museology grounded in open-minded liberalism. These achievements were phenomenal by any standard but they were even more impressive when one considers them in the light of economic circumstances and the prevailing political climate in Germany. Bode and his successors held steady despite rapidly changing and often adverse conditions, from Wilhelminian reaction to the First World War, postwar inflation and economic collapse, and to the slow and menacing ascent of Fascism, a chain broken only by the few golden years of the Weimar Republic.

The rise of Nazism brought the Bode tradition to an abrupt end. Hitler and his acolytes viewed all cultural institutions with deep suspicion and it was, not surprisingly, the Kronprinzenpalais that became one of the Nazis' first, high profile institutional victims. The display of hated modernist art in the heartland of Prussian power, Unter den Linden, could not be stomached for long. The most radical rehang at the Kronprinzenpalais – which saw the removal of all Impressionist paintings to the Nationalgalerie, so that the emphasis was now entirely on Post-Impressionist, Cubist and Expressionist works – had ironically coincided with Hitler finally gaining power at the beginning of 1933. At a preview, Goebbels and Rust (the education minister) were infuriated by what they saw and, by June,

Justi was officially asked to resign. When he refused, he was, on Goebbels' orders, sent on 'indefinite leave, with immediate effect'.

The Nazi *Gleichschaltung* of German culture moved at a lightning pace. In August 1933 the 'museum workers' of the Reich met at a conference in Mainz and ominously resolved that 'museums too should cooperate in the great task and with all their powers contribute to the shaping of an amorphous mass of population into a nation.'[37]

Within months of the Nazis gaining power, the museums of Bielefeld, Essen, Mannheim, Lübeck and Hamburg (amongst others) had their directors dismissed. These were men of great distinction and dedication who had built up collections for their institutions that in some cases surpassed even the Kronprinzenpalais in scope and radicality. In their place declared supporters of the Nazi cause were installed, who were only too eager to toe the official line and wasted no time in showing gratitude for their appointments: by the end of 1933 no fewer than ten major defamatory exhibitions of avant-garde art were on view all over Germany. Drawing on local collections, these propaganda exercises were never as large as the infamous 'Entartete Kunst' (Degenerate Art) show, but they predated it by nearly four years, illustrating that the cultural climate had been changing much faster than is often assumed. Posterity owes one of the most prescient and chilling first-hand accounts of this period to Alfred H. Barr who, whilst on leave from the Museum of Modern Art, spent four months in Stuttgart and witnessed the Nazi takeover.[38]

It was one thing for the Nazis to move with brutality and speed in the provinces, but Berlin was a different matter. By July 1933 Alois Schardt was appointed as Justi's successor at the Nationalgalerie and at the Kronprinzenpalais. Schardt, who had previously worked under Justi and had until recently been director of the Halle Museum, was a known champion of modern art and tried his best to rescue as much as he possibly could.

He reinstalled the Impressionists at the Kronprinzenpalais and removed the most radical works of art from display – there would no longer be works by Kandinsky on display, the Beckman room went into storage, and the Expressionists were represented by landscape paintings only. Under pressure from the

37
F.T. Schulz,
'Die Notwendigkeit der Umgestaltung unserer Museen' (On the necessity to change our museums) in *Museumskunde Journal*, 1933, quoted after Wittlin, op. cit., p 161.

38
Published as 'Art in the Third Reich – Preview, 1933' in: *Defining Modern Art, Selected Writings of Alfred H. Barr Jr.* (New York: Harry N. Abrams, 1986) pp 163-175.

Nazis, Schardt went to absurd lengths to construct a historical lineage of German art from the Gothic to Expressionism, going as far as to describe in a lecture Albrecht Dürer's Italian sojourn of 1494 as an 'artistic mistake'. Yet none of this was enough, and when Rust came to inspect the reinstallation in November, he refused permission for the Kronprinzenpalais to reopen.

Schardt kept tinkering and the Nazis kept grumbling, and the museum miraculously reopened and then remained open, on and off, for the next two years. The 1936 Olympic Games offered Schardt a welcome respite: because of its obsessive concern with appearances, the Fascist government was clearly reluctant to take decisive steps while so much international attention was focused on Berlin. But the foreign guests had hardly quit the capital when Goebbels finally leapt into action and ordered the closure of the Kronprinzenpalais on October 30.

In November of the same year Goebbels set up the Reichskulturkammer, thereby effectively establishing full control over every aspect of cultural life in Germany. Every person active in the arts – visual art, literature, film, theatre, journalism and music – had to register as a member, and the right to write, compose or paint was subject to such membership.

The following spring preparations for the notorious 'Entartete Kunst' exhibition began. A commission was set up which visited the public collections of modern art all over the Reich. They confiscated 16,000 works of art which were taken to Kopernicker Strasse in Berlin, where a warehouse had been rented especially for the purpose. Always careful to give their actions at least the appearance of legality, the Nazis passed a law on May 31, 1938, that turned confiscation into expropriation; the government became the sole owner of the Kopernicker Strasse cache. Works were sorted according to their marketability and others singled out for inclusion in the planned exhibition. Those considered saleable were taken to Schloss Niederstein outside Berlin. Sales from there – including the infamous auction at Galerie Fischer in Lucerne[39] – continued until June 1941. More than 5,000 works that remained at Kopernicker Strasse, judged to be of no commercial value, were burned on March 20, 1939, in the courtyard of a Berlin fire station as part of a training exercise.

Goebbels, desirous as always to add insult to injury, briefly

[39] Held on June 30, 1937, the auction included major works by Matisse, Picasso, Beckmann, Kirchner and many others.

considered turning the Kronprinzenpalais into a museum for official, Nazi-approved art, effectively a branch of the Munich Haus der Kunst. His plan came to nothing and the Kronprinzenpalais was finally handed over to the Akademie der Künste – by then only a shadow of its former self.[40]

It had taken Bode fifty years of dedication and hard work to turn his plan for the Berlin museums into reality, and much of it, including the Dahlem complex, was still unrealised. He died in 1929 and therefore did not have to witness the destruction of his life's work during the Nazi years and the Second World War.

The evacuation of the Museum Island collections at the outbreak of war in 1939 set off a fifty-year saga that to this day has not reached a conclusion.[41] As a result of Hitler's pointless, not to say Wagnerian orders for an all-out battle against the advancing Allies who were closing in on Berlin, the Museum Island became part of the capital's last line of defence. On May 2, 1945, after a protracted battle, the Russians finally took the smouldering complex. An immediate survey revealed destruction on a devastating scale. The Pergamon Museum and the Nationalgalerie were badly damaged but salvageable, Schinkel's interiors at the Alte Museum were beyond repair and the Kaiser Friedrich-Museum was partly burned-out, while the Neues Museum was the most severely damaged of the buildings. It would remain a ruin for the rest of the century.[42] The East German government made valiant efforts at rebuilding but the process, dogged by the precarious financial situation of the Communist regime, was drawn-out and the results disappointing. A full restoration and rebuilding programme is currently being undertaken under the supervision of the English architect, David Chipperfield.

It was not only the material fabric, the buildings and the collections, that had suffered greatly: German museum practice was discredited and its great, epochal lineage shattered.

After the war, no German curator claimed the Bode inheritance. Those in East Germany were already busy dancing to a new tune, and the generation that had been forced to leave the country was still too hurt – or too angry – to associate itself openly with the Bode tradition. Although Bode's achievement remained extremely influential, it lived on without acknowledgement. As for West German museology, there would be

[40]
The Kronprinzenpalais was completely destroyed during the war and in 1968-1969 was rebuilt as an official guesthouse for the government of the German Democratic Republic.

[41]
The most authoritative and comprehensive account of the postwar saga of the Berlin collections can be found in:
Lynn H. Nicholas, *The Rape of Europe* (New York: Alfred A. Knopf, 1994) pp 327-406.

[42]
Ernst Badstubner et al., *Das Neue Museum in Berlin: Ein denkmalpflegerisches Plädoyer zur ergänzenden Wiederherstellung* (Berlin: Senatsverwaltung für Stadtentwicklung und Umweltschutz, 1994).

nearly two decades of embarrassed silence. Only in the 1970s did a new generation of German curators and art historians emerge who were untainted. Slowly and carefully, they began to analyse their elders' misdemeanors.

That museums were easily affected by politics was not new. The museum, after all, was born out of politics, and since the French Revolution had played an important role in the formulation of national identities, a process spurred on by the conflicts between European nation states. It therefore was not the Nazi politicisation of art and the museum that was shocking, it was the Nazis' thoroughness that was unsettling, the fact that they were not just satisfied with censorial interference but that they were so blatantly set on destruction.

In the light of their eagerness to take over and 'reform' museums as quickly as possible, it is surprising how marginal a role the museum finally played in overall totalitarian propaganda. A reason for this may be that ultimately, however much of a propagandistic spin was put on the displays, the visitor remained remarkably immune to manipulation. That more than a few visitors were deeply enthralled by works in the 'Entartete Kunst' exhibition, for example, cannot have escaped Nazi officials. Looking at art remained a solitary activity, unobservable and ultimately difficult to engineer, far less effective than radio, film and parades in bending people's minds to the party line.

From the experience of Germany an image emerged of the museum – and culture – as something that was exceedingly vulnerable and required special protection, a notion reinforced by the contemporaneous goings-on in the Soviet Union under Stalin.[43] After 1945 the protection of museums from state interference – and in a wider sense the freedom of speech and artistic expression – became an important issue in many Western countries. In Britain, the Arts Council was created to shield recipients of state funding from direct government interference. In West Germany the cultural authority was vested with the regions, rather than with the federal government, to guarantee that it would be impossible to exercise central control in any form. In general in the West a new sensibility emerged which has safeguarded a remarkable degree of autonomy for museums ever since.

43
For an account of the Hermitage under Stalin see: Geraldine Norman, *The Hermitage: The Biography of a Great Museum* (London: Random House, 1997), pp 154-240.

4.

New York 1930–1950

Three major museums had been founded in the United States within a relatively short time span at the beginning of the 1870s: the Metropolitan Museum of Art in New York, the Museum of Fine Art in Boston and the Art Institute in Chicago. After that the pace did not slacken until the 1930s, and sizeable institutions were set up in most large American cities in quick succession.

Although in appearance these museums resembled their European counterparts, they were different in many important respects. If European museums were instruments of revolution and, later, of imperialism, the same could not be said of their American sisters. The politics of social reform were missing from the American agenda and, as far as global and imperialistic politics were concerned, it would be another half century before the United States was to step onto the world stage. As a result, the nature of the first great American museums was much more civic than nationalistic, and the emphasis was decidedly on education.

In the most radical departure from European models, American museums were founded, controlled and endowed not by politicians, but by private individuals.

Despite these important differences, American museums copied European concepts closely. Maybe this was the result of some cultural inferiority complex, but more likely it was because the European museum format had, by the end of the nineteenth century, become the accepted standard. Whatever the reasons, the idea of the museum and its wider implications dovetailed neatly with the desire of the owners of freshly-minted post-Civil War fortunes to demonstrate that not only were they extremely rich, but they were cultured and public-minded into the bargain.[44] They wanted the best for their museums and they had the means to obtain it, a constellation that resulted in an unprecedented art-market bonanza.

Not since the eighteenth century, when the English roamed

44
In America to this day museums play an important part in 'legitimising' newly made money. For an analysis of this important aspect of American culture see: Francie Ostrower, *Why the Wealthy Give: The Culture of Elite Philanthropy* (Princeton, New Jersey: Princeton University Press, 1995).

Europe to fill their country houses, had cultural property been transferred on such a stupendous scale. Lured by unheard-of prices, the heirs of the eighteenth century buyers were the latter-day sellers, and paintings, sculptures, furniture, silver, drawings, manuscripts and books, all the trappings of aristocratic lifestyle, left England for the New World.

This stream swelled to such proportions that nervous questions were asked in Parliament about the wholesale loss of the nation's heritage. On a number of occasions the Treasury was forced to give special grants to the National Gallery in London so that certain key paintings could be rescued from the hands of disappointed American buyers.[45] Britain was by no means the only European country affected. Arguably the most spectacular transaction was Andrew Mellon's purchase of twenty-one paintings from the Hermitage in 1936. This included major works by Hals, Rubens, Rembrandt, van Dyck, van Eyck, Veronese, Chardin and Perugino, Raphael's *St George and the Dragon*, and the Alba Madonna, Velásquez's *Portrait of Innocent X*, Botticelli's *Adoration of the Magi*, and *Venus with a Mirror* by Titian. The group is to this day at the heart of the collection of the National Gallery in Washington.

Propelled by these acquisitions and protected from the ravages of war, American museums grew impressively, and by the 1940s, if not slightly earlier, a number of them began to rival their European counterparts in the scope and quality of their holdings. While spectacular purchases continued to be made after 1945, the scale of pre-war buying has never been matched. Dwindling supplies and European nations' much tighter control of their cultural heritage saw to this. The most publicised instances were the Metropolitan Museum's purchases of Rembrandt's *Aristotle Contemplating the Bust of Homer* at Parke Bernet in New York in 1963 and Velásquez's *Juan de Pareja* at Christie's in London in 1971.

In their conceptual layout American museums mirrored European institutions: at the centre of the collections were Egyptian art, Greek and Roman antiquities, applied arts (furniture, silver, etc.), Old Master and nineteenth-century paintings, to which the Americans added Impressionists and Asian art. It was an updated version of the old Hellenocentric view.

45
For an overview of this period see: Gerald Reitlinger, *The Economics of Taste* (London: Barrie & Rockliff, London, 1962 [Second edition, New York: Hacker Art Books, 1982]), vol. 1, pp 175-204.

40 THE CURATOR'S EGG

Antiquities were of course much harder to come by than at the beginning of the nineteenth century,[46] yet as late as 1931 John D. Rockefeller was able to donate a collection of fifty-five major Assyrian sculptures and reliefs to the Metropolitan Museum, the balance of what was already held in London, Paris and Berlin.[47]

Whatever the disappointments in the area of antiquities, the consolation was great collections of Asian art, particularly in Boston, as well as Impressionist and Post-Impressionist paintings. The cultural and artistic battles that were still being fought over Impressionism in Europe did not really concern Americans. If anything, there was a natural affinity between the new but essentially bourgeois French painting and the self-understanding of the American industrialist oligarchy, and, as a result, Impressionist works reached the New World on a truly staggering scale from the 1890s onwards.[48] To this day, Impressionist art is still the most conspicuous area in which American museums routinely surpass their European counterparts.

It was not only Bode's ideas that reached North America. In 1909 one of his former assistants, William R. Valentiner, became the Metropolitan Museum of Art's first curator of Decorative Arts. In a letter of recommendation to New York, Bode had described Valentiner as 'the most gifted and best equipped young student of art that I have ever had in the museum.'[49] Valentiner had worked closely with Bode on the Kaiser Friedrich-Museum installations and greatly admired his teacher's synthesis method of display, and the older man was clearly reluctant to let his former pupil go.

In New York, Valentiner was able to develop Bode's ideas further, not just by following his teacher's precedent of placing objects of related geographic and historic context in the same gallery, but by recreating entire period settings. Complete interiors were acquired, mainly in France and England, dismantled and shipped to America. In 1927 the concept was taken to its apotheosis – or ridiculous extreme, depending on one's point of view – with the Cloisters, a branch museum housing the Metropolitan's medieval collections. Parts of monasteries and churches were collected from all over Europe and reassembled in Manhattan. Today the overall impression is decidedly more 1930s than medieval.

46
See: Cornelius C. Vermeule, *Greek and Roman Sculpture in America* (Berkeley and London: University of California Press, 1981).

47
For a full account of this gift see: Russell, op. cit.

48
For the most significant collection in this field see: Frances Weitzenhoffer, *The Havemeyers: Impressionism Comes to America* (New York: Harry N. Abrams, 1986).

49
Calvin Tomkins, *Merchants and Masterpieces: The Story of the Metropolitan Museum of Art* (London and Harlow: Longman, 1970) p 166.

To this day, period rooms are a hallmark of North American museums, despite the fact that the idea has become rather discredited. Too often the line had been blurred between faithful reconstruction and fanciful invention, the resulting rooms telling us less about the era to which they pretend than that in which they were recreated. Often-quoted in this respect are the period interiors in the Robert Lehman wing at the Metropolitan Museum. Installed in 1975, they are a faithful reconstruction of rooms in Lehman's New York mansion, decorated for him in 1959 by the Paris firm Jansen in imitation of 1905 rooms that were themselves an approximation of French eighteenth-century interiors.[50] It is hard to identify the results with any particular historical style, and the rooms are maybe best described as high Robber Baronial.

The latest incarnation of the period room concept are Thierry Despont's highly controversial designs (1995–96) for the decorative art galleries in Richard Meier's Getty Museum in Malibu, California.

No other architect has determined the image of the American museum as much as John Russel Pope (1873–1937). By the 1920s, at the zenith of his career, he had developed an architectural language of such imperial hauteur and classical severity, so clearly suited to expressing civic and national aspirations, that he became the obvious choice for major government or museum buildings. When he did not build, he advised, and Washington DC is, to this day, very much Pope's city.

Although European in vernacular, the scale of his work is definitely American. How much so can be discovered by looking at his two London projects: the Duveen Gallery (1929–37) at the Tate Gallery and the galleries housing the Elgin Marbles at the British Museum (1930–37), both donated by the art dealer Joseph Duveen, who had made his fortune selling European art to eager American collectors.

The Duveen Gallery at the Tate was planned for modern sculpture, yet from the outset its scale tended to overwhelm displays. In the 1950s the museum's curators finally capitulated and began to use temporary walls and false ceilings to contain the vast vaulted expanse of Pope's space.

The British Museum's experience was not dissimilar: when

50
Carol Duncan, *Civilising Rituals: Inside Public Art Museums* (London: Routledge, 1995), pp 68f and 90f; Tomkins, op. cit., pp 335-338 and 354-355.

shown Pope's first plans for the galleries which were to house the Elgin Marbles, Sir George Hill, the director, nervously quipped that they 'will make the rest of the British Museum a doghouse'.[51] Even after being halved in size, the Parthenon Gallery is still overwhelming in its scale and severe simplicity. The main criticism is that the monumentality of the space competes with the sculptures for attention; to the untrained eye it can make the Acropolis marbles look like a mere decorative detail. Despite these reservations, both galleries have become the signature spaces of their respective museums.

Pope's final design, often considered his masterpiece, was Washington's National Gallery, Andrew Mellon's gift to the nation and commissioned by him in 1936.

To this day, visiting the National Gallery is a strange experience and Pope's pitiless monumentality can still come as a shock. Nothing quite prepares the viewer for the breathtaking austerity of the windowless façade,[52] the awesome scale (the building is 765 feet long), the overpowering grandeur of the entrance rotunda with its highly polished dark green marble columns, reddish-brown marble floor and pink marble walls, and the hushed lavishness of the wood-panelled galleries in their theatrical expansiveness. There is no break, no room to recover, the rhetorical pace never slackens: from beginning to end the architecture is out to impress, seduce and overwhelm. Pope does not just spell it out, he relentlessly hammers home his vision of a quasi-sacral space devoted to masterpieces, ironically succeeding to the point where the paintings can appear secondary, blanked out by the architectural spectacle that frames them.

Pope died in August 1937 and never saw his two London projects finished, nor was he to witness the completion of the National Gallery building. The Washington museum had hardly opened in March 1941 when it became the object of severe criticism and the butt of many unkind jokes. The architectural critics, without exception, were savage: 'Beaux-Arts in the purity of death',[53] as one reviewer put it. The head of the US Treasury Department's art section reportedly called the building a 'pink marble whorehouse', and Philip Goodwin, co-architect of the Museum of Modern Art in New York, referred to it as that 'costly mummy'.[54]

51
Steven McLeod Bedford, *John Russel Pope: Architect of Empire* (New York: Rizzoli, 1998).

52
Appearing even more austere because the sculptural decorations originally envisaged by Pope were never carried out.

53
Duncan, op. cit., p 98.

54
McLeod Bedford, op. cit., p 200.

Pope's architecture was derided as reactionary, derivative and out of touch with the realities of modern America, its monumentality dismissed as monomaniacal and vacuous, and within a few years of his death he and his work were virtually forgotten. It was not just the changing fashion in architectural style and the advent of modernism that led to the condemnation of Pope's work as retardataire. The fact that the architectural language of both Hitler's Germany and Stalin's Russia was neoclassical had not escaped American critics, architects and curators. Classicism, rightly or wrongly, had become increasingly identified with totalitarianism. In its newly emerging role as the guardian of the free world, America could no longer be seen to be adopting a style that had become so besmirched.

To express unequivocally its own ideals and aspirations, its destiny and mission, the United States had to find an untainted, and therefore preferably new, architectural language. The modernist idiom was in a way an obvious choice, because it was both contemporary and not only untainted but actually vilified by the totalitarian regimes. In this respect the emergence of the International Style was not a matter of aesthetics alone but was dictated, to a fair degree, by politics as well.

Pope was the last exponent of American neoclassicism, and his National Gallery in Washington its last great monument. Ironically, the National Gallery building stands up very well in today's post-modern architectural context and is probably more appreciated than ever before.

While the final chapter of neoclassicist museum architecture was acted out in Washington, in New York an institution was founded that would influence museum practice for the second half of the twentieth century as definitely as the Berlin museums did during the first half.

The idea of a museum dedicated exclusively to modern art had grown out of casual conversations between Lillie P. Bliss, Abby Aldrich Rockefeller (the wife of John D. Rockefeller Jr.) and Mary Sullivan. Discussions progressed swiftly and in 1929 the 28-year-old Alfred H. Barr became – on the advice of the Yale art historian Paul Sachs – the founding director of the Museum of Modern Art in New York.

In the past American museums had not deviated much from

the European museum concept but had merely fine-tuned it. It was impossible to ignore the European model because it had become so much a part of the cultural fabric of Western nations, and, in this respect, the United States were aspirational and only too happy to conform. A museum dedicated to modern art, on the other hand, was different because there was no European precedent, no format to follow and no history to genuflect to. American in nature and outlook, the Museum of Modern Art was the New World's truly authentic contribution to the history of the museum.

Its location was the first indication of how different MoMA was to be. It was not housed in a purpose-designed building of suitably imposing monumentality but located in an office suite on the twelfth floor of the Heckscher Building at 730 Fifth Avenue (and West 57th Street), conspicuously far away from the Metropolitan Museum or the Frick Collection: what, with the addition of the Guggenheim Museum, would later become 'Museum Mile'. *The New York Times* reported on November 6, 1929, that the new museum 'occupied about 4,430 square feet of office space. About 3,800 square feet is devoted to galleries – one large gallery, three medium-sized galleries and two small galleries. Opening off the large gallery is a small room which is to be used as a library and reading room.'[55]

The Museum of Modern Art as envisaged by Alfred Barr in the 1930s was truly revolutionary in concept. It was, in Barr's own famous phrase, 'a laboratory; in its experiments, the public is invited to participate'. Besides its concentration on modern painting and sculpture, there was the unprecedented inclusion of photography, architecture, industrial design and film, covering the entire spectrum of contemporary visual culture.

The museum was not satisfied with simply documenting but took a proactive stance, instigating and participating in, if not actually directing, critical debate in all the areas it covered. It was normative in its pronouncements, not to say dogmatic, and to this day inclusion in its collections is considered a great accolade.

In 1937 Barr set up an education department under the directorship of Victor d'Amico (who retained the post until 1969). Education for Barr was not a side issue but central to the success of the whole venture, and with missionary zeal he devoted him-

55
Terence Riley, *The International Style: Exhibition 15 and the Museum of Modern Art* (New York: Columbia University and Rizzoli, 1992), p 165.

self to developing new methods and approaches in this area. Barr looked at every detail and instigated changes that were to affect all aspects of future museum practice.

Wall labels were no longer half-hearted affairs, sometimes appearing as if they were deliberately obscure, but included concise explanatory notes. Exhibitions were accompanied by extensive lecture programmes and guided tours.

Comprehensive catalogues were published for most exhibitions, with texts often written by Barr himself in his famously fluent yet information-packed style; Barr also insisted that as many works as possible were illustrated. He carefully supervised the layout and design of the museum's publications, and in due course they became design classics in their own right. Widely distributed, the publications were an important instrument for spreading the museum's gospel, influencing curators and artists all over the globe.

From the outset MoMA had a department that sent touring exhibitions across the country. The seminal 'Modern Architecture – International Exhibition', for example, travelled to no fewer than fourteen cities after its launch in New York in 1932-33. During the first ten years of the museum's existence, ninety-one MoMA exhibitions were seen at nearly 1,400 US venues. After the war an international touring department was set up, and in recent years much has been made of the fact that it periodically received funding from the CIA via the United States Information Agency.

No detail was too small for Barr's attention and he created a strong, easily recognisable 'corporate identity' for his museum, the first time that this was consciously attempted in an institution of this type.

In case all this was not sufficient to win a captive audience, in 1930 Barr hired a publicist to polish MoMA's image, the first museum director ever to do so.[56]

Barr's hunch that the American audience was ready for modern art was confirmed by MoMA's immediate great success. Press coverage was ample and glowing, and by 1931 the cramped office suite at the Heckscher Building had become the sixth most visited art museum in the United States. Up to 3,000 visitors would sometimes arrive on Sundays, patiently queuing for the

56
Alice Goldfarb Marquis, *Alfred H. Barr: Missionary for the Modern* (Chicago: Contemporary Books, 1989) p 79.

lift to take them to the twelfth floor, and space restrictions soon became a serious problem.

Only two years after MoMA's foundation a search for a new home was instigated, and at the end of 1931 a five-storey brownstone was rented at 11 West 53rd Street. This property in turn was outgrown within a few years and at the end of the decade a purpose-designed building was commissioned from Philip L. Goodwin and Edward Durrell Stone, located again on West 53rd Street. Barr was not pleased with the choice of architects and would have preferred one of the more radical Europeans for this important job, but the trustees prevailed. In the end the Goodwin/Stone design may not have been the first or most revolutionary International Style building in the United States, but it was definitely the most high-profile.

It would be hard to overstate Barr's achievement: with his collecting policy, his exhibition programme and his standard-setting publications, he had turned the study of contemporary art into a respectable field of research. Bringing to modern art the scholarly precision and a level of attention that in the past had been reserved for Old Masters only, he was the first to formulate a cohesive history of modern art and create the terminology that would govern all future critical discussion in the field. Not since Denon or Bode had a museum director wielded such influence. At the time of Barr's death in 1981, Philip de Montebello (the director of the Metropolitan Museum of Art in New York) described him and Wilhelm Bode as 'the two greatest twentieth-century museum directors in the world'.[57]

Despite all this success, Barr was aware that there was a dilemma at the centre of his enterprise. What would happen when part of the collection became historical? Gertrude Stein's critique of MoMA, that one could either be modern or a museum but not both simultaneously,[58] holds true to this day for all museums devoted to contemporary art. For the rest of his career Barr tried hard to solve this inherent contradiction.

For the trustees he had developed the image of the museum's collection as a torpedo, its nose 'the ever-advancing present, its tail the ever-receding past'.[59] In 1932 Barr wrote that 'the composition of the collection will change; the principles on which it is built will remain permanent [...] After an intermediate period in

57
Goldfarb Marquis, op. cit., p 357.

58
This statement has been attributed to Stein repeatedly but there is actually no trace of it in any of her writings. It is nevertheless sufficiently Steinean in spirit to warrant attribution and may indeed be a remark she made in conversation.

59
Goldfarb Marquis, op. cit., p 116.

the permanent collection of MoMA, many [...] works will find their way into [...] other museums.'[60] The trustees were in agreement with this and even considered establishing a rule whereby works would be de-accessioned within fifty years of an artist's death,[61] and there was serious talk about MoMA becoming a 'feeder' for the Metropolitan Museum of Art.[62]

All this was stated in MoMA's infancy, before the initial trickle of twentieth-century works entering the collection turned into a torrent of masterpieces. In the beginning, MoMA relied heavily on loans and functioned more like a Kunsthalle, with a programme of constantly changing exhibitions. The first great boost to the permanent collection came in 1934 with the arrival of the Lillie P. Bliss Bequest. During the 1940s and 1950s the museum's collection kept growing rapidly, and as time passed the declaration of constant renewal became just lip-service: although the focus was on the head of the torpedo, the tail kept expanding. Rare pruning was limited to upgrades, and the intended bulk de-accessioning of the more historic works never took place. A belated result of this policy was a clause in Abby Aldrich Rockefeller's 1948 will that obliged MoMA in 1998 to hand over drawings by van Gogh and Seurat to the Metropolitan Museum and the Art Institute of Chicago. After half a century, she reasoned, they would no longer be 'modern'.[63]

The question of collaboration with other New York museums came up periodically over the years, but pride of ownership, not to mention donors' feelings and expressed wishes, made it increasingly difficult to effect any change. In 1948 a pact had been signed by the Metropolitan Museum of Art, the Whitney Museum and MoMA.[64] The idea was that the three museums would divide areas of responsibility to avoid duplication – if not triplication – in their exhibition programmes and collecting policies, but professional jealousies and paranoia saw the agreement expire with little ever being implemented.

By the 1960s Barr's revolutionary idea of perpetual renewal had been supplanted by the concept of MoMA as *the* collection of record for modern art. The claim was not made idly: the holdings at 53rd Street were unrivalled and included masterpieces in such abundance that no other museum could match MoMA in encyclopedic range or quality.

60
Goldfarb Marquis, op. cit., p 115.

61
Goldfarb Marquis, op. cit., p 115.

62
The precedents for this were not exactly encouraging: in London, the National Gallery's right to raid the Tate Gallery's collection at will created great resentment and a climate of cold war between the two institutions. Although the practice was effectively stopped in the 1960s, it took until the mid-1990s for more cordial relations between the two institutions to be re-established. See: Frances Spalding, *The Tate Gallery: A History* (London: Tate Gallery Publishing, 1998) pp 122-124.

63
Jason Edward Kaufman, 'Her Will Be Done', *The Art Newspaper*, no. 87, December 1998, p 7.

64
Goldfarb Marquis, op. cit., pp 246-248.

Despite the increasing emphasis on the historical, MoMA remained resolutely dedicated to contemporary art and played an important part in the establishment of Abstract Expressionism as the first great postwar movement, signalling the arrival of an authentic American art of international consequence. Abstract Expressionism fitted into Barr's concept of Modernism as the logical outcome of Surrealism, and it was therefore relatively easy for the museum to fit the new movement into its canon. MoMA's conceptual problems really only started after Abstract Expressionism. Neither Pop Art nor Minimalism fit easily into Barr's canonical narrative, and, although MoMA gamely tried to keep up with new developments, the efforts were often half-hearted.

By the late 1950s the radical institution Barr had envisaged in the 1930s had itself become establishment, held back by its own history and the growing weight of the torpedo's ever-expanding tail. MoMA was coming under increasing attack from a younger generation of artists and critics who perceived the museum as a staid WASP bastion: conservative in attitude, programme and outlook. Despite the fact that Pop Art happened on MoMA's doorstep, its institutional and critical battles were fought in Europe, and, to this day, the museum has only an average representation of this seminal movement in its collection. Minimalism, Conceptualism and the art of the 1980s and 1990s are presented even less convincingly, but maybe this outcome was inevitable. It was of course easier to pronounce on matters that took place on a different continent, a remove that gave the museum a safe distance and made it possible to generalise often complex goings-on without the risk of being accused of superficiality, partisanship or vagueness. The lack of intercontinental long-distance perspective, paired with Barr's unashamedly Eurocentric outlook,[65] left the museum ill-prepared for the complex critical warfare and heated debates that accompanied the ascent of American art after Abstract Expressionism.

When the Museum of Modern Art was founded in 1929 the terms 'modern' and 'contemporary' were virtually synonymous in the minds of most observers. Gradually the meaning of the two terms pulled apart, as Barr's 'comet' became tail-heavy. Cor-

early as 1944 this was cognised as 'the greatest ngle source of animosity wards the museum', as nes Thrall Soby put it in internal memo dated ugust 19, 1944, quoted er Barr, op. cit., p 15.

respondingly, from the late 1960s onwards, 'contemporary' and 'post-modern' became increasingly synonymous, leaving MoMA in the cold as a completely new chapter of contemporary art and culture began to unfold.[66]

Whatever the reasons, by the 1970s – Barr himself had retired in 1967 after thirty-eight years of unflagging service – the museum's role as the ultimate arbiter of modern and contemporary art was severely questioned. Yet until then, the Museum of Modern Art ruled supreme, an admired and agenda-setting model for curators and museums all over the Western world.

66
See: Arthur C. Danto, 'Introduction, Modern, Postmodern and Contemporary', in: *After The End of Art, Contemporary Art and the Pale of History: The A W Mellon Lectures in the Fin Arts, 1995* [Bollingen Serie XXXV: 44] (Princeton: Princeton University Pres 1997), pp 3-19.

5.

Europe 1945–1970

The Second World War had hardly affected American museums at all. After the bombing of Pearl Harbour on December 7, 1941, there was a brief threat of Japanese air strikes on East Coast cities, and the museums of Boston, Washington and New York made hurried arrangements to safeguard their collections. The Metropolitan Museum of Art in New York began evacuation in February 1942 but it kept up a programme of special exhibitions, including 'The Art of Rembrandt', 'The Art of Advertising' and, unsurprisingly, 'Artist For Victory', an exhibition of American contemporary art. The plaster cast collection, in storage since the 1930s, was dusted off and reinstalled. Yet no enemy bomb ever hit United States soil and American museums survived the war with their buildings and collections intact.

In the years after 1945, US museums actually benefitted from the war in some ways: highly important loans were easily obtainable as the curators of Europe's bombed-out and war-torn museums were quite happy to send their star exhibits to the air-conditioned safety of American institutions. As a result of a questionable political rather than curatorial decision, the exhibition 'Paintings From the Berlin Museum' reached Washington in 1948. The show included 202 paintings, the cream of the Kaiser Friedrich-Museum collection and probably the greatest assembly of European masterpieces ever to reach the United States.[67] After Washington, it travelled to a further twelve venues and was seen by more than 10 million people. The same year there was also a huge van Gogh retrospective at the Metropolitan Museum in New York.

In the post-war years art was often used to curry favour with American politicians. There was, for example, André Malraux's highly controversial decision to send the Mona Lisa to Washington and New York (1962–63), and it would be possible to chart the intricacies of the Cold War simply by recording the appear-

or an account of this ighly controversial episode e: Nicholas, op. cit., p 386-405.

ance – or sometimes the last minute non-appearance – of Soviet-owned Impressionist and Post-Impressionist paintings in Western exhibitions.

While many European collections were without buildings until well into the 1960s and the museums that had survived were often barely habitable, the Metropolitan Museum of Art in New York renovated ninety-five of its galleries between 1950 and 1954 at the then staggering cost of $9.6 million.

The situation in Europe could not have been more different. Hardly any of the museums had escaped damage and often the situation remained precarious for many years, if not decades, after the end of hostilities. Buildings were flattened, and many collections were destroyed, severely damaged or had simply disappeared in the chaos of battle.

The war had shown that museums were vulnerable to both physical and political destruction. Yet this susceptibility to ideological and political hijacking did not so much trigger protective instincts but rather led to a growing sense that directors and curators had themselves to blame as they had been only too willing to collaborate with those in power. As a result, European museums after the Second World War were left to their own devices, perceived by many – politicians and audiences alike – as outmoded bastions of questionable bourgeois values and aspirations, politically opportunistic and stuck in the past.

This perception of the museum as a symbol of an outdated, nineteenth-century concept was reinforced by physical appearance. The great European museums looked, without exception, careworn, bedraggled and dowdy. As late as 1960 Sir Mortimer Wheeler would describe the appearance of the British Museum as follows: '… objects in serried lines like an untidy regiment on parade, many unlabelled or not in context, dusty and unloved.'[68] David Wilson wrote that 'over the years different styles of exhibition [and] changing taste led to hideous ad hoc-ery … labels were enigmatic. Only in one or two important instances were any information panels introduced into the display… The British Museum was a mess'.[69] He could have said the same about any of its European sister institutions.

There was little money – or public interest – to counter this negative impression. Politically and economically, the post-war

68
Caygill, op. cit., p 56.

69
Wilson, op. cit., p 21.

emphasis was on housing, welfare, education and infrastructures, and museums were just not high on the list of priorities. In a vicious circle, delays in dealing with museum dilapidation while post-war reconstruction in other areas went on at full throttle, only reinforced the negative impression.

Funds to restore and upgrade facilities did not become available until the 1960s and 1970s, and in Eastern Europe it took even longer before essential repairs were set in motion. Until the 1980s, the Museum Island was in a state of semi-dereliction, with the few buildings in use crudely patched up. Inside, galleries were underlit, cold and dirty, the displays dreary and unimaginative, with the smell of dust, wax polish and stale canteen food hanging over everything.

Even in the West the process of renewal was often drawn-out and arduous. It took the British Museum, for example, until 1962 to reopen the Duveen Galleries, which had been severely bomb-damaged during the war, and as late as 1980 part of the museum was still protected by temporary post-war emergency roofing.

The German museums were without doubt hardest hit. All major urban centres had suffered terribly from Anglo-American bombing raids and the great majority of museum buildings had either been severely damaged or totally destroyed.

The process of rebuilding, like elsewhere in Europe, was painfully slow, and it took thirteen years before the first new museum building went up: the Wallraf-Richartz Museum in Cologne opened to the public in 1958.[70]

The building itself was a political statement. Unmonumental and self-effacing, it looked more like a Stadtsparkasse than a major cultural institution. Clearly, the past image of the museum as signifier of cultural superiority or political power was to be avoided at all costs, and well into the 1970s the designs for German museums closely followed the understated Cologne precedent. Examples of watered-down International Style museum buildings, in concrete and with glass façades, can be found in most (West) German cities. The glass façade had become an important architectural shorthand, signalling openness, transparency and declaring that there was nothing concealed within, no hidden ideological or political agenda. Even in the East this theme was picked up on, belatedly, and in 1982 the

70
Other Cologne museums remained homeless well into the 1980s, for example the museum for Far Eastern art and the museum for applied arts.

Pergamon Museum was given a glass and steel entrance hall – although this turned out to be extremely bland architecturally.

The buildings in their architectural reticence and nondescript sameness clearly indicate a desire to blend in and make amends.[71] The post-war period was the age of invisible museum architecture. The first truly monumental, unapologetic museum building in Germany after the war was Mies van der Rohe's Neue Nationalgalerie in Berlin-Tiergarten (1963–67). In its severe modernist monumentality and the division between top (entrance) and base it recalls the classicism of Schinkel's Alte Nationalgalerie on the Museum Island. Even here, the massive entrance hall from where one descends into the basement galleries echoes the already noted theme of transparency. Yet van der Rohe's design was not so much an indicator of museums' regained confidence but rather an important, if not central image in the escalating propaganda war over the newly divided city.

With this one notable exception, museum buildings during the post-war years were marked by a conscious reversal of the classicism and monumentality of the past which had become unacceptable as a result of both Fascist and Stalinist abuse. At the same time, many of the new buildings were a cautious attempt at rehabilitating the modernist tradition disrupted by twelve years of Nazi rule.

Not until the Neue Pinakothek in Munich (1976–81) and Stirling's Staatsgalerie in Stuttgart (1979–83) were there any new museum buildings with historicising references in Germany, and even then the return to a more classicist and authoritative architectural language was only possible by way of ironic post-modern pastiche.

Reading the annual reports of museums from the 1960s, there is a palpable sense of loss of direction, indicating that the institutions had been left behind and were playing only a comparatively minor role in the reordering of post-war society, a far cry from their unquestioned supremacy in the past.

In the public imagination the museum probably never conformed so much to the idea of the ivory tower and a place of the past as during these post-war decades. Yet the question of reform was hardly raised either inside or outside the museum. Outside, the feeling was that the museum was beyond reform and of little

71
For a summary of German, Austrian and Swiss projects after the war see: Hannelore Schubert, *Moderner Museumsbau* (Stuttgart: Deutsche Verlags-Anstalt, 1986).

importance in the greater, post-war picture. Those on the inside were too preoccupied with making good war loss and damage.

In the 1950s and 60s the cultural battles that really mattered were fought not in museums but in areas that had a more immediate impact; the universities, for example. After the war, theatre, literature and music mattered, but art did not. The future of the museum looked bleak: it appeared increasingly marginal to cultural discourse, outdated and ideologically suspect. Had anyone predicted then that just two decades later the museum's fortune would change dramatically, he would have been laughed at.

6.
Paris 1970–1980

Three developments finally brought about massive changes for museums all over Europe. Post-war reconstruction and economic recovery had run their course and were effectively concluded in the West by the early 1970s. Infrastructures, housing, education and the performing arts – music, opera and theatre – that were primarily in favour during the post-war years had all been taken care of. Therefore, for the first time, there was spare cash for the neglected museums.

The second factor was the arrival of mass tourism and the accompanying leisure culture of the 1970s. The development of jet aircraft had allowed the introduction of transatlantic services by 1958. Global passenger figures had trebled during the 1960s, but this was nothing compared to the revolution brought on by the introduction of the wide-bodied plane in 1970: Boeing's 747 heralded the age of cheap, mass travel. The shift from travel as elitist, luxury pastime to low cost activity for the masses is rarely commented on, although it may explain travel's lingering allure and glamour, despite the fact that today's reality does not bear any resemblance to the experience of the past.

More than the availability of funding and the advent of mass tourism, it was the cultural changes of the 1960s culminating in the events of 1968 that affected the fate of the museum so profoundly. This is not the place to analyse in detail the momentous events of that decade, but it is no exaggeration to describe them as a cultural watershed.[72]

1968 was centred on the universities of Western Europe and North America but there were repercussions all over the world. The events were too unfocused to effect direct political change yet they showed remarkable indirect results and have affected assumptions underlying political and social discourse ever since. Power in all its manifestations, visible or invisible, normative or institutional, came under intense scrutiny, and its motivations

72
See: Arthur Marwick, *The Sixties, Cultural Revolution in Britain, France, Italy and the United States 1958-1974* (Oxford: Oxford University Press, 1998).

and intentions were questioned like never before. No area, from politics to education, the society at large to basic family structures, escaped an in-depth review, and museums were not exempt. They symbolised cultural influence and normative power yet had escaped reform for the entire post-war period. They had long been considered outdated and out-of-touch – middle-class enclaves that were long overdue for a major shake-up.

At the centre of the 1968 critique of the museum stood the question of its credence. D. Murray's seemingly innocuous 1904 definition of the museum 'as a collection of antiquities or of other objects interesting to the scholar and the man of science, analysed and displayed with scientific method',[73] which had been accepted unquestioned for so long, raised more questions than it answered in the new climate. In the post-1968 light, Murray's definition took on an almost sinister meaning, implying to many observers a cabal-like conspiracy of vast proportions. If the question of accessibility and objectivity had always been an important issue – it had first been raised during the French Revolution – it now became a key concern.

Who exactly was the museum serving, and how were curatorial choices made and implemented? Who was deciding which story was told? The stories that were not told suddenly became as interesting (if not more so) than those that were. Which objects entered the museum and which were left out? On whose authority were such choices and omissions made? The assumption of curatorial autonomy, which had never before been questioned, was now viewed with great suspicion. As a consequence, new museological conventions emerged within a few years: these were no longer merely satisfied with presenting end results to visitors, but opened the entire process leading up to such decisions to scrutiny and made it an integral part of museum practice. As a result of this deconstruction the museum became truly self-conscious and aware of both its built-in powers and limitations, no longer just in passing or accidentally but permanently and on purpose.

From this point on, reflections on the nature of the museum and its underlying assumptions became an integral part of its day-to-day practice. The museum lost some of its past authority and its air of infallibility as a result, but by the same token it

73
Quoted after Wittlin, op. cit., pp 142-143.

became more transparent, more accountable and, in the end, a great deal more democratic.

It is one of those ironies of history that it was a Gaullist, conservative politician who was the first to realise the implications – and the great potential – of all this. When Pompidou came into office in 1969, he, like his party and the rest of France's political establishment, was deeply shaken by the events of the previous year: the students had come perilously close to bringing down the state. Pompidou was eager to harness some of that anarchic energy and cast it into an institutional mould. Without wasting any time he announced his idea for a cultural centre, to be built in a run-down area in the centre of Paris.

It has to be stressed that it was the president's own idea, not something that officials in the Ministry of Culture had thought up. As a matter of fact, Pompidou studiously avoided established political and institutional channels and, to the intense annoyance of Edmond Michelet (the new Minister of Culture), set up an independent government agency that was to deal exclusively with the new project and reported to the president directly.

In July 1970 an international architectural competition was announced, the winner of which was the then unknown Anglo-Italian team of Renzo Piano and Richard Rogers.

The language of the brief to the architects remarkably recalled in spirit Barr's half-century-old phrase describing the museum as 'a laboratory; in its experiments, the public is invited to participate'. Pompidou's new centre was to be not so much multi-departmental in the way of the Museum of Modern Art, but strove to be truly interdisciplinary. The democratic and experimental spirit of the place was stressed emphatically. Easy, unhindered access was one of the central requirements: 'the pedestrian at street level should not be forced [...] towards a special entrance,' but 'the public will enter from all sides'; 'the visitor should be tempted to go everywhere'. The division between those visiting the galleries and those heading for the library was to be broken down, because if 'these two groups were to stay separated, the desired effect would be lost.' 'Everything is based [...] upon the ease and freedom with which the visitor will share in the Centre's offerings, and the way in which he will be constantly attracted towards them.' Flexibility and adaptability were central

considerations: 'the areas given [in the brief] have been estimated sufficient for the full exercise of all activities presently foreseen. No extension of the building is to be planned, as the collections will be periodically renewed [another Barr idea] … the Centre's internal flexibility should be as great as possible … the evolution of needs is to be especially taken into account.'[74]

In his submission to the competition, Rogers picked up this language of flux and openness and expanded on it. He talked about a place of 'information and live entertainment': 'a cross between an informational Times Square and the British Museum', invoking a 'more lucid' definition of culture.[75] This concept expanded the reach of the museum towards a whole new audience that had so far taken no interest and dismissed the institution as stuffy and irrelevant to modern life.

Piano and Rogers' architectural innovations were reinforced by equally revolutionary curatorial decisions. During the first ten years of its existence the Centre Pompidou, under the directorship of Pontus Hulten, organised a series of epoch-making exhibitions that challenged the single-strand, linear narrative championed by MoMA. Shows like 'Paris-New York' (1977), 'Paris-Berlin' (1978), 'Paris-Moscow' (1980), and 'Paris-Paris' (1983), as well as 'Les Réalismes' (1980) and 'Vienne: Apocalypse Joyeuse 1880–1938' (1986) revealed the history of modernism as something much more complex, anarchic and volatile than so far conceded by a MoMA-inspired, apolitical aestheticism and its insistence on a strictly formal and autobiographical reading of art. The Pompidou exhibitions set aside this isolating approach, emphasising instead a pan-European dialogue and interdisciplinary cross-fertilisation that could only be truly grasped if political and social circumstances were properly taken into account.[76]

The effect the example of the Centre Pompidou had on art historical and curatorial practice can still be felt: not only did it allow individual institutions a wider range of readings of their collections, but in the end it allowed different concepts of art history to coexist in different museums. Instead of the MoMA-cloning that had been the norm in the 1950s and 1960s, it was now possible for museums to develop their own house styles and identities in terms of the scope of their collections, interpretative perspectives and display techniques.

74
Quoted after Nathan Silver, *The Making of Beaubourg* (Cambridge, Mass. and London: MIT Press, 1994), p 24.

75
Victoria Newhouse, *Towards a New Museum* (New York: The Monacelli Press, 1998), p 193.

76
Other exhibitions that were extremely influential in this respect were the 1977 Council of Europe 'Kunst der Zwanziger Jahre' in Berlin and 'Westkunst' in Cologne in 1982.

In terms of architectural functionality the Pompidou was rather a mixed success. Although Piano and Rogers' building is iconic and has provided Paris with a new landmark, it has proved, like Frank Lloyd Wright's Guggenheim Museum in New York or Mies van der Rohe's Neue Nationalgalerie in Berlin, less of a success as far as the display of art is concerned.

The open-plan layout with its free-standing temporary walls made it virtually impossible to show paintings and sculptures satisfactorily. Part of the problem could be ascribed to the extraordinary success of the new museum with the public. From the start, attendance figures were twice as high as most optimistically predicted, and the building often resembled a busy airport concourse rather than a museum. The noise level and overcrowding made it impossible to concentrate on individual works of art in any meaningful way.

The Centre Pompidou was a high-maintenance structure anyway, but the armies of visitors quickly wore out the fabric of the building and gave it an unkempt and shabby appearance. Repairs and maintenance became an ongoing Sisyphean battle. In 1985-86, only eight years after opening, the Centre Pompidou was subjected to a massive structural overhaul and the Italian architect Gae Aulenti was asked to design more conventional, 'solid' galleries to be shoehorned into the open-plan floor spaces. While definitely an improvement, there was the question of whether her changes were not in contradiction to the Centre Pompidou's spirit.[77]

The Centre Pompidou was, despite the new approach it heralded, the swansong of the old order. Its architecture was late-modernist and its concept harked back to romantic notions of modernism first espoused by Barr in the late 1920s: in its outlook and intentions it was unashamedly utopian.[78] The Pompidou was an all-out attempt at coming to terms with the emerging post-modern culture by modernist means.

It proved impossible to maintain the pace set by Hulten during the first couple of years, the demands made on curatorial and maintenance staff being just too great. The building quickly became a victim of its own success, literally worn out by the attending masses. The Centre was an exceptionally expensive place to run and maintain, yet as soon as the sensation of the new

77
A second, even more drastic refit is currently under way and the museum is scheduled to reopen in the spring of 2000.

78
Ironically it was all the high-tech, futuristic aspects that were edited out at the planning stage, like the moveable floors or the electronic information boards which would have turned the Centre Pompidou into the museum equivalent of Times Square that Rogers had envisaged.

had faded, government funding was gradually cut back, particularly after Mitterrand took office in 1981 and turned his attention to the Louvre.

After Hulten's resignation the Centre Pompidou often appeared directionless, and there was intermittent curatorial and administrative in-fighting. The appointment of Dominic Bozo to the directorship was seen as a new dawn but his untimely death in 1993 came as a cruel blow.

Like MoMA, the Centre Pompidou has surrendered many of the more revolutionary aims of its infancy and has settled into servicing an ever-growing and diverse audience, competent and professional but rarely truly inspired.

The arrival of post-modernism fundamentally altered the position of the museum.

Post-modernism cannot be defined without reference to modernism: it is the flip side of the modernist coin – even the very term illustrates this dependency. The museum, on the other hand, is inextricably tied up with modernist ideals and aspirations. From the outset modernism was destined for the museum because it shared the museum's penchant for hierarchy, chronology, order and normative classification, while post-modernism by definition is anti-hierarchy, anti-chronology, anti-order and anti-classification.

Post-modernism is everything modernism – and, by extension, the museum – is not, and this conflict is now at the centre of the discourse on the museum. Post-modernism is the Trojan horse at the museum's gate: how different institutions have responded to the challenge, and how it has affected the way museums look and how they are interpreted, is the subject of Part Two.

II

1.
After the Centre Pompidou

'How would you like it if we tried to compose a history?'
'I would like nothing better. But which?'
'Indeed, which?'
Gustave Flaubert, *Bouvard and Pécuchet*[79]

The story of the museum concept up to the creation of the Centre Pompidou was linear insofar as its evolution could be charted by focusing on a succession of individual institutions which, at different times, took the lead and elaborated on the idea, in this way performing a sort of museological relay race. Starting in Paris in the 1790s, the narrative shifted to London for the latter part of the nineteenth century, to Berlin at the beginning of the twentieth century, to America in 1929 with the founding of the Museum of Modern Art, and back to Paris again in the 1970s. The story could alternatively be told in terms of individual curators, of which Dominique-Vivant Denon, Wilhelm Bode and Alfred H. Barr were the most inspirational; or, at least from the beginning of the nineteenth century onwards, by describing a sequence of museum buildings designed by the leading architects of their times. Although it is a very simplistic description of a complex process and there are numerous national and regional deviations, it is nevertheless possible to fit the vast majority of institutions into this story-line.

Unfortunately, developments since the Centre Pompidou are not quite as easily summarised. The vast number of museums that have since opened and the different, often contradictory concepts behind them makes it virtually impossible to generalise in any meaningful way.

If the Pompidou was the first museum to apply multiple perspectives to its subject, in place of the Museum of Modern Art's insistence on a single-strand narrative, it not only opened the field for other institutions but for the first time made it possible

79
London: Penguin, 1976,
p 124.

for museums to be legitimately very different from each other. The notion that an institution could be particular without being parochial marked a dramatic departure after decades of MoMA-inspired uniformity. This fundamental change was not only inspired by cultural developments – the advent of post-modernism – but also by the realisation that today's museum audiences are widely travelled – often up to half of all visitors come from out of town – and therefore identical collections in different locations were no longer desirable. The idea that you may travel halfway across the globe only to see what you could also see at home seemed quite nonsensical.

Instead of there being a few single institutions that 'show the way', today there are numerous museums that have developed their own answers to particular cultural, national, political and economic circumstances.

This is not to say that there is no longer any common ground between various institutions. Many of the issues that directors and curators are grappling with are shared by most museums. There is an unprecedented awareness of the audience and of its diverse needs: questions of architecture and display methodology concern museum officials as never before; the fact that politicians have once again begun to harness museums for unrelated goals is disturbing; escalating conflicts over state and private funding have increased museums' awareness of their autonomy; where institutions are dedicated to contemporary art their relationship with artists and their complex requirements have become an important part of the discourse. Finally, the process of self-analysis and -critique, which was set in motion during the 1960s, has become an integral part of curatorial practice.

Although most of these questions and issues are the same for most institutions, the answers and resulting museological practices are surprisingly diverse. The following is not an attempt to comprehensively chart the entire range of solutions but to give at least an overview of the astonishing diversity of approaches, a diversity that has become the main characteristic of today's museum world.

2.

The 'Discovery' of the Audience

With the emergence of cultural and demographic changes towards post-modernity and the post-industrial leisure society, the public's perception of the museum shifted from educational to recreational, from research and display to a more audience-driven and service-oriented approach.

Instead of understanding themselves as both standard-setting and elitist store-houses of cultural prototypes that were presented to the public without further discussion and explanation, museums increasingly began to view their permanent collections and temporary exhibitions as invitations to an open dialogue between curator and viewer. In a way, museums during the past two decades have actually come much closer to fulfilling Barr's vision of the institution as a laboratory and of the visitor as an active participant.

Museums no longer hide the curatorial hand and present only the end product, but make visible the entire underlying decision-making process; they say 'this is how we see things (and you are entitled – and may indeed be right – to disagree)', instead of 'this is'. Museums have fundamentally changed and have become democratic in ways that go well beyond the provision of free access. In the process museums have opened up in all kinds of directions: towards new audience segments that until quite recently felt that the museum was not their place; towards art and artists that had not been represented or had been considered beyond the institutional scope; and towards new curatorial voices for which there had been no room in the single-strand master narrative of the past. These developments were reinforced by corresponding political and economic shifts.

While American museums had always relied on their own fundraising activities, during the Reagan years whatever little state funding there was finally disappeared altogether.[80] In Europe the tide of neo-conservatism came, as far as cultural

80
This is the period when the National Endowment for the Arts finally became hostage to right-wing zealots in both Senate and Congress.

institutions were concerned, as a much greater shock. Entitlement to public funding, occasionally supplemented by philanthropic giving from individuals, had never before been questioned and was taken for granted. All of a sudden institutions were urged by their political masters to rescind what was now derisively termed the 'culture of dependency' for a new approach centred on self-reliance and 'plural funding'.

In the UK – where under the Thatcher government these policies were pursued much earlier and more vigorously than in the rest of Europe – many museum directors and curators responded with surprise and dismay. It was hard for them to overcome their personal, ideological and moral objections to the new policies that seemed to go against all their experience and instincts. They were given hardly any time to come to terms with the new reality or to put in place organisational structures to deal with it. Swingeing cuts had swiftly been implemented and many institutions soon found themselves in dire financial straits, long before any alternative funding arrangements could be successfully organised.

The effect of all this was often devastating. The classic example is the Victoria and Albert Museum in London which spent most of the 1980s and 1990s limping from one financial and administrative debacle to the next. It was trapped in a vicious circle, because the more the general position deteriorated, the harder third party support was to come by. The museum was locked in a downward spiral that took nearly a decade to halt, and, on a number of occasions, it seemed as if institutional bankruptcy was inevitable, an outcome dramatically avoided on each occasion by the most parsimonious, humiliating and grudging eleventh-hour government hand-outs. The Victoria and Albert Museum was by no means the only UK institution badly affected, but it was by far the most high-profile. In the process it lost much of its audience, its scholarly standing and its historic place as one of the great European museums.

That the UK government's policy towards museums (and other cultural institutions) was one-sided – institutional budget cuts were never matched with corresponding tax concessions for potential donors (as happens in the United States) – did not make the situation any easier.

The long-term outcome has been very much a two-tier development. On the whole, large museums in the metropolitan areas fared better than the smaller institutions in more rural areas, and overall the London museums did best, yet even amongst the London institutions there were wide discrepancies. Some directors were clearly more attuned to the new circumstances, but the particular nature of individual institutions was also a contributing factor. It appeared that the more focused a museum's collection was, the easier it seemed to attract sponsorship and donations, and in this respect both the National Gallery and the Tate Gallery succeeded beyond all expectations. The institutions that appeared the most multifaceted in their collecting – the Victoria and Albert Museum, for example, or the British Museum – found it the hardest.

Despite the handful of success stories, the plight of museums in the UK was alarming. On the whole, sponsors came forward only for the flagship institutions, and even then the competition was fierce and largesse perilously tied to the general state of the economy. That is to say sponsorship was least available when it was most needed, and during the severe 1990–92 recession corporate sponsorship in the UK virtually dried up. As a result, many museums were operating hand-to-mouth and quite a number accumulated deficits for the first time in their histories. Whenever matters reached breaking point, the government stepped in at the last minute, providing financial stop-gaps. For most of the Thatcher and Major years many museums operated under the threat of imminent financial collapse, a state of affairs that badly affected scholarship, programming and acquisitions. None of this was conducive to long-term planning, and talking to curators during those years revealed deep dissatisfaction, anger and frustration.

It is hard to imagine what would have happened without the timely announcement in 1993 of future capital funding for museums through the newly-established state lottery, made possible by the National Lottery Bill which had passed into law in December 1992. This set off an overdue renaissance of long-neglected UK museums,[81] allowing institutions to deal with the results of decades of structural neglect and to bring their buildings and facilities up-to-date in time for the next century. It is

81
Limiting funding to capital projects has already created its own problems: now upgraded facilities are available but there are no means to utilise them effectively.
See: David Benedict, 'Lottery with Violence', *The Independent*, February 3, 1999, p 10.

worrying that these golden years are already drawing to a close as this vital source of funding is gradually being eroded by the policies of the present Labour government,[82] although it is a relief to note that Labour, like the Conservatives before them, has not dared (at least for the time being) to cross the politically highly sensitive threshold towards museum admission charges.

As museums could no longer automatically count on unconditional government hand-outs they began to focus much more on their audience. Visitors suddenly mattered, because high attendance seemed to guarantee, if not increasing, then at least static annual budgets. They also provided desperately needed revenue generated by museum shops and other commercial activities. High (and preferably dramatically growing) attendance figures were an irrefutable argument in the annual fights over finances with local authorities and central government. They went down equally well with sponsors and donors. Head-counts, unlike many other, more intricate arguments about museums, are easy to understand and hard to squabble with.

How to increase attendance figures in order to justify public expenditure - and attract sponsorship - became the new focus of curatorial thinking. It is probably no exaggeration to say that, until that point, comparatively little attention had been paid to the audience, its needs and motivations, and that the history of the museum from the French Revolution to the present could be viewed as a gradual shift of the visitor from the periphery to the centre of museal practice. Although the museum had come a long way since the late eighteenth century when visitors were envisaged in the curator's image and grudgingly let in, a barely tolerated distraction from scholarly pursuits and solitude, it was not until the 1980s that the visitor finally became the absolute focal point of the enterprise.

In the past, the curator was considered primarily the guardian of the collection he was in charge of, and his duties could be summed up as sourcing new acquisitions, researching, conserving and displaying. The director was a benign scholarly figure at the helm, overseen by an equally amenable board of trustees. An air of eccentricity and amateurism hung over everything. The museum was the ivory tower par excellence where questions of accountability – ideological or financial – hardly ever came up, a

82
One of the ironies of the present situation is that, while museums are again financially strapped, the Labour government is willing to spend nearly £900 million of Lottery funds on the Millennium Dome in Greenwich, an amount exceeding by far what governments elsewhere are willing to allocate to millennial projects.

place reassuringly insulated from the bustle of the outside world and the perceived ugliness of politics.[83]

The subsequent changes therefore amounted to nothing less than a revolution. An elite middle-class pastime gradually evolved into a mass activity and museums changed from state funded institutions to revenue-generating enterprises, increasingly involved with marketing and fundraising. The audience and its needs were, for the first time, the key to the success of the whole enterprise, resulting in a fundamental overhaul of institutional practice. All major museums today have high-powered fundraising, development and marketing departments. Even ten years ago this was the rare exception.

Whereas 'high culture' in the past had needed no further justification than its very existence, it now had to prove itself in the market place. It was subjected to the same sort of scrutiny that was increasingly applied to all other areas involving state funding, such as social and medical services, education, etc. The returns on museum funding – the benefits that accrued to society in exchange for public money – became the subject of careful consideration. The suggestion that museums should resist this pressure to justify their purpose is naive. The fact that curators may find the question distasteful will not stop politicians from asking it: a refusal to answer may indeed be interpreted as an admission of obsolescence.

Obliged to justify the outlay of tax payers' money, museums now have to show that they provide a necessary service at a reasonable cost, and that they are continuously improving the cost and effect ratio.

How to effectively measure museum performance is still a matter of ongoing debate. It is difficult to quantify curatorial and institutional output and turn anecdotal, subjective evidence into irrefutable, objective fact. Much of the literature on the subject is inconclusive, not to say pseudo-scientific.[84] Of the different types of performance indicators, the most workable seem to be red flag indicators, warning signs that may include the detection of growing financial liabilities, a disproportionate growth of managerial staff, declining attendance figures, accelerating staff turnover and other tell-tale signs of institutional erosion and disquiet. The advantage of red flag indicators is that they utilise data

83
Until 1989 the Tate Gallery, for example, employed a single accountant 'on the top floor of a distant part of the [...] site who sat surrounded by paper doing all the accounts himself, by hand. [...] Trustees never received any breakdown of the annual accounts [...]': Frances Spalding, op. cit., pp 252-253.

84
For a summary see: 'Progress Report from the Field: The Wintergreen Conference on Performance Indicators for Museums', in: Stephen E. Weil: *A Cabinet of Curiosities: Inquiries into Museums and their Prospects* (Washington DC and London: Smithsonian Institution Press, 1995) pp 19-31.

that is collated as part of the museum's normal operation, so no expensive apparatus need be put in place to collect information.

How such information is then compatible with other areas of state activity is likewise still an unresolved and highly contentious issue. At the core is the old philistine argument that all money spent on culture should rather be applied to something like primary education or social services. Curators have countered this reasoning by focusing on external proofs of institutional effectiveness – the museum's impact on tourism or the local economy, for example. The inherent danger in this line of thinking is that it undermines the museum's position in the long run. If it could be demonstrated that some other organisation – a theatre, theme park or concert hall, for example – was having an even greater impact for the same sort of outlay, the museum would ultimately lose out. To counter this threat it is important for museums to answer the value for money question strictly within the parameters of their own definition. Any emphasis on side issues would potentially undermine the museum's standing: 'If museums cannot assert their importance as museums, then museums may not be perceived to be important at all.'[85] It could be argued that museums, in their desperate struggle to deal with their financial plight over the last two decades, have already inflicted a fair amount of damage to themselves, damage that will only begin to show with the passing of time.

Like the market place, museums have become preoccupied with growth, and those in charge have begun to track their attendance figures as anxiously as factory owners monitor their output. Both the director and his curators have become involved in myriad activities which often have very little to do with art, in the process changing their job descriptions beyond recognition. Today, museum directors and curators speak the languages of management, marketing and accountancy as fluently as that of museology and art history.

The most prominent and earliest indication of the shift towards an audience-driven museum was arguably the appointment of Thomas Hoving as director of the Metropolitan Museum of Art in New York. Hoving's reign, which spanned eleven years, from 1967 to 1977, turned the Met into the brashest and most commercially-minded museum of its time.[86] As to

85
'Creampuffs and Hardball', in: Weil, op. cit., p 36.

86
Thomas Hoving, *Making the Mummies Dance* (New York and London: Simon & Schuster, 1993).

Hoving's thinking, the language of his autobiography is particularly revealing: although written two decades later, it is unapologetic about everything that happened. He presided over the most ambitious expansion programme in the history of the Metropolitan, instigating a master plan that was to double the museum's size to a mind-boggling seventeen acres of galleries at completion, a programme that was finally concluded only in 1990.

Hoving envisaged the museum as a place of mass entertainment. As far as exhibitions were concerned, Hoving writes, 'I almost agreed to any kind [...] without much thought',[87] provided the outcome was 'dazzling', 'glitzy', 'grandiose' and had 'zap'. Discussing the design of his first major exhibition project, 'In the Presence of Kings',[88] Hoving stated that in the galleries he 'favoured lots of rich colours for the walls, for fabric in showcases, purples, vermilion, azure, crimson. I wanted a huge purple banner with gold letters hanging in the central arch of the façade.'[89]

It was no longer just a question of displaying works of art to their best advantage but of turning art into visual spectacle. Hoving's terminology is that of the department store executive or fashion magazine editor, and it is therefore not altogether surprising that he describes the head of the costume department, Diane Vreeland, the legendary former editor of American *Vogue* and *Harper's Bazaar*, as 'one of the finest curators the Met ever had'[90]: 'no curator in the history of the Met ever had a more successful run…'[91] Vreeland had succeeded in turning the annual show of the costume department into one of the most glittering events of Manhattan's social calendar. In the end, however, her exhibitions were little more than glorified window displays and thinly disguised marketing opportunities for the fashion industry, conspicuously lacking all scholarly insight and purpose.[92]

Another exhibition instigated by Hoving early on in his reign was 'Harlem on Your Mind'. It managed the amazing feat of giving, in the words of Calvin Tomkins, 'offence to Negroes, Jews, Puerto Ricans, Irish, liberals, reactionaries, artists, politicians, *The New York Times*, and several Metropolitan trustees',[93] and very nearly caused the director's premature downfall.

As to acquisition policy, Hoving felt 'the hell with the dribs and drabs – the little Egyptian pieces, the also-rans.' He wanted

Hoving, op. cit., p 49.

3
. spurious undertaking
which charted 5,000 years
f royal patronage from
arly antiquity to the twentieth
entury.

9
Hoving, op. cit., p 54.

0
Hoving, op. cit., caption
o plate 44.

1
Hoving, op. cit., p 354.

2
or an excellent account
f Vreeland's years at
he Met see: Deborah
ilverman, *Selling Culture:
Bloomingdale's, Diana
Vreeland and the New
Aristocracy of Taste in
Reagan's America*
New York: Pantheon
ooks, 1986).

3
omkins, op. cit., p 353.

to acquire 'only the big, rare, fantastic pieces, the expensive ones, the ones that would cause a splash. With the incalculable number of treasures already in the museum, why bother with footnotes?'[94]

The driving desire was for razzle-dazzle and publicity, and questions of scholarship became a secondary concern. If all this was not already worrying enough, under Hoving's stewardship the Metropolitan Museum became embroiled in a number of arguments over shady deals, involving questionable, not to say illegal, de-accessioning as well as the acquisition of looted and smuggled works of art. Hoving not only tacitly approved, but also bragged openly about this, clearly unable to grasp the implications this was having for the institution's standing. He was willing to sacrifice scholarly integrity and a commitment to educational goals for a deeply troubling populism which, in the end, was the opposite of what it claimed to be, showing a sneering disrespect for the audience and its needs and wishes: a cold elitism sailing cynically under the flag of wider access.

Hoving seemed to acknowledge no ties outside his own gargantuan ego and displayed a kind of pathological disdain for everyone he came across: the audience – which he supposedly courted; his curators – who he was expected to support and protect; and his trustees and donors – to whom he claimed to be grateful; all were sacrificed on the bonfire of his vanity. To Hoving none of this mattered as long as the Met became, in his own words, an 'art metropolis',[95] 'the biggest, richest – and loudest - museum in the world'.[96]

The Hoving years of the Metropolitan Museum are today a byword for curatorial sell-out, a case study in how things should not be done and a stark reminder that checks have to be put in place and balances respected between the various spheres of influence that constitute a museum. Although it is acknowledged that the museum has become more of a commercial place and a part of the leisure and tourist industries, Hoving clearly had been veering too much in one direction, without paying sufficient attention to the traditional educational and scholarly goals. How to successfully steer a middle course between education and entertainment has been at the centre of curatorial thinking ever since.

94
Hoving, op. cit., p 102.

95
Hoving, op. cit., p 13.

96
Hoving, op. cit., p 139.

That there was a mass audience for museums was obvious from the growing attendance figures – and Hoving was by no means the first or only director to seize on this – yet as to the nature and composition of this audience, surprisingly little was known. The information and statistics available often appeared contradictory and it was hard to draw any useful conclusions from them.

The mass audience is, in a way, confirmation that the museum is the most democratic cultural institution of all, attracting by far the widest cross-section of the population. Especially with free admission, the museum is truly open to everyone who cares to enter. Unlike opera, for example, the museum does not involve its audience in a complicated and intimidating game of class, money or cultural and social aspirations. Being in a museum, one does not have to pass muster or dress up, and there is no peer pressure. The museum is, as far as the interaction between those visiting is concerned, virtually neutral; that is to say, visitors remain comparatively invisible to each other. And unlike most other cultural institutions, the visitor is free to pick and choose, skip what does not interest him and concentrate on his personal preferences. This democratic anonymity of the museum has made it nevertheless particularly difficult to work out who the audience really is and to properly assess its needs and wishes.

In order to get a clearer idea of who they are serving, museums have adopted sophisticated techniques from market research, and although this was only begun about a decade ago, a lot has already been learned. By the same token, much of the data still remains hard to interpret.

Museums can now relatively easily assess the effectiveness of exhibitions and displays and identify audience wishes and preferences, allowing curators to finely calibrate their activities.[97] Curators have become deft at marketing their collections and target-advertise special exhibitions, events and other services. Museums now have a much clearer idea of who their visitors are, know their gender, race and creed as well as their educational and social backgrounds. They can differentiate between various audience segments' educational standards, needs and expectations.

The information on which such an assessment is based is no

Much of this information remains quite subjective, and attempts at developing more empiric methods of measuring museum performances have so far been relatively unsuccessful.
See: Susan Pearce (ed), *Museum Economics and the Community* [New Research in Museum Studies: An International Series, Vol. 2] (London and Atlantic Highlands NJ: The Athlone Press, 1991).

longer obtained by volunteers with clipboards and dry multiple-choice questionnaires who corner hapless visitors. Today's visitors are often not even aware that their responses are closely observed. For example, video recordings assist in assessing visitor behaviour and movement, and electronic stock control in museum stores allows instant analysis of spending patterns.

At the Museum of Modern Art in New York the marketing and communications department is made up of six divisions: marketing, communications, writing services, graphics, visitor services, new media/e-commerce. There is a full-time staff of fifty.[98] Comparatively, about thirty employees are occupied with aspects of marketing and fundraising at the Tate Gallery in London, probably the most successful operation of its kind in Europe.

Ongoing weekly surveys at the Museum of Modern Art monitor visitors' responses to permanent displays, exhibitions and services. Focus groups are deployed to analyse everything from audience reaction to exhibitions, merchandising preferences, spending patterns in the museum shop, eating habits in the restaurants, and the effectiveness of advertising: little, if anything, is left to chance. Similar marketing techniques have been adopted by most large Western museums.

One of the most unexpected discoveries has been that audiences seem to measure the success of their visit, not only by the quality of museum displays or the calibre of special exhibitions, but that other factors – such as the choice of food in restaurants, the cleanliness of toilets, the range of products in the museum shop – are equally important for making a visit pleasurable.

The information gained by market research is shared with curatorial staff, yet to what degree this actually affects curatorial decisions is hard to assess as it is obviously not a subject that those in charge are willing to talk about openly. As curators are increasingly acting like managers they will probably make a lot of marketing-influenced decisions more or less subconsciously, without actually referring directly to marketing men.

At the beginning of the 1990s there was still a fair amount of curatorial resistance to the marketing departments.[99] Curators tried to limit their influence to external matters (advertising and public relations, for example) but attitudes have gradually

98
B S M, 'Aiming at the Young Professionals', *The Art Newspaper*, no 48, September 1998, p 19. In May 1997 MoMA also established an Office of Planned Giving, to provide potential donors with advice and accounting and legal services, *MoMA Magazine* vol. 1, no. 6, October 1998, p 34.

99
Hooper-Greenhill, op. cit., pp 24–25.

changed. Everybody now acknowledges that marketing is vital to the survival of most museums. Marketing departments have in turn taken on board curatorial concerns, and there is an understanding that crass marketing can actually repel potential visitors. As a result, the museum is arguably the one area in today's leisure industry where latent rather than overt marketing has become the norm. There is no denying that the overall power balances within many institutions have changed and that curators are no longer quite as absolutely in charge as in the past. In the United States total resources provided to museums rose by 32% between 1987 and 1992. A breakdown of this figure reveals that 'the resources directed towards their administration increased by a rate of half again higher than their curatorial and exhibition expenses.'[100]

At the Museum of Modern Art in New York, curators rule supreme beyond the turnstiles, and marketing activities are limited to the lobby area (and the internet). Other museums are less discreet. There seems to be, for example, a stall selling catalogues, postcards and scarves every time one turns a corner at the Metropolitan Museum of Art. At the Tate Gallery in London the in-house magazine is hawked in the entrance rotunda rather too aggressively for the taste of some. More recently a discreet line appeared on some wall labels next to specific paintings, helpfully pointing out that posters of the image could be purchased from the museum store.

Museum publications have also changed. Partly driven by marketing needs and aided by advances in printing technology, they have metamorphosed into coffee-table books, which are often distributed in hardback by trade publishers. This is not to say that catalogues now neglect scholarly concerns. At their very best they combine up-to-date in-depth research and numerous illustrations on a level not seen before; and in this respect the monographs published by the Réunion des Musées Nationaux in particular have set a new standard of excellence. For major blockbuster exhibitions it is now possible to publish different types of publications simultaneously: a short leaflet, a small souvenir guide and a scholarly catalogue to accommodate various audience segments.

Over the last decade marketing has turned from a reluctantly

[100]
Weil, op. cit., p 24.

accepted side-issue into an integral part of the modern museum. For those who still find the idea hard to accept it may be a consolation that, despite strenuous efforts to second-guess audience wishes, there is still a refreshing margin of unpredictability.

Like the film industry, which knows that even if one adds together all the ingredients that made for a past success one can still have a flop on one's hands, museums equally can be faced with inexplicable – and costly – failures. In 1991 the Tate Gallery's Constable retrospective was predicted to break all previous attendance records. These expectations were based on the experience of a similar show in 1976, which was one of the great successes in the Tate's history. To deal with the expected vast influx, a special entrance was created, with awnings, portaloos, a Red Cross station and childcare facilities. In the event, visitor numbers were low and within a few weeks of the exhibition opening the tent town had been quietly taken down. MoMA's 'Picasso and Portraiture' likewise failed to live up to expectations in 1996, while the museum's 1998 summer season had been an unexpected success, with a number of smaller and often highly specialised and demanding exhibitions running concurrent.

The biggest marketing disasters in recent memory were maybe the two decidedly Vreelandesque exhibitions at the Victoria and Albert Museum in 1992, a year of deep crisis and great turmoil at the museum.[101] 'Sovereign: A Celebration of 40 Years of Service' was a show which ran from April to September 1992, on the occasion of the fortieth anniversary of Queen Elizabeth II's accession to the throne. Timed to coincide with the annual tourist influx, the show was unashamedly driven by commercial considerations: it had at its exit one of the biggest museum shops ever seen at a London exhibition venue, a veritable superstore of royal souvenirs. It was a deeply patronising exhibition insofar as it attributed a soppy sentimentality to the perceived target audience, an assessment that in the end spectacularly backfired in two directions. The target audience never showed up – maybe it did not even exist outside the curators' imagination – and at the same time the museum's regular visitors were offended by what they rightly perceived as a cynical marketing ploy. The synthetic money-spinner, rather than filling the museum's coffers, undermined its already precarious finances even further. A few months

101
It was also around that time that the museum scored a spectacular own goal with its advertising campaign, 'An ace caff with quite a nice museum attached to it'.

later another show at the Victoria and Albert Museum, 'Sporting Glory',[102] a celebration of hunting and shooting, exuded the authenticity of a Ralph Lauren ad and lacked any identifiable scholarly purpose or thematic concept. Again, the number of visitors was small, and the exhibition caused such controversy and financial havoc that it closed prematurely.

The reverse, of course, can happen as well, and exhibitions can become surprise crowd-pullers, defying curators' predictions and experience. 'Pieter de Hooch', for example, proved a great success at the Dulwich Picture Gallery in the late summer of 1998, something the museum clearly was not prepared for.

Well-attended blockbuster exhibitions have increasingly become a way of balancing the books and of providing the means for 'cross-subsidising' less profitable but nevertheless important areas of museum activity. The Tate Gallery's Cézanne retrospective in 1996 turned a healthy profit, enabling the museum to finance a range of unrelated activities. 'Monet in the '90s: The Series Paintings' rescued the Royal Academy's precarious finances in 1990 and he will no doubt again help to clear an accumulated deficit when 'Monet in the Twentieth Century' arrives at Burlington House at the beginning of 1999. As for the Metropolitan Museum in New York, it seems to be forever relying on a diet of exhibitions with words like 'impressionist', 'impression' or 'impressionistic' in the title.

The dependency on this kind of show can be problematic: a disproportionate amount of curatorial time and museum resources are devoted to such projects, often at the expense of other, more scholarly exhibitions. There is also the question as to what degree today's reliance on corporate funding makes blockbusters even more prevalent, in the process distorting the pattern of scholarly activity even further.[103]

In 1996 more than 100 million people attended art museums in the United States and in the UK the figures for 1993 exceeded 74 million. Not only has the number of visitors grown, but also there are more museums today than ever before. In the United States there are 1,421 art museums, half of which were founded since 1970.[104] Overseas visitors account for 20% to 30% of the UK museum attendance. It is estimated that between 29% and 58% of the adult UK population visits museums. The enormous

102
November 11, 1992 to January 12, 1993.

103
For a detailed look at this important issue and its implications see: Victoria D. Alexander, *Museums and Money: The Impact of Funding on Exhibitions, Scholarship and Management* (Bloomington, Ind: Indiana University Press, 1996).

104
Glenn D. Lowry, 'Building the Future, Some Observations on Art, Architecture, and the Museum of Modern Art', in: Barbara Ross (ed), *Imagining the Future of the Museum of Modern Art*, [Studies in Modern Art vol. 7] (New York: The Museum of Modern Art, 1998) p 77.

spread of these figures gives an indication of how difficult it still is to obtain reliable statistics.

Although overall visitor figures have increased, the average figures per UK museum have been declining steadily, from 72,000 visitors in 1972, to 61,000 in 1982, 51,000 in 1986 and 48,000 in 1988. This fall could be partly explained by the growing number of museums, but it may also indicate that a natural plateau has been reached. Many larger museums could not accommodate any additional visitors without the whole experience turning decidedly unpleasant. There is also the possibility that marketing-driven changes may bring new audience segments to museums but that this is achieved at the cost of corresponding losses in other areas. Whatever the explanation, museums have to work ever harder to attract visitors against the competition of a growing number of rival institutions, not to mention the offerings of other areas of the leisure industry, such as heritage sites or theme parks.

As a result of social and political shifts, the 1980s brought the discovery of the museum audience. It was a great surprise for many curators to discover how much their actual audience differs from their long-treasured assumptions. In fact many of the assumptions curators had acted upon for so long were not borne out by reality at all. Instead of a single core audience they discovered myriad audiences, their diversity mirroring modern society at large. How to best serve these visitors and retain their attention and loyalty has become the museum's greatest challenge.

3.

Artists

At the same rate as museums have moved from excluding living artists to making them the centre of their attention, so have artists' attitudes towards the museum undergone a corresponding evolution. The full art historical and museal emancipation of the modern artist, so long fought for, had finally come with the opening of the Museum of Modern Art in 1929. For the first time there was an institution that approached living artists with the same respect and sensitivity so far reserved only for dead artists. In MoMA the twentieth-century avant-garde found an institution that was willing to faithfully record new developments as they were happening. Although this new simultaneity between creativity and institutional embrace was, on one level, welcome and flattering – to be paid attention is always preferable to being ignored – its implications made many artists feel rather uneasy.

If by definition the museum was a storehouse for cultural artefacts that had lost their function or meaning in the context for which they were initially created, would this by implication mean a corresponding loss of meaning and radical potential for contemporary art once it was placed inside the museum? Creative audacity was – and still is – the gauntlet thrown at the museum. That it was picked up so demurely, without hesitation or complaint, artists found deeply disturbing. Here lies the origin of so much ambiguity about the museum amongst artists, the spectre of the museum as a kind of institutional play-pen for avant-garde dissent, and it is this conflict that has not been far from artists' minds ever since the 1960s.

The Abstract Expressionists had struggled too long and hard and, as a result, were not interested in addressing this particular point: in fact for them it was not an issue of real concern at all. They were the last generation of modern artists to allow co-option by the museum culture without much protest. They were primarily painters, without a political or ideological agenda, and

as their work was mainly concerned with questions of painting and marked by an inward ethos, they considered the museum not as an alien space, but as their spiritual home. Like the museum, these painters had turned their back on the world, and they actually approved of the image of the museum as a temple: for them the museum was a record of the lineage to which they aspired and a place of monastic calm and contemplation, removed from the bustle of the world.

It would be inaccurate to attribute the creative outburst that followed Abstract Expressionism entirely to the artists' need to escape the museum. Yet the staid and dusty image of the institution in the 1960s dovetails too noticeably with the insistence of a new generation of artists that their art was to reflect the cultural and social battles of their age, to ignore the point altogether.

The 1960s was a period of great artistic fecundity: Pop Art, Happening, Fluxus and Minimalism emerged virtually simultaneously, followed by the 'New Sculpture'[105] in the second half of the decade. In place of the Abstract Expressionist ivory tower there was now a wholehearted embrace of popular culture, everyday materials and an insistence on an entirely new concept of authorship, centred on the image of the artist as a maker operating in the everyday world, rather than a studio-bound genius.

The demise of frame and plinth which resulted from this shift, changed forever the role of the curator. It was no longer a question of merely placing a canvas on a wall or a sculpture in a space; instead the curatorial process had become subject to direct interference by artists. After Abstract Expressionism a lot of work became either temporary, site-specific or escaped the museum altogether, but even those works that were still 'museum-compatible' made exceptional demands on institutional conventions and patience. A letter sent in 1967 by the artist Donald Judd to the editors of *Artforum* illustrates this:

Sirs: The piece reproduced on p 38 in the summer issue was put together wrong and isn't anything.[106]

A painting could be hung to its disadvantage or poorly lit, and a sculpture may not be placed in the best way possible; but they would always, however badly compromised, remain what they were. What Judd's terse note implied was something much more fundamental: the work could no longer survive compro-

105
This was the title of an exhibition at the Whitney Museum of American Art, New York in 1990. It surveyed the work of Eva Hesse, Robert Smithson, Richard Tuttle, Bruce Nauman, Richard Serra, Barry LeVa, Alan Saret, Keith Sonnier, Lynda Benglis and Joel Shapiro.

106
Quoted after Thomas Crow, *Modern Art in the Common Culture* (New Haven and London: Yale University Press, 1996) p 86.

mise of any sort, however minor: as a result, it simply stopped existing altogether.

Having created an art that was primarily about spatial relationships and interacted with the architecture into which it was set, for Judd the spaces in which his work was shown became a matter of great concern and anguish. For him, as Renate Petzinger wrote, 'the boundaries between art and architecture were in flux'.[107] Over nearly four decades of his career, Judd would acquire a fearsome reputation as the uncompromising defender of his art, forever berating curators, collectors and dealers for being blind to what his sculpture required in order to exist at all. In this he was not alone, and his thinking is shared by many of the artists of his and subsequent generations, but he took care to express his thoughts on this matter more eloquently than most. He also put his thinking into practice, first in New York at 101 Spring Street in Soho (1969), and, on a truly monumental scale, in Marfa, Texas. There he realised, from 1971 until his death in 1993, permanent installations of his own as well as other artists' work, mostly housed in a series of military sheds he had acquired over the years. In Marfa, Dan Flavin and John Chamberlain are represented with large groups of works, and there are smaller displays by Ilya Kabakov, Richard Long, Claes Oldenburg, Barnett Newman, Richard Paul Lohse, Frank Stella, Roni Horn and others.

By realising these two permanent installations, Judd created a perfect demonstration of his thinking. Spring Street and Marfa illustrate Judd's complex attitude towards architecture and its relationship with art.

Weary of the often ego-driven agendas of the vast majority of contemporary architects, Judd, like so many artists, preferred existing spaces to new, purpose-built ones. For Judd, space had to function primarily as space. It had to be neutral – which should not be mistaken for bland or nondescript – and in his opinion this was best achieved by adapting existing buildings. An inherent architectural structure is there, but it relates to a former function and therefore does not interfere with the works on display any more than is absolutely necessary.

Marfa has become, especially since Judd's death, an often-quoted example of absolute artistic autonomy, a place where the

107
Renate Petzinger,
'Specific Elements in
Donald Judd's
Architecture', in: *Donald
Judd, Räume/Spaces,*
[exhibition catalogue]
(Stuttgart: Cantz Verlag,
1993) p 131.

intentions of the artist are respected above everything else. Franz Meyer described Marfa as an '*haut lieu* of art',[108] admired by curators and artists alike, one of those rare and magical places where art, architecture and landscape become one. As a model it is nevertheless of limited use. Because of its inaccessibility in the middle of Texas, it has escaped the crowds that have become such a problem elsewhere. Despite its great fame, Marfa has remained very much a place for the 'happy few'.

Judd's insistence on space *per se* – a space that carries no other meaning than its space-ness, a kind of tautological space – could be read as a strategy for escaping the levelling power of the museum.

The more contemporary art was institutionally accepted, the more difficult it became for artists to come to terms with this acceptance. On the one hand institutional interest was welcome – it meant, if nothing else, large audiences – but on the other hand the fear of the museum as the usurper of artistic power continued to haunt artists. This is attested to by the long line of artists' museum-destruction fantasies, from Hubert Robert's *Imaginary View of the Grand Gallery in Ruins* (1796)[109] to Ed Ruscha's monumental *The Los Angeles County Museum on Fire* (1965–68).[110] By their insistence on spatial autonomy, contemporary artists could at least escape architectural, symbolic entrapment. Yet the battle was by no means fought over questions of architecture alone.

How to resolve the conflict between institutional might and artistic freedom, how to have one's cake and eat it, has become an important issue for much artistic practice. Artists since the 1960s have developed a multiplicity of techniques that simultaneously acknowledge and undermine the museum. If artists were worried about the institutional and canonising power of the museum and the corresponding loss of their works' meaning and radical potential, they have often responded by making this cultural 'castration complex' itself the subject of their art.

The methods deployed range from the mere reference-in-passing to the total usurpation of the museum concept: Philip Taaffe's appropriation of Newman and Riley paintings in the mid-1980s; Sherrie Levine's continuous references to both historic and contemporary work; Thomas Struth's photographs of

108
Franz Meyer, 'Marfa', in: Petzinger, op. cit. p 35.

109
Oil on canvas, 114.5 × 146 cm, Musée du Louvre, Paris.

110
Oil on canvas, 136 x 340 cm, The Hirshhorn Museum and Sculpture Garden, Smithsonian Institution, Washington DC.

museum interiors and visitors; Oldenburg's *Mouse Museum* (1965) and *Ray Gun Wing* (1976)[111]; Beuys' *Darmstadt Block* (installed by the artist in 1970 and expanded at various later dates)[112] or Broodthaers' *Musée d'Art Moderne, Département des Aigles* (1968)[113]; the installations of Allan McCollum. These are only a handful of examples where the historicising power of the museum has itself become the subject of art, often taking the form of mock-museology.

Other works make less obvious references to museological practice yet affect it profoundly. Installations, such as Michael Landy's *Scrapheap Services* (1994–97),[114] when seen in a museum context, disrupt the curatorial narrative by inserting storylines of their own. By making it impossible to install works as part of 'mixed' galleries, artists effectively undermine the pace and chronology of museum displays. Film and video works take this a step further, turning the museum experience into a succession of self-contained, autonomous events by way of introducing the modality of watching in lieu of viewing.

All these developments have changed the role of the curator dramatically. Today, he is often engaged in developing solutions to specific installation and space problems in close dialogue with the artist, more like a collaborator than a curator. Matters are complicated further where artists are absent or dead, so that the artist's continuous creative input has to be substituted with the far less flexible rule of precedent. The artist's ability to make ad hoc decisions or on-the-spot revisions is lost and the curator has to rely on the example of past installations. A case in point is the work of Joseph Beuys. His talent for improvisation allowed him to make fundamental revisions at the last moment, and as a result his installations often had a deceptively casual appearance. Posthumous installations of his work, by comparison, look rather stilted and feel strangely sanitised. They exude an elegant artfulness, which is actually in contradiction to the very nature of Beuys' work and fills those who had the good luck to see installations during his lifetime with melancholic dread. The Beuys Block in Darmstadt is probably the last surviving example of an untouched installation, but for a true flavour of the 'authentic' Beuys one will increasingly have to refer to Ute Klophaus' contemporaneous photographs.

11
Museum Ludwig, Cologne.

12
Hessisches Landesmuseum, Darmstadt.

13
Estate of the artist.

14
Tate Gallery, London.

Joseph Beuys is by no means the only or most extreme example of the difficulty in conveying the artist's original intentions. By foregoing oil paint for the new synthetic materials that were developed after the war, painters have created a conservation time bomb. Early acrylic paints are unstable, tend to turn powdery-brittle, and fade quite quickly. Acrylic paint cannot be varnished and the porous surfaces attract dirt and grime that sink into the paint surface and are impossible to clean off. At the other extreme, film, video and photography pose particularly difficult questions for conservation. Colour photography is notoriously unstable, and much 1960s and 1970s video equipment, for example, has become obsolete. How does one adapt historic video works to new technology? How does one preserve film work?[115]

Minimalists insisted on the use of everyday, prefabricated materials in a pristine state. Does one therefore re-spray Sol LeWitt's structures or let them acquire patina? Should Judd's sculptures look forever new or begin to show their age? In the case of Dan Flavin a strange convention has emerged where collectors and museums keep the old, fluorescent fittings – often useless, as most types of Sixties tubes and fittings have long been discontinued by manufacturers – and a matching, up-to-date set for exhibition purposes.

Even when the artist is around, how does a much later reconstruction relate to the original? How, for example, does Richard Serra's *Splash Piece: Casting* (1969–70) relate to its periodical reprises, and what kind of authentic experience (if any) does the reconstruction convey?[116] Nothing ages faster and more noticeably than the ephemeral. What is the curator to do? Arrest the process, reverse it, or let it run its course? Is it conceivable that in future the reconstruction could exude more authenticity than the original in its decayed state?

The use of unconventional – and sometimes unstable – materials, the speed at which technology changes,[117] the temporariness of many installations and the ephemeral nature of much contemporary art will increasingly become an issue for curators, making today's arguments about the conservation of old master paintings look straightforward and clear-cut by comparison.

Many museum curators have already responded to these challenges by compiling extensive records on works that could be

115
In Bruce Nauman's 1995 retrospective at The Hirshhorn Museum (Washington DC) 1960s filmwork had been transferred onto (digital) disk but showing was accompanied by a soundtrack of the whirring of an old-fashioned 16mm projector.

116
For a discussion of Richard Serra's *Splash Piece: Casting* see: Douglas Crimp, 'Redefining Site Specificity' in *On the Museum's Ruins* (Cambridge, Mass and London: MIT Press, 1993) pp 150-197. Crimp's argument is slightly blunted by the fact that he omits to mention that Serra has remade the piece on a number of occasions.

117
The issue of technological obsolescence and its devastating effect on archival records is discussed by: Alexander Stille, 'Overload', *The New Yorker Magazine*, March 8, 1999, pp 38-44. Many of his observations apply to art museums as well.

installed in a number of ways or might be subject to future material or technological changes. They have asked individual artists series of questions which deal with a whole range of assumed installation conditions, thereby establishing catalogues of dos and don'ts for future reference. These records are often quite extensive and although they may not succeed in covering all eventualities, at least they establish parameters within which the work can be shown or restored at a future date. Artists responded initially with irritation to these interviews but it has dawned on many that the establishing of as precise and detailed a record as possible is in their own interest. It will help to avoid future mistakes, disappointments and misunderstandings, so that letters like Donald Judd's to *Artforum* become unnecessary.

The nature of art after Abstract Expressionism has redefined forever the role of the curator. It is no longer sufficient for him to be concerned with the work of art alone. The artist has an important and ongoing involvement, and it is the curator's role to negotiate between the artist's demands and the institutional necessities. Where the artist is not available – or dead – the onus is on the curator to interpret and fulfil his (or her) intentions as faithfully as possible.

4.
Politics

Today's curator navigates between the Scylla and Charybdis of audience and artists, a task not made easier by the fact that there are other, smaller rocks and treacherous undercurrents that also have to be negotiated. There are the ideas and wishes of the politicians who control public funding. For them, culture, rather than being 'the icing on the cake', has become an important political tool, too powerful a device for the forging of social cohesion and national identity to be left to its own devices. As a result, the museum and its methodology have again become highly politicised, a rather unexpected development after decades of political stand-off.

There are the sponsors who have very clear agendas of their own, buying classy advertising under the guise of magnanimity. It is often difficult to make meaningful connections between cultural and corporate goals, as can be gauged from reading sponsors' forewords in exhibition catalogues the world over. There is the nagging question of how much a museum is compromised when being harnessed by corporations to polish up their sometimes quite tarnished reputations, a conflict that Hans Haacke has repeatedly made the subject of his art.

There is also the issue of corporate sponsorship's determining the type, not to mention the content, of exhibitions and displays. How sponsors' expectations implicitly affect curatorial decisions, and how it is possible to square financial dependency with institutional autonomy, are issues of great concern.[118]

As far as private donors are concerned, their motives can range from truly inspired and selfless acts of exceptional generosity to the purely self-serving. If the corporate donor's influence on an institution can be insidious and his motives questionable, the private benefactor's agenda is generally more above board. Donors have always been difficult to accommodate, but their role has become even more important as public purchase grants

[118] See: Alexander, op. cit., particularly chapter III.

have stagnated or dried up altogether. The growth of many museum collections depends increasingly on the largesse of private collectors.

The trustees can likewise be torn by conflicting aims. Today they are no longer inconspicuous and benign custodians but often political appointees who may be inclined to toe the line of official policies rather than defend the interests of the institutions they supposedly serve. Matters are further complicated where trustees represent corporate interests or are collectors in their own right.

In addition, there are the competitive squabbles between curators, driven by ideological disagreements, scholarly ambition or career considerations.

The interaction of all these spheres creates a minefield of opposing impulses, and the younger and smaller an institution the more volatile the situation can become.[119] To deal with the various factions and instill some sort of workable consensus requires exceptional skills from the director and curatorial staff. The old scholar-curator is a figure of the past. Today's curatorial job-description encompasses the widest possible range of skills: the curator is the guarantor of the artist's authentic voice, fulfils the politician's cultural ambitions, furthers the museum and its collection by soliciting donations, sells the sponsor access without compromising the institutional autonomy, and interprets the audience's educational needs and entertainment wishes. Diplomat, scholar, educator, financial officer, henchman and entertainer: there is hardly a profession that requires such a diversity of highly developed skills.

The workload can be immense, and, as a result, quite a number of major American museums find it increasingly difficult to appoint directors. Recognising the difficulty, in some museums a division has been made between curatorial and administrative areas of responsibility by placing a chief executive officer next to the director. Another suggestion occasionally made, that of splitting the research and curatorial realms, is surely unworkable. Like research and teaching at universities, research and curating cannot be divided because one without the other would quickly wither and become outdated. The two are meaningful only in tandem.

119
The notorious sale of the Pasadena Art Museum to Norton Simon in 1974 is clearly exceptional in this context, but fundamental policy changes are a possibility and recently took place at the Museum of Contemporary Art in Chicago and San Francisco MoMA. For a summary of the Pasadena debacle see: John Coplans, 'Pasadena's Collapse and the Simon Takeover: Diary of a Disaster', in: *Provocations* (London: London Projects, 1996) pp 157-203.

Not a week passes without a major new building project or expansion being announced somewhere in the world. Never have so many museums been built or expanded as today. The majority of these new institutions are dedicated to modern and contemporary art, and a high percentage play an important role in politically motivated programmes of urban renewal.

The reason for the disproportionate number of new museums – when measured against overhauls of existing institutions – may have something to do with the day-to-day nature of politics. Politicians on the whole prefer their own, new projects and are only too happy to leave the maintenance of their predecessors' projects to civil servants. It is easier – and more glamorous – to come up with a brand new proposal than work on the fine-tuning of an already existing institution. Politicians are also primarily result-orientated and think in electoral terms: to reform large, long-established museums is a slow and arduous process, and there is always the possibility that such attempts may run up against fierce resistance from within the institutions. The reorganisation of the Louvre, for example, began in 1981 and will not be concluded until 1999, a programme stretching over three presidential terms. The British Museum has been undergoing constant upgrades since 1981, a process that will culminate in the reorganisation of the spaces vacated by the British Library in 1996–99.

It is difficult to reform old institutions because it tends to threaten tradition and long-standing institutional modes. New museums, on the other hand, can be established comparatively easily. That so many of the new museums are devoted to recent art seems to reflect a general shift of interest towards this field, but may also be dictated by the realities of the art market and the mechanics of supply and demand.

It would seem impossible today to build museum-quality collections in most areas: truly great old master paintings, for example, appear on the market at the rate of one or two a decade. Even Impressionist paintings of outstanding quality, still an art market staple not a decade ago, are increasingly hard to come by. As for antiquities and old master drawings, there is nothing available that could even remotely match what individuals and institutions were able to acquire up to the nineteenth century or even

during the first half of the twentieth. Today whole categories of collectibles are already held by public institutions. As a result the collections of most old museums are, in effect, 'closed' – that is to say the lack of available historic works of exceptional importance makes it impossible for institutions to acquire works of the kind that would dramatically change the balance and overall character of their holdings. The only field that is constantly replenished is that of contemporary art. With very few exceptions – the Getty Museum in Los Angeles and the Kimbell Museum in Fort Worth are the two most prominent examples - new museums are therefore focusing their activities on this area.

Even in the field of post-war and contemporary art surprisingly little remains available. Only a handful of key paintings by Jackson Pollock, for example, are still in private hands, and most of Duchamp's or Rothko's works are already in museum collections. It would be hard to put together a really outstanding group of American Abstract Expressionist paintings, and great icons of Pop Art have become equally scarce. Because of the large number of new museums, even in the area of very contemporary, up-to-date art, demand can outstrip supply, and popular artists can find themselves with long waiting lists of institutions ready to purchase their latest work, presenting a new kind of dilemma. The pressure to fulfil museums' demands and to create work on a suitably institutional scale can be crushing. Under these new conditions the concept of the avant-garde has become truly notional – today's museum culture has made the discovery, interpretation and historicisation of new art virtually simultaneous.[120]

As the museum of record, whose collections are unrivalled in quality and scope by any other institution and whose practice has influenced curators all over the world for many decades, developments at the Museum of Modern Art in New York are always followed with particular interest.

Its evolution from pace-setting institution to establishment bulwark was accompanied by periodic expansions throughout its history. The 1938 Goodwin/Stone building (56,000 square feet) was first expanded in 1951 by 17,850 square feet, again in 1964 by 63,000 square feet, and most recently in 1984 by 164,000 square feet. The declared purpose of each expansion was to create more space for contemporary art.

120
For an indication of how much this process has accelerated over the last decade see: Virginia Button, *The Turner Prize* (London: Tate Gallery Publishing, 1997).

Yet on each occasion the opposite was achieved. As more and more of Barr's torpedo tail went on display, proportionally less space was allocated to truly contemporary work. Because of the chronological hang, contemporary art was always experienced last, when the average visitor was already tired out from trudging through 150 years of art history: contemporary art increasingly felt marginal. If this was not problematic enough, many of the new spaces were ill-suited to the often complex and expansive nature of much contemporary art. The museum's galleries were designed with paintings and sculptures of a conventional nature in mind and were not easily adaptable to installation, film or video work. This bias was increasingly leading to a distortion of the record, and in this respect the 1984 expansion was of particular concern, forcing the museum back to the drawing board only a decade later.

The latest expansion project, to be realised at the beginning of the twenty-first century, will add a further 280,000 square feet of space, roughly a third of which is in the form of new exhibition galleries. This time the Museum of Modern Art is clearly trying to avoid the mistakes that were made in 1984.

How to make the museum more accommodating to the requirements of contemporary artists, while at the same time displaying the historical collection to its best advantage, has been the subject of much curatorial soul-searching.

The Museum of Modern Art's greatest challenge yet has been to find a way to rescue at least a vestige of the beguiling simplicity of Barr's single-strand narrative, yet at the same time include every imaginable sub-plot. This is the central question in the formal debate instigated by the museum in preparation for its latest expansion. Behind this insistence lies the belief that a certain amount of information about the basics and origins of modern art is needed to understand the art of our century. As in literature, the canon is no longer perceived to be binding, but it still forms the basis of any informed debate: or, to put it another way, in order to disagree with the canon one needs to have at least a cursory knowledge of what it entails. It seems to be MoMA's ambition to provide both perspectives simultaneously in its new quarters, scheduled to open in 2004.[121]

The proposed layout of the building (designed by the Japan-

121
For the debate about the MoMA expansion see: Barbara Ross (ed), op. cit.

ese architect Yoshio Taniguchi[122]) will replace the present linear plan - the architectural equivalent of the single-strand narrative - with a variety of routes. That this time post-Abstract Expressionist art will play a much less marginal part can also be deduced from MoMA's recent purchase programme. Acquisitions like James Rosenquist's *F-111* (1965), Andy Warhol's *Campbell's Soup Cans* (1962), the complete set of black and white stills by Cindy Sherman, and Gerhard Richter's *18. Oktober 1977* cycle (1988) seem to indicate a new level of commitment.

As if to quench any future criticism of its contemporary art record, MoMA announced, in February 1999, that it was joining forces with PS1., thereby in effect 'out-sourcing' the one area it has been struggling with for quite some time. Founded by Alanna Heiss in 1976 and located in Long Island City, PS1. has been one of America's most Kunsthalle-like venues, with an impeccable track record and programming focusing on installation, video and performance art.

MoMA's example is noted but it no longer sets the agenda for other institutions: it is merely one possible solution of many, reflecting particular historical, geographic and institutional circumstances.

The Museum of Modern Art's problems could be described as resulting from too much great art and an overabundance of institutional excellence, along with the overwhelming weight of an exceptional history. In this respect its situation is unparalleled. As far as other museums of modern or contemporary art are concerned, their experience is often the reverse. They are without the benefit of an extensive historical collection of a high quality and without a great history of their own, struggling to assemble and present collections in a meaningful way that gives the institution an identity and the curator in charge at least some interpretative range. Few museums have been able to actually turn the lack of a reasonably balanced permanent collection to their advantage, the way Jean-Christophe Ammann managed to do at the Museum für Moderne Kunst in Frankfurt.

The museum can be likened to a clock: the buildings, displays and exhibitions are the face, while the workings remain hidden from view. This unseen part, the working of the mechanism that in the end constitutes the museum and determines its

122
For an overview of his work see: Fumihiko Maki (ed), *The Architecture of Yoshio Taniguchi* (New York: Harry N. Abrams, 1999).

profile and ideological direction, the interplay of curators, trustees, artists, donors and architects, can best be observed where an institution is either moving to new premises or at least undertaking major renovations. The process becomes even more visible where an entirely new institution is created from scratch: the clock's component parts and their assembly can be watched. This, it seems, is one of the rare occasions when the decision-making process and the workings of the museum become exposed to the outside. It is not always as admirably open and well documented as in the case of MoMA's latest expansion[123] but it is at least a great deal more visible than under day-to-day conditions. That museology has made such strides over the last two decades may be to no small measure due to this intermittent transparency.

Whenever a new museum is built or an old one is updated, a whole range of demands come to the fore. Everybody involved, it seems, has a different agenda that hardly ever corresponds to or overlaps with that of the other interested parties. The architect, the curator, the politician, the donor, the artist and the visitor seem to address opposing needs and speak different languages, and they often make not only different, but contradictory demands.

The architect wants to make a statement. He wants to say, clearly, with audible voice, that this is his building, reflecting his own architectural thinking and philosophy, his signature. This immediately brings him into conflict with both the artists and the curators who consider it primarily their building. For the architect a museum is the dream commission, an opportunity to indulge in pure architecture, without the mundane restrictions and demands posed by an office or residential building.

Artists, on the other hand, already wary of the institutional power of the museum, do not share the architect's desire for a personal statement but would like a space that takes the back seat, so to speak, that steps behind the works of art and allows them centre stage. For artists, the museum's architecture is at most a supporting cast, entirely subservient to their work.

The curator in turn wants a building that gives him the greatest possible flexibility and an opportunity to respond to changing artistic demands and evolving curatorial thinking. He does not

123
See footnote 104.

wish for an architecture that needs to be laboriously renegotiated from exhibition to exhibition, dictating, time and time again, particular modes of display. Few buildings are quite as extreme in this respect as Frank Lloyd Wright's Solomon R. Guggenheim Museum in New York, but many new museums have what may be termed a 'Guggenheim aspect' to their architecture.

Ideally the curator wants a building that, in Terence Riley's words, is endlessly 'reprogrammable': 'the only way to efficiently reprogram architectural space is to lessen the effect of the architecture, which is to get rid of it – what I call a Dumpster architecture, which is totally transformable.'[124]

Only the architect and the politician (and, when involved, the donor) appear to be in some sort of agreement, preferring an architecture that is demonstrative. For them the architecture illustrates status: for the politician it has to illustrate unequivocally national or community aspirations and financial clout; as far as the architect is concerned it shows his signature style, demonstrating that he is at the top of his profession.

The way in which artists seem to prefer museums fashioned from already existing structures to new, architect-designed buildings may partly reflect their deep suspicion of this collusion between architects and politicians and their shared desire for grand statements.

For politicians, museums have become the most desirable civic status symbol; the way ring roads, universities, state-of-the-art hospitals or opera houses and concert halls were in the past. They indicate communal affluence and are the municipal equivalent of an individual driving a certain expensive make of car.

Museums, compared to other cultural institutions, are relatively cheap to build and inexpensive to run. Unlike opera houses, their democratic credence remains undoubted. They deliver entertainment and education in equal measures and are hugely popular.

Museums are also an inexpensive and effective way of kickstarting run-down or neglected inner city areas. Where industries have fallen on hard times or have disappeared altogether, local governments are faced with difficult tasks. The monuments of industrial dereliction are depressing to look at, constant markers of a better past, conspicuously indicating economic and social

124
Ross, op. cit., pp 9-10.

decline. It is not something politicians want their electorate constantly reminded of.

The Metropolitan Museum of Art in New York was the first museum to be located on the basis of town-planning considerations. Today the Metropolitan is in the heart of Manhattan's Upper East Side on the edge of a fashionable residential and retail area, but this was not the case in the 1870s when the area was only sparsely settled. 'Polite society' was located at least twenty blocks further north, on Fifth Avenue from the Fifties below Central Park to Washington Square (what today is termed 'midtown').

If the Met's siting was about channelling the growth of Manhattan into a new, uncharted direction, the thinking behind the Centre Pompidou - besides the political aspects already discussed - was about the regeneration of a heavily built-up area of Paris that had fallen on hard times. The Pompidou (so named only after completion and Pompidou's death in 1976), the reasoning went, would lead to a renaissance of the Les Halles quarter, an area that had been in steady social and economic decline for most of the century. The centre did indeed put Les Halles back onto the urban map and it has remained one of the main tourist draws of Paris ever since, the French capital's first truly iconic landmark built since the Eiffel Tower.

The example of the Centre Pompidou has since been followed in many cities all over the world, and it was applied again in Paris in 1984. The Musée Picasso in the Hôtel Salé in the Marais has been a vital factor in the rehabilitation of this former royal quarter, helping to preserve the architecture of the neighbourhood, which had fallen into dereliction. So neglected had the Marais become that at one point after the war the city of Paris had planned to raze the entire district to make room for high-rise social housing. Similarly, the positioning of Richard Meier's Museum of Contemporary Art in the medieval Raval quarter of Barcelona, completed in 1995, has played an important part in the reversal of the area's economic slide and population decline.

The location of the Andy Warhol Museum in the rather run-down downtown neighbourhood of Pittsburgh is another example of a successful application of the Pompidou formula, as is the Tate Gallery Liverpool, located in the former docks of this once bustling port city.

When the Tate Gallery submitted its planning proposal for the new Bankside museum to Southwark Council there was a lot of talk about economic regeneration for this run-down part of London and the prospect of thousands of jobs being created both at the museum and in its vicinity. It sounded remarkably like the arguments deployed when Japanese car manufacturers propose to build factories in remote parts of Wales or the North of England. Likewise the museums in Valencia and Wolfsburg were made palatable to politicians mainly by stressing the regenerative power of the projects. It seems that the instinctive unease that those in political office feel about cultural matters can only be overcome by translating them into hard economic facts. It is probably not unfair to state that it is not art or culture *per se* that politicians are interested in, but the economic and social 'side-effects'.

The most prominent recent example of a museum as an instrument of urban regeneration is the Guggenheim Museum in Bilbao (see below). The flamboyant new museum designed by the American architect Frank Gehry has instantly become a symbol of the port town and the Basque region, drawing attention and visitors to this rather neglected part of Spain.

The Tate Gallery Bankside has had an equally dramatic effect on urban renewal in the poor and neglected Southwark area of London, and may in the end herald the demise of the historic economic and social division of London between the south and north side of the Thames.

In Brazil, preliminary discussions about the renewal of the semi-derelict harbour quarter in Rio de Janeiro also focus on the regenerative power of museums.

With the global shift from manufacturing to service industries, urban regeneration is a topical political issue in most metropolitan areas all over the world. Politicians have recognised that museums and other cultural institutions can play an important part in this complex process. Huge crowds of visitors to museums require a multitude of additional services, hotels and restaurants as well as shopping and transport facilities. The arrival of these facilities will in turn make people think about moving into a neighbourhood they would previously have given a wide berth. In Southwark this happened at lightning speed,

and even before building work at the Tate had started, residential properties in the vicinity had become extremely desirable (and expensive).

Admittedly there is a negative side to all this: the influx of so many temporary and permanent newcomers can put a strain on local communities, and there is the real danger that the locals are driven away by the superior financial power of the new arrivals. When the Centre Pompidou was built, the Les Halles neighbourhood and its demographics changed dramatically. It was not so much a case of renewal of the old community, but of displacement and subsequent wholesale gentrification, not quite what Pompidou had in mind. Today city planners are much better at controlling and directing the effect of their regenerative efforts. The lessons have been learned and safeguards are put in place to give the old communities at least some degree of protection from the superior financial muscle of the new arrivals.[125]

Unfortunately, politicians often lose interest in their new cultural toys the moment the ribbons have been cut and the television crews have moved on. Spanish museums in particular seem to be prone to this: after promising starts at the Museo Nacional Centro de Arte Reina Sofia in Madrid and ICAM, Centre Julio Gonzalez in Valencia, both institutions very quickly became pawns in national and local politics. The Museum of Contemporary Art in Barcelona has an even more chequered history and is today run by a triumvirate of appointees from the regional Catalan government, the city of Barcelona, and a private foundation; a museum in desperate search for an identity and mission.

For politicians, museums today have an appeal that goes well beyond their original educational function: they guarantee tourist revenue and play a central role in urban renewal, and are a relatively cheap way of generating huge, indirect financial returns for the community.[126] As a result, politicians take a much more active part in the planning of new museums, to the point where the political agenda can overshadow the cultural one.

There is a danger that the museum as urban status symbol can shift the emphasis onto the building and its symbolic meaning, to a degree where what is inside hardly seems to matter at all. In this respect, many of the new museums have only reinforced the old fears and suspicions that artists have long harboured.

125
Again, it is the Tate Gallery Bankside project that has set new standards on this issue. Consultations between the Tate and Southwark Council promise that the new museum will enhance the community and not drive out the old inhabitants at a stroke.

126
The Bilbao Guggenheim Museum, for example, has generated $219 million of revenue for the community and $35 million in tax during the first year of operating (*The New York Times*, November 19, 1998, p B5).

5.
Architecture 1:
Making and Remaking Museums

When looking at museum architecture over the last two decades it is very hard to draw up even a rough typology. The nature of the collections, the underlying political motivations and the intentions of both architects and curators ensure that museums differ in character and emphasis as never before. After decades of MoMA-inspired conformity, museums are as different from each other as they used to resemble each other in the past. Yet it is possible to identify those factors that seem to make for successful museums and those that appear to guarantee failure.

Museums with the most focused and high-quality collections seem to succeed where those with vague or uninteresting collections fail. To a large degree the nature of the collection will dictate the architecture, and focused collections inspire focused architecture.

Museums that have a high level of autonomy – either because they are privately or self-funded or have been granted semi-autonomous status – succeed to a greater degree than those that are subject to direct political interference. At the same time, the more the architecture is driven by institutional requirements (rather than by unrelated political agendas) the more workable the results tend to be.

Museums where architects work towards a succinct brief succeed over those where such detailed instructions are not given. Those museums where architects work in connection with the directors and curators (and can count on the advice of artists) succeed over those where architects have been given carte blanche by politicians.

It would be possible to position all recent museums somewhere on these three graphs. The more they are located on the right-hand side, the more problematic the nature of a specific institution would appear to be:

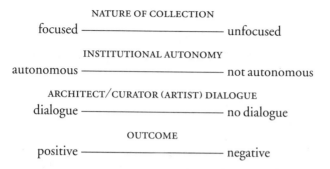

NATURE OF COLLECTION

focused ———————————————— unfocused

INSTITUTIONAL AUTONOMY

autonomous ———————————————— not autonomous

ARCHITECT/CURATOR (ARTIST) DIALOGUE

dialogue ———————————————— no dialogue

OUTCOME

positive ———————————————— negative

The American architectural critic, Victoria Newhouse, recently published a survey of new museum buildings, *Towards a New Museum*.[127] Her book takes a spirited, and often polemical, look at nearly forty international museum projects, the majority of which were realised over the last decade. Each project she describes can be analysed in terms of the three categories outlined above: the nature of the collection, autonomy from outside (political) interference, and the curator's ability to determine or at least influence the nature of the architecture. Judging by Newhouse's book, it is the small new museums with either private or monographic collections that most consistently achieve their goals. The Musée Picasso in Paris, the Warhol Museum in Pittsburgh, the Menil Collection in Houston and the Beyeler Museum in Basel are amongst the most outstanding examples.

Both the Musée Picasso and the Warhol Museum are monographic museums. While there is a tradition of this type of museum in France, and particularly in Paris (where the Musée Picasso joined the Musée Rodin, the Musée Maillol and the Musée Delacroix, to name but three), the Warhol Museum is the first institution of its type and scale in the United States.

As a result of Picasso's insistence on keeping back a fair amount of his own work, the Musée Picasso today offers the most comprehensive overview of his art anywhere in the world. Only MoMA's Picasso collection rivals that of the Musée Picasso. The difference between the two holdings is that the Paris museum gives an insight into Picasso's working process while MoMA's collection focuses on masterpieces. Both collections complement each other perfectly, as was first demonstrated by the 1980 Picasso retrospective in New York.

127
Newhouse, op. cit.

The Musée Picasso is located in Jean Boullier's seventeenth-century Hôtel Salé in the centre of the Marais quarter, within walking distance of the Centre Pompidou. The conversion was supervised by the French architect Roland Simounet. The imposing setting, if anything, enhances the collection, reflecting in a way Picasso's own, lifelong penchant for grand houses. Diego Giacometti's furniture and light fittings provide a striking yet subtle link between the baroque grandeur of the building and its contents. The museum has rapidly become a well-loved tourist attraction and is at the same time the centre of ground-breaking Picasso scholarship. Since its opening in 1984 it has instigated a series of important exhibitions, investigating specific aspects of Picasso's work and career in depth. Of these shows, the most memorable was 'Les Demoiselles d'Avignon', curated by Hélène Seckel in 1988.

Immediately after Warhol's death a debate began about how to best honour his achievement. As in the case of Picasso, enough work was left in Warhol's estate to contemplate the founding of a museum dedicated to the artist. Early on it was decided that such an institution should not be located in New York – where it would be just another museum in an already rather crowded cultural landscape, chasing funding from the same sources as everybody else – but in Warhol's birthplace, Pittsburgh.

Financed by the state of Pennsylvania, various members of the Heinz family, the Warhol Foundation and Henry Hillman, a Pittsburgh philanthropist, the Warhol Museum is located in a converted six-storey, 88,000 square feet warehouse at the Allegheny River in a rather gloomy, down-at-heel neighbourhood of Pittsburgh. The conversion of the building into a museum was directed by the New York architect Richard Gluckman in close consultation with the museum's founding chief curator, Mark Francis.

Comparable to the Musée Picasso in Paris, the Warhol Museum offers an in-depth overview of Warhol's career from the late 1940s until the time of his death in 1987. The emphasis is clearly on works of art, but each floor has a lobby area dedicated to source material and contemporaneous ephemera, with Warhol's magpie nature guaranteeing a superabundance of interesting documents.

There is a library and study centre, and an area where visitors can watch through a glass partition the ongoing cataloguing of the contents of Warhol's 'time capsules'. These are boxes that he filled with miscellaneous material, taped shut and stored away.

Despite acknowledging the personality cult Warhol himself did nothing to discourage, the museum categorically emphasises his art, showing Warhol as a sophisticated and insightful commentator of our age and a great painter into the bargain.

The research undertaken at the Warhol Museum has shed light on the genesis of many of his most famous works, and the gradual cataloguing and analysis of the documentary material passed from the estate to the museum promises further important insights.

Other museums dedicated to single artists are less successful. They are often concerned with figures not nearly as towering as Picasso and Warhol, and sometimes the scope of their collections is too limited with too few important works represented. In the end, the monographic format is clearly limited to key figures who have influenced the course of art history disproportionately and whose lives have caught the public imagination.

In a way, museums dedicated to single owner collections stand or fall on similar grounds. They succeed where collections are based on a concentration of masterpieces – like the Bührle Foundation in Zurich or the Sammlung Oskar Reinhardt in Winterthur – or where they cover a specific historical period comprehensively – like the Musée Jacquemart-André in Paris – or, even better, combine both perspectives as in the Wallace Collection in London. Even a place as madly eccentric as Isabella Stewart Gardner's Italianate palazzo in Boston is in the end redeemed by the breathtaking quality of art on display. On the other hand, where collections include too many also-runs or where the overall nature remains too eclectic, there is a real danger that the museum is nothing but a moribund monument to the donor's misguided vanity. The Armand Hammer Museum in Los Angeles is a case in point, as is the Fredrick R. Weissman Museum in Minneapolis.

At their very best, single owner museums combine an abundance of great art with a personal vision that holds everything together. Two of the best-loved small museums in this respect are

the Barnes Foundation outside Philadelphia and the Frick Collection in New York. Of more recent examples, the most lauded are the Menil Collection in Houston and the Beyeler Foundation in Basel.

Dominique de Menil (née Schlumberger), the heiress to a Texan oil-services fortune, and her husband John started collecting in 1945. She surely could not have foreseen that this was the beginning of a collecting dynasty which ultimately was to benefit major institutions in Houston, New York and Pittsburgh.

At the centre of Dominique de Menil's own activities (John died in 1973) remained the collection she and her husband had formed and which she continued adding to until her own death in 1997. The de Menil's collection today includes roughly 15,000 items, encompassing twentieth-century art, antiquities, Byzantine and medieval art, and tribal art from Africa, the Pacific and the Americas, as well as photography and illustrated books and manuscripts.

The collection's eclecticism is mitigated by the inclusion of a very high number of works of unquestionably great quality and historic significance. A particular field of strength is the de Menil's unrivalled holding of Surrealist art and related areas. The collection is Malrauxian in spirit, with a strong American slant. Not striving to be universal, the de Menils chose art for which they felt a true passion, and, despite the institutional setting, it is the highly personal character of their choices that still permeates the museum.

Initially the collection was homeless, although large numbers of works were generously lent to exhibitions all over the world as well as to local museums for extended periods. Finally, at the beginning of the 1970s, preliminary discussions were held with the architect Louis Kahn whose work the de Menils much admired, but Kahn's and John de Menil's sudden deaths within months of each other halted the project.

A decade later Dominique de Menil, on the advice of Pontus Hulten, the founding director of the Centre Pompidou, commissioned the Italian architect Renzo Piano to design a permanent home for her family's collection. Piano's building in Houston, Texas, opened to great acclaim in 1987. Although it shares with the Pompidou the sense of airiness and an indebtedness to

the modernist idiom, it is not at all high-tech or futuristic in character. The white, colonnaded louvre roof and the understated, austere simplicity of the exterior fits happily into the predominantly residential neighbourhood in downtown Houston. The interior spaces are flooded with natural light, an effect beautifully counterbalanced by the black staining of the pine floors. Only about ten percent of the collection is on view at any one time, giving the displays a spacious and elegant feel, reminiscent of the installations pioneered by Charles and Doris Saatchi at their north London gallery in the mid-1980s.

The Menil Collection is at the centre of a whole range of educational and scholarly activities, reflecting Dominique de Menil's belief that only a 'working museum' would remain meaningful. In its vicinity are the Rothko Chapel and the recently opened Cy Twombly Gallery as well as a tiny new museum housing a cycle of Byzantine frescoes.

The de Menil's example inspired another collector, the Swiss art dealer Ernst Beyeler, to turn to Renzo Piano as well.

Beyeler, arguably the most successful modern art dealer of his generation, had over the years amassed a personal collection of great quality and distinction. In about two hundred paintings (and a handful of sculptures) it provides a comprehensive overview of modern art from Impressionism to the present day, a group of work any museum would be proud of.[128]

Initially the collection was destined for the Kunstmuseum in Basel, and Beyeler had acquired certain paintings with such a union in mind. However, space restrictions at the museum and the realisation that a proportion of the collection would be consigned to storage at least periodically made Beyeler and his wife conclude that they should build their own museum to house the collection – which by then they had transferred to a foundation bearing their name. After drawn-out negotiations a deal was struck between the Fondation Beyeler and the city of Basel: the foundation would finance a new building and contribute its collection for an initial period of at least fifty years. In return, the city of Basel would provide a site and funding for the day-to-day running of the new institution.

In close collaboration with Renzo Piano, Beyeler developed his vision of what the museum should look like. As a result of this

128
Markus Bruderlin (ed),
Fondation Beyeler (Munich and New York: Prestel, 1997).

dialogue a remarkable balance between architecture and content has been achieved, to the point where it feels as if individual spaces have been designed with specific works of art in mind, in particular the galleries devoted to Monet, Giacometti and Picasso. Beyeler's collection could be described as dogmatically modernist, a kind of miniature Museum of Modern Art in its Barr heyday: in fact, the collection rather fizzles out after Abstract Expressionism. Piano's building shares the collector's self-imposed limitations: monumental yet at the same time open and airy, the museum, like the collection, is an unwavering hymn to Modernism.

Although the Menil Collection and the Fondation Beyeler buildings resemble each other superficially, there are marked differences. The light-flooded and somewhat utilitarian character of the de Menil spaces has at the Beyeler turned into a more severe architecture and interiors that are much more contained (an impression underlined by the frosted glass ceilings). The pale wood panelling of the de Menil exterior has metamorphosed into porphyry cladding at the Fondation Beyeler. The simplicity and lightness of the de Menil building has taken on grander overtones in Basel. The Menil Collection is as unassuming as the Fondation Beyeler is classicist, each building in its way perfectly reflecting the nature of the collection it houses.

The Fondation Beyeler does not share the Menil Collection's quirkiness and eccentricity. Neither collection is comprehensive, and both museums may as time passes tell as much, if not more, about collecting tastes in the decades after the Second World War as about the art of this century, adding a fascinating dimension to the works of art on display.

The monographic and the single collection museum both stand at one extreme of museum typology. The successful single collection museum, commissioned by an inspired individual from a great, understanding architect, remains, like the single artist museum, a rare exception. At the opposite end of the typology is the large, multi-departmental museum, created by way of political process and committee decision. Here the risk of failure is infinitely greater.

It is extraordinary to observe how many post-war museum buildings have been disappointments, from the points of view of

both architecture and function. Their blandness and formulaic nature may be partly explained by the fact that museum directors and curators were often only marginally involved in the design process. After decades of post-war neglect it seemed to be advisable to accept what was on offer without too much criticism in order not to risk last minute changes of heart by the political paymaster. The outcome was, with few exceptions, uninspiring and sometimes catastrophic.

The biggest let-down in this respect must surely be the Kulturzentrum near Potsdamerplatz in Berlin. It is centred around Hans Sharoun's Philarmonie (1960–63), his Staatsbibliothek (1967–78) and Mies van der Rohe's Neue Nationalgalerie (1965–68), to which were added new homes for the Kunstgewerbemuseum (applied arts), the Kupferstichkabinett (European drawings and prints), the Kunstbibliothek (art library) and the Gemäldegalerie (European painting to 1800). An architectural competition held in 1966 to establish an overall concept for the complex was inconclusive.

Rolf Gutbrod, a young and then largely unknown architect, was finally awarded this prestigious project *hors concours* in 1968, although his submission to the competition had been rejected two years earlier.

The start of building work was delayed endlessly, and the first of the museums, the Kunstgewerbemuseum, was only constructed in the years after 1978. By then the Sixties vogue for Brutalist architecture had definitely passed and was discredited, but as a result of political considerations the project was pushed through regardless.

The museum opened to the public in 1985, nearly two decades after Gutbrod had submitted his initial plans. Rumours had been rife that the building would be problematic, but nothing could have prepared for the actual result. The reality exceeded even the most pessimistic predictions.

The Kunstgewerbemuseum is a building without a single redeeming feature, a catastrophic design failure that, considering the scale and prominence of the project, should never have been allowed to become a reality. Gutbrod's museum lacks architectural logic and clarity. It is a building without proportion and any natural rhythm or grace. While the exterior exudes blandness

and a fortress-like inaccessibility, the gloomy interior has the air of a cheaply converted multi-storey car park, a space that actually manages to instil physical discomfort in the visitor. There seems to be no connection between the architecture and the works of art on display; the sense of alienation between the two is palatable. It is a building that is virtually unworkable for its purpose, stretching curatorial ingenuity and patience to the limit.

Maybe the initial delays over Gutbrod's project were due to the fact that those in charge knew instinctively that his plans were, at best, mediocre. In the light of the Kunstgewerbemuseum fiasco, Gutbrod was asked to review his plans for the Kupferstichkabinett and the Kunstbibliothek. The Gemäldegalerie commission, the heart of the project, was cautiously taken away from him.

Gutbrod's revised Kupferstichkabinett and Kunstbibliothek were finally built between 1987 and 1993, and the Gemäldegalerie (redesigned from scratch by Hilmer & Sattler) between 1989 and 1997. The Gemäldegalerie opened to the public in the summer of 1998, thirty-three years after the initial competition.

Like the Kunstgewerbemuseum, the Gemäldegalerie was pushed through, primarily for political reasons, in order to rescue the project from certain cancellation, in a race against a full review of the Museum Island site which, as the result of reunification, was again a potential home for the reunited Berlin collections.

There was little Hilmer & Sattler could do about the exterior appearance of the building and its setting – the Gemäldegalerie is firmly embedded in Gutbrod's overall scheme and shares an entrance lobby with the other museums – its forbidding exterior, an architectural cross between limpid modernism and tempered, late post-modernism, just adds to the overall impression of desolation and lack of clarity that characterises the Kulturforum. Approaching the museums via the wind-swept plaza, it is hard to believe that one is about to enter one of the premier galleries of Western art in the world, its collections on a par with those of the Louvre or the Hermitage.

In the interiors at least, Hilmer & Sattler managed to do justice to the painting collection. Their designs are a confident but ultimately unremarkable variant of the subtle, streamlined pas-

tiches of Beaux-Arts spaces that have become the norm everywhere. Architecturally, the galleries are in self-denial, and although they are perfectly workable and provide sufficient room for the superlative collection, they narrowly border on the bland and unimaginative, recalling the German post-war fear of museum architecture that dares to make a statement. Why the central hall of a museum dedicated to European painting of the last five centuries should quote Islamic architecture is a strange quirk that remains unexplained.

The fact that the Kulturforum was hastily completed as the result of political considerations – against the advice of most experts – and at the expense of a full rehabilitation of the Museum Island, makes the result even more tragic.

The Kulturforum is a prime example of what can go wrong when political agendas override curatorial and museological requirements. The outcome can run counter to all curatorial and audience needs and make it virtually impossible for those in charge to run their institutions in a productive and meaningful way.

The one example in the public (rather than private or semi-private) domain where curatorial considerations were from the outset at the centre of all thinking is the new Tate Gallery of Modern Art at Bankside. This was not the result of some far-sighted political inspiration, but rather the by-product of complete political indifference towards cultural issues in Britain. It may indeed be the only occasion where political neglect of cultural matters has actually led to positive results.

Of the new museum projects in Europe over the last two decades or so, none has caught the public imagination quite as much as the new Tate Gallery of Modern Art. Its location (on the river, opposite St Paul's Cathedral), the exceptional care taken to guarantee that the result will be a success in every respect, its ambitious scale and the proximity to the millennium celebrations have already raised expectations to fever pitch. It is the largest museum project undertaken in Europe since the Centre Pompidou and the first museum in London dedicated exclusively to twentieth-century art. That it will have a massive impact – on London as well as on the Western cultural landscape – seems a forgone conclusion.

The genesis of the Bankside museum is atypical in many respects. Unlike the Pompidou, Bankside was not the idea of an ambitious or visionary politician, nor is it the initial spark of some inner city regeneration plan, although its location might suggest this. When the project was first announced by the Tate Gallery's director, Nicholas Serota, and his trustees in December 1992, the public reaction was immensely favourable, yet politicians kept noticeably quiet. Amazing as it may sound, it was to take nearly two years before Virginia Bottomley, by then Heritage Secretary in John Major's Conservative government, mentioned the project in a speech, thereby indicating at least tacit agreement to the gallery's plans. This indifference may at times have been hard for those in charge, yet in a strange way it ultimately contributed to the project. It insulated the museum from political interference at the critical early planning and development stage, and made it possible for the Tate Gallery team to consider the idea carefully, research requirements, and formulate a detailed programme for the new institution. Few national museums on this scale have ever benefitted from such a high level of curatorial autonomy.

The cultural indifference of successive Conservative administrations created a vacuum that, by default, guaranteed the Bankside Tate's success. That it was possible to formulate what was in effect national cultural policy from within the confines of a state subsidised institution would have been unimaginable anywhere else but Britain. Even when it became clear that the project was a sure 'winner', the political instincts of the Conservatives were already too confused to realise this and claim the project their own.

It could be argued that this may not have so much to do with political exhaustion but is indicative of a deeply ingrained English brand of philistinism. It also explains why the incoming Labour government under Tony Blair also failed to embrace the project (which was well under way by the time of Labour's historic landslide victory in May 1997). Even the Blair government, never particularly shy to claim credit in matters that looked worthwhile, let the Bankside opportunity pass.

The only three critical arguments levelled against the new Tate Gallery have their origin in this lack of political support and

leadership. Firstly, that the Tate with its many branch museums, of which Bankside will be the latest and by far the largest, may wield too much power. Secondly, that the opportunity of the new museum should have been used for a more wide-ranging review of national museums and a redistribution of their often overlapping holdings. Thirdly, it has been repeatedly pointed out that the Tate Gallery officials have played their cards too close to their chests: no public consultations have taken place, and no planning papers or progress reports have been published. To date, seven years into the project, the Tate Gallery has not published a single volume documenting the new museum's progress or its intended policies. Initially this may not so much have reflected institutional high-handedness or arrogance, but could have been prompted by a fear that too early and too public a debate may have frightened a Tory dunce into ham-fisted interference or, worse, prompted cancellation of the project, an argument slightly less convincing now that construction is nearly completed. The metastasising of the Tate may indeed not be the best solution, but who is to criticise it for the lack of political will to explore other options – and what exactly are the alternatives? Yes, a once-in-a-lifetime chance offered by the new museum to review national holdings in general has been lost, yet it would have required supreme political dedication to achieve such an ambitious goal. The wholesale redistribution of museum holdings as practised in France during the 1980s could never be quite the English thing. The political and institutional antagonism to such an approach makes the Tate Gallery proposal look like the only solution possible under the circumstances.

Ultimately it has to be acknowledged that these are criticisms that should not be directed at the Tate Gallery but at successive governments.

Conceptually and architecturally, there is little that is completely new about the Bankside project. Coming at the end of the current museum building frenzy, the Tate Gallery was able to learn from the examples of others. The architects (the Swiss team of Jacques Herzog and Pierre de Meuron), curators and trustees of the Tate Gallery were in a position to look at dozens of new museums both in Europe and America where they were able to identify those aspects of projects that were successful and adapt

them for their own specific purposes. Likewise they took care to exclude other museums' mistakes from their deliberations.

As a result, Bankside will be a distillation of the best aspects of many other institutions. Yet this is not to say that the Tate is just a parasitic compilation of other peoples' successes: at Bankside all the elements and ideas that have been adopted from elsewhere have been applied in often surprising and quite unexpected ways and combinations. Part of the lavish advance praise for the Bankside project is due to a willingness by those in charge to think the unthinkable, leading to results marked by an elegant economy between the means deployed and the benefits derived.[129]

Although Bankside follows an already established formula for converting utility buildings into cultural institutions, it often does so in startling ways.

Bankside utilises an already existing industrial structure, but this is a building that is quite the opposite of the type of 'neutral' architecture that has so often been chosen for this purpose elsewhere. Sir Giles Gilbert Scott's power station, designed in the 1940s but not put into service until 1960, is not an 'invisible' structure but a fixture on the London skyline. It is a building that cannot be described as particularly elegant, but its voluminous, hulking presence exudes a strange and rather unexpected beauty.

Herzog de Meuron have in no way hidden the power station past of the building – in any event, part of it will remain in use by London Electricity for the foreseeable future – but neither can it be said that their architectural interventions are in total self-denial. Their skylights have changed the overall appearance of the building considerably, and Bankside's gigantic entrance hall, conceptually at least, recalls the entrance plaza of the Centre Pompidou, but architecturally it goes well beyond Piano and Roger's functionality. The space is a marvel, with its ceiling height of nearly 100 feet, giving London a truly monumental contemporary public space of which there are relatively few in the capital.

The exhibition galleries clearly incorporate many of the suggestions made by the artists who were consulted at the planning stage, resulting in spaces that accommodate their needs like few institutions on this scale. Public areas, on the other hand, take care of a wide range of educational, entertainment and retail

a result of this – d the politicians' refusal provide adequate nding – the Tate Gallery ll be by far the cheapest ajor museum project dertaken anywhere. ne current overhaul of e Pompidou will cost ore than Bankside, and e projected price tag of oo million for the new oMA makes the new Tate llery of Modern Art one the great civic bargains.

needs. Yet this twin functionality has not led to the kind of unsatisfactory division between public and gallery spaces that characterises so many other new museums. Instead a harmonious integration between the two functions has been achieved.

This is not only true of the integration of artist and audience. Although the range of ideas taken up from elsewhere is astounding, in the end it is the level of overall synergy that guarantees the architecture's success. While Bilbao, for example, is marked by an obvious breach between outside (exterior and lobby) and inside (galleries), at Bankside Herzog de Meuron have achieved a harmonious balance between exterior symbolism and interior function, artistic requirements and audience need, intimacy and grandeur, utility and pure form. They have demonstrated conclusively that it is possible to accommodate the needs of a mass audience - two million visitors are expected at Bankside annually - without having to compromise the art on display.

Bankside may actually be the one large-scale museum project that has succeeded in accommodating both artistic and audience needs successfully, a fusion that has eluded so many other projects for so long. The Tate Gallery of Modern Art seems to be on course to show the way into the twenty-first century, as other great museums have signalled the way in the past. It is an achievement that looks even more poignant and remarkable when one considers that Britain's record, as far as modern art is concerned, has been rather patchy until very recently.

6.

An Experiment:
The Global Museum

The fact that museums have to grow and expand is taken for granted today, to the point where the reasons for this are hardly ever queried. When the question does arise, the answers are often evasive or, at best, tautological. 'Expand or perish' is how Thomas Krens, the director of the Solomon R. Guggenheim Museum in New York, dramatically summed up the dilemma.[130] While the Museum of Modern Art decided to concentrate its efforts on a single site, and other institutions – the Kunstmuseum in Basel or the Tate Gallery in London, for example – have elected to split to multiple sites in the same locality, the Guggenheim Museum under the directorship of Thomas Krens has chosen a very different approach by attempting to turn itself into the first global museum.

For a decade prior to Krens' arrival in 1988, the Guggenheim Museum had been in crisis. The museum's flagship building, despite its great fame, was impractical and in a state of disrepair. Attendance figures were falling, the financial situation was precarious and most of the Guggenheim's fabled collection confined to storage. Krens' predecessor had struggled to develop an institutional identity to distinguish the Guggenheim Museum sufficiently from the two other New York museums dedicated to both modern and contemporary art, the Museum of Modern Art and the Whitney Museum of American Art.

To achieve the goal of a distinct institutional profile that had eluded his predecessor and to reverse the institution's fortunes, Krens formulated radical new policies and instigated a major shake-up of curatorial thinking and exhibition programming. At the centre of Krens' plans stood the idea of global expansion of the Guggenheim, a move prompted by the over-abundance of great museums in New York. The Guggenheim would turn itself into an international network of semi-autonomous satellite institutions, the first time that such an audacious plan was

)
uch of the following
ragraph is based on
formation contained in
:alk given by Thomas
ens on the invitation
' the Royal Academy,
ondon, at the Royal
stitution on
ovember 23, 1998.

undertaken by a museum: the concept of globalisation, though commonplace in corporate practice, had never until then been applied to a cultural institution.

Krens commenced his tenure as director by restoring and expanding the museum's Fifth Avenue headquarters. He reversed architectural interventions that had accumulated over the decades and expanded the building as far as the museum's landmark status would allow.[131] This did not however resolve the space problems. The director therefore proposed a Guggenheim branch in the SoHo district in downtown Manhattan.

To these projects he added, over the intervening years, ambitious plans for an extension of the museum's activities in Venice, where it already owned and administrated the Peggy Guggenheim Collection at the Palazzo Venier dei Leoni on the Grand Canal.[132] Krens also instigated projects for Salzburg (a spectacular museum set into a mountain side, designed by Austria's leading architect, Hans Hollein) and Berlin (a collaboration with Deutsche Bank, the museum was finally christened Deutsche Guggenheim), as well as branch museums in Bilbao and Seoul.

Krens kicked off his expansion drive with what have remained to this day the two most contentious acts of his tenure. In 1989 the Guggenheim Foundation launched, in true 1980s style, a $54 million bond issue which was guaranteed with a floating charge over the museum's collection, effectively mortgaging the Guggenheim's prime asset. At the same time the Guggenheim sold three major paintings by Chagall, Kandinsky[133] and Modigliani at auction. The ethics of these activities were questioned from the outset, and the bond launch in particular was accompanied by a storm of protest – and resulted in the resignation of a number of trustees – yet in the end Krens prevailed. Both actions were to set the tone for the future.

The Guggenheim Museum's in-house culture gradually changed as issues of scholarship and curatorial responsibility were more and more sidelined by discourses on management, politics and money. It seemed that Krens was beginning to look at the Guggenheim in terms of being an international corporation that just happened to be active in the business of the visual arts. His language became unapologetically managerial and his thinking preoccupied with issues of growth and expansion.

131
For a critique of this expansion see: Newhouse, op. cit., pp 172–170.

132
For a history of the Peggy Guggenheim Collection see: Carol P. B. Vail (ed), *Peggy Guggenheim: A Celebration* [exhibition catalogue] (New York: Guggenheim Museum Publications, 1998).

133
Kandinsky's *Fuga* 1914 (oil on canvas, 129.5 × 129.5 cm), a key picture in the evolution of abstraction, is now in the Fondation Beyeler in Basel see: Bruderlin, op. cit., no. 68.

Expansion at the Guggenheim was – and still is – achieved not just by way of branch museums but also by what Krens terms 'curatorial diversification': there were the exhibitions 'Africa: The Art of a Continent' in 1996 and 'China: 5,000 Years, Innovation and Transformation in the Arts' in 1998, both dedicated to subjects outside the Guggenheim's brief, and historically in the domain of the Metropolitan Museum of Art further down on Fifth Avenue. 'The Art of the Motorcycle' in the summer of 1998 marked an even more unexpected foray, although it was, according to Krens, the most successful show in the museum's history.[134]

Under Krens, the number of curators at the Guggenheim Museum has risen from four to twenty-six who put together exhibitions and displays not just for the Manhattan home base but for the various Guggenheim satellites and other institutions as well, a formidable sweatshop for scholarship and curating that generates a wide range of touring shows geared towards earning much-needed income for the museum. This dependency on touring show income creates an awkward conflict of interests: surely the need for travelling shows lowers the threshold at which fragile works are allowed to travel.

With the Fifth Avenue expansion barely completed, Krens turned his attention to the SoHo plans. Located on West Broadway at the corner of Prince Street, the Guggenheim's SoHo branch which opened in 1992 – the handsome galleries were designed by Arato Isozaki – has from the outset been a major headache for the museum. Attendance figures have remained stubbornly below expectations, and the initial prediction of some synergy between SoHo's artistic community and the branch museum was never borne out, especially not recently with SoHo rapidly turning into a gigantic open-air shopping mall and the art community decamping en masse to the nearby Chelsea neighbourhood. The SoHo branch has in fact been a financial drain on the museum, with losses reported at close to $40 million over a six-year period.[135] As a result, exhibitions and displays on Broadway have become increasingly perfunctory, and for some years now it has been rumoured that closure would be imminent.[136]

Today, the projected Salzburg and Seoul Guggenheim satel-

134
The exhibition ran from June 26 to October 20, 1998, and was seen by 301,000 visitors.

135
The New York Times, November 19, 1998, p B5.

136
In March 1999 the museum closed at very short notice 'temporarily for renovations'. It never reopened.

lites are shelved indefinitely,[137] the Venice expansion is snarled up in Italian politics and bureaucracy, and the response to the Berlin Guggenheim is muted - it is in the end nothing more than a smallish venue for a glorified corporate collection. The Guggenheim Museum in Bilbao is therefore the jewel in Krens' crown, the engine that powers the entire Guggenheim enterprise (its architecture is discussed in the next chapter).

This winning formula, in Krens' own words, of great art, world-class architecture and local money is indeed so tempting that he now wishes to apply it in New York as well. A proposed new Guggenheim – to replace the SoHo branch – is to be located on Pier 40 on Manhattan's West Side near the Holland Tunnel, within walking distance of both the SoHo and West Village neighbourhoods. Frank Gehry has again been retained as architect. The cloak-and-dagger secretiveness that surrounds this new project – not even the trustees had been informed initially – seems to indicate that Krens is hoping to present his board as well as the city politicians with a fait accompli, a plan so dazzling that it would be churlish to refuse consent.

Thomas Krens' idea of the global museum raises many questions. Is cultural colonialism in any way less objectionable than its past political and present-day economic equivalents? In fact, is there not something decidedly old-fashioned and outdated about Krens' concept now that museums have finally stopped cloning each other and have begun to develop highly individualistic profiles? Is long-distance curatorial care really workable, effective or even desirable? How does the Guggenheim make sure that local needs and particularities are reflected, and how exactly are such considerations factored in? In many cases exhibitions can be transferred from one venue to the next, but in other instances this is not so straightforward. Robert Rauschenberg's retrospective, after showings in New York, Houston and Cologne, reached Bilbao in severely truncated form, with the majority of early key works missing, an exhibition that was doing neither the artist nor the audience any favours.[138] Another show, 'After Mountain and Sea: Helen Frankenthaler 1956–1959', held at the Guggenheim Museum New York in the spring of 1998 may have made a lot of sense in New York, especially as part of a season dominated by exhibitions on De Kooning, Gorky, Pol-

137
There is no indication that the Austrian government has any intention of funding the Salzburg museum and the Asian economic meltdown has put paid to the Seoul project for at least a decade or so.

138
'Robert Rauschenberg: A Retrospective' was at the Guggenheim Museum Bilbao from November 20, 1998, to February 26, 1999.

lock and Rothko, but when it transferred to Bilbao it became a little obscure. What is topical in one context can become more or less meaningless in another. How do the branch museums and local artistic communities interact? Does the museum's programme record and support local artistic activities? And, on a more practical level, how does the constant shuttling of works of art affect their long-term state of preservation? Is it defensible to subject works of art that are often extremely fragile to the dangers of frequent long-distance travel? It appears that all New York is willing to send to Bilbao (after the dazzling opening exhibition) is surplus to Manhattan requirements. The selection of New York temporary loans is supplemented by the purchases that were made with a special grant from the Spanish government. This $50 million seed money for the collection was used to purchase a rather disjointed group of works, encompassing, amongst other things, a monumental Rothko painting, a second-rate Robert Motherwell, Jeff Koons' *Puppy*, a cycle of murals by Francesco Clemente, and works by Gilbert & George, Richard Long and Julian Schnabel. Rather than laying the foundations for a coherent collection, the purchases only further increased the museum's dependency on the largesse of the New York headquarters. The overall effect is decidedly motley.

Krens is deft at deflecting most of these questions by claiming that the Guggenheim's policies only mirror wider cultural trends, implying that, given a choice, he would have probably proceeded differently. Considering the power he holds, this sounds rather disingenuous. There is the growing suspicion that Krens has only picked up where Thomas Hoving left off at the Metropolitan Museum a decade ago, and is attempting to turn the Guggenheim Museum, to quote Hoving's notorious phrase, into 'the biggest, richest – and loudest – museum in the world'.[139]

This impression is confirmed when one compares the goals set when Krens took office in 1988 and the factual record of his achievements.

Rather than easing the financial plight of the Guggenheim, Krens' myriad projects have in fact made the situation far worse. Over the last ten years or so the museum has been lurching from one budget crisis to the next, sometimes coming perilously close to financial meltdown. The fiscal uncertainty has jeopardised

139
See footnote 96.

day-to-day operations and has repeatedly set off desperate scrambles for funding. As a result the Guggenheim has become ever more dependent on private and corporate sponsorship - and increasingly susceptible to the pressures that come with it. The catalogue for the exhibition 'China: 5,000 Years',[140] included no fewer than four separate sponsors' statements: Lufthansa, Nokia, Ford Motor Company and The Coca-Cola Company. Although Krens stresses that sponsors are given choices by the curators – rather than sponsors making direct demands on curators – we can safely assume that the need for sponsorship will at least partly influence what is put forward for their consideration.

The constant need for big cash injections – at one point things were so bad that the Guggenheim's rent payments for SoHo fell behind – has led to some rather questionable deals being struck. The most contentious was the suggested re-naming of the Fifth Avenue flagship building in return for a multi-million dollar donation. The transaction was scuppered at the last minute by the New York landmark commission when it ruled that the existing lettering was an integral part of the Guggenheim's listed façade and therefore could not be removed.

As far as the shoring-up of the museum's standing in relation to the other major New York institutions is concerned, it could be argued that Krens has in fact undermined the Guggenheim's position even further. Rather than focusing the museum's exhibition programme and related activities, they now appear to be all over the place, swaying from masterpieces from the Centre Pompidou collection to motorbikes, a very mixed bag showing little or no cohesion. It feels as if the museum regularly picks up on things that other institutions are either not particularly interested in or cannot be bothered with, turning the Guggenheim into a last chance venue once the other Manhattan museums have declined. To make matters worse, in the last couple of years the museum has suffered countless last-minute cancellations of exhibitions and programme changes. The overall impression is one of chaos and disorganisation. Today, the curatorial highground is unquestionably held by the Whitney Museum of American Art and the Museum of Modern Art while the Guggenheim exhibition programme seems haphazard and often plain opportunistic.

140
'China: 5,000 Years, Innovation and Transformation in the Arts' was on view at the Solomon R. Guggenheim Museum in New York from February 6 to June 3, 1998. It was shown, in a much reduced form, in Bilbao in the autumn of the same year.

Like a corporation that cannot increase margins and therefore depends entirely on expansion as the only means of increasing overall profitability – the McDonalds syndrome – the Guggenheim Museum under Krens has been hastening from new project to new project, the bigger and more headline-grabbing the better. One is beginning to suspect that those in charge are unwilling to allow a break and reflect on the museum's mission because they know that this might reveal a major flaw at the very centre of the present concept.

A more worrying implication is that the latest project is always needed to generate the revenue to pay for the deficits amassed by its precursors, an institutional robbing of Peter to pay Paul. The Spanish government paid the Guggenheim Foundation a staggering initial 'consultation fee' of $20 million, an amount mostly used to deal with the most pressing financial needs in New York.

It seems that expansion does not solve problems but only creates additional (financial) demands.

Krens' idea of the global museum is an attempt to emulate concepts of global branding and marketing of mass-produced goods. From a manufacturing point of view the creation of global brands makes perfect sense because the larger the quantities produced the cheaper the resulting unit cost. On the downside the costs relating to the creation of a global brand are colossal. To introduce, for example, a new razor brand worldwide today requires an initial outlay well in excess of £100 million. The process is helped along by nationally and often even regionally diversified advertising to allow for cultural variants between different markets. It appears that global brands can only be established by advertising that has been customised to local circumstances.

If we liken the museum to the factory, art to the global brand, and the curator to the ad man, then three fundamental differences become glaringly obvious.

First, compared to the financial muscle of corporations operating internationally, even the largest and richest museum is a small player. The larger the corporation, the bigger the proportion of time and resources taken up with internal communication and organisation, a fact Krens clearly did not take into con-

sideration: any savings achieved by curatorial synergy between component institutions is more than cancelled out by additional administrative expenditure.

Secondly, unlike the factory, the museum is concerned with unique objects, so there are none of the savings resulting from high volume production. However streamlined the activities between satellite museums, they are as labour-intensive and expensive as those conducted between independent institutions. The 1999 budget for the Guggenheim Bilbao was Ptas 3,391 million (approximately $23 million),[141] indicating that the museum is comparatively expensive to run and that savings achieved as a result of being part of a larger, global organisation appear to be negligible.

Thirdly, like the advertising man, the curator has to mediate the product he is trying to 'sell' (art) in order to reflect specific local cultural circumstances. Rather than from a Manhattan central office, this is a task that could arguably be performed better in an independent museum by local curators with a particular geographic and cultural understanding.

It seems that the idea of the global museum is severely limited by the specific parameters that define individual institutions: their fixation on unique objects is mirrored by their goal to interpret those objects with local (national and regional) circumstances in mind. In this light all the global museum seems to do is create a cumbersome and expensive administrative super-layer to orchestrate activities the majority of which could be co-ordinated as efficiently, and probably more effectively, on a local level.

Until there is a truly global cultural context – where not only nation-states have disappeared but also language barriers, and where the difference between centre and periphery no longer exists – the global museum finds itself out of tune with the actual situation. Even if the goal of global culture were obtained it is hard to see how the museum could overcome the issue of the unique object which for the last two hundred years has been at the core of its activity.

Krens' plan is ahead of today's cultural reality and as a result fails to deliver over and above that which independent museums can already achieve in the present context.

141
Guggenheim Bilbao, Action Plan and Program for 1999, press release, January 12, 1999.

7.
Architecture 2:
Museum Makeovers

The current spate of museum building has resulted in literally hundreds of new institutions, a few of which have become instant classics and are a great success with the public. However, the majority are to some degree flawed, often in minor ways but occasionally to a point where curatorial patience and ingenuity are tested to their limits.

In the end, where architecture disrupts or hinders day-to-day operations or compromises displays, nothing can be done but undertake major overhauls and renovations, a delicate business particularly where original donors and architects are still alive.

Today museum directors and curators work in close collaboration with architects to achieve the kind of museum architecture that accommodates curators' requirements, and so common has this practice become that it is easily forgotten how relatively recent a trend it is. The Bode-Ihne collaboration over the Kaiser Friedrich-Museum, for example, was an exceptional occurrence, but for most of this century architects routinely ignored and overrode museological advice.

The British architect James Stirling was able to overrule curatorial objections on many important issues when he designed the Tate Gallery's Clore Gallery (1978–85) which was to house the nation's Turner collection. The effect of Stirling's design was decidedly awkward, as if art and interiors were not really destined for each other, yet another museum building where architecture and art were deeply at odds. A few years after James Stirling's death, the Tate Gallery decided to make over its Clore Gallery.[142] Now curators were able to correct mistakes they could not talk the architect out of committing at the time of construction. Luckily the Tate was blessed with an open-minded and perceptive original donor, Vivienne Duffield, who not only agreed to the makeover but also graciously underwrote it. More often architectural blunders remain uncorrected for decades, either in

2
oincidentally, little of
:irling's original design
986–88) for the Tate
allery Liverpool survived
ıe 1996–1998 makeover
ıd expansion of the
cilities.

order not to offend donors or political masters – or simply because of lack of funding.

But it is by no means only design blunders that lead to museum makeovers. As curatorial thinking is (like everything else) evolving at an ever-accelerating pace, buildings tend to age faster, and both spaces and technical facilities quickly become outdated. This presents architects with the seemingly unresolvable dilemma of having to come up with architecture that is simultaneously distinguished – authentic and of its time – yet endlessly adaptable to new requirements from artists and curators. The idea of a shell architecture into which any kind of spatial concept can be temporarily introduced had been tried first at the Centre Pompidou and revealed as flawed by curatorial practice, although the argument for perpetual 'reprogrammability' has gradually re-entered the debate over the last couple of years.

Now that the museum building boom of the last two decades is slowly beginning to run its course, the questions of how to work within given architectural parameters, how to utilise old and new buildings, how to overcome certain architectural limitations and, at the same time, present collections and individual works of art in their best light, may well dominate the museum discourse for the foreseeable future.

With so much emphasis recently on museum architecture, the issue of displays can become dangerously sidelined. In all the excitement over Frank Gehry's Bilbao Guggenheim Museum it is often conveniently forgotten that the interiors of his celebrated building are extremely compromising when it comes to the effective display of art. The museum's largest, ground level gallery is 450 feet long with an arched ceiling above twenty-three foot high walls. It is a space so large that it feels more like an airport concourse than an exhibition space designed for the display of works of art, and no photograph conveys a true sense of its gargantuan scale. Although Krens claims that the space is 'inspiring, not overwhelming',[143] his statement is not quite borne out by the reality of the interior: the voluminous gallery demands art on a truly heroic, not to say corporate scale, but even very large work seems to be lost in the expanse of Gehry's architecture. A sculpture as monumental as Richard Serra's *Snake* (1996)[144] looks like a weightless cardboard maquette, whilst even a thirty-foot long

143
Newhouse, op. cit., p 251.

144
Snake 1996, weatherproof steel in six conical sections each 13ft 2in × 52ft x 2in, overall length 104ft, illustrated in: *Richard Serra Sculpture 1985–1998* [exhibition catalogue] (Los Angeles: The Museum of Contemporary Art, 1998 pp 168–169.

Andy Warhol painting finds it hard to hold its own. That some of the walls of the gallery are slightly curved does not help either, and paintings suffer in particular. Seven smaller, equally 'organic' galleries are dedicated to more intimate displays of works, often by a single artist. These galleries are as overpowering as the large spaces, this time not so much by their scale but because of their quasi-expressionistic spatiality. Some of them feel like cul-de-sacs or random cut-offs from larger spaces, indicating that in the end it proved impossible for Gehry to fully integrate the inside and outside of the building. The exciting chaos and drama of the exterior is mirrored by the interiors, but what works outside turns to a disadvantage on the inside. Many visitors find it hard to orientate themselves within the three-storey structure. Especially when exhibitions occupy a multitude of spaces, it becomes hard to find one's way around and gain a sense of curatorial and architectural cohesion. A suite of six comparatively conventional, square galleries dedicated to the museum's permanent collection only adds to the overall sense of spatial confusion. The overwhelming impression is that of the architecture setting the agenda at the expense of the art on display. In Bilbao, to quote Victoria Newhouse, 'the dominant image is the container rather than the contents.'[145]

The sheer theatre of Gehry's Bilbao building is its greatest museological drawback, recalling I.M.Pei's statement: 'Now there's a danger when you have this kind of richness [...] – considerable confusion. And if the public, the viewer, cannot grasp the space, what good is richness? It creates confusion.'[146] Watching visitors in Bilbao it becomes clear that they are not really focusing on the works of art on display but that they are wandering through the building in a state of trance. It seems that the Bilbao Guggenheim as a structure is so demanding that there is the danger of no energy being left to grasp the art on display.

It is a great irony that the Guggenheim Bilbao branch should in a way replicate what has dogged Frank Lloyd Wright's flagship building in Manhattan, and that the Guggenheim Foundation now owns two of the greatest architectural icons of our century, both, as far as their purpose is concerned, deeply dysfunctional.

How to display works of art to their best advantage, either within given buildings or in purpose-built structures, is a subject

145
Newhouse, op. cit., p 260.

146
Carter Wiseman, I.M. Pei, A Profile in American Architecture (New York: Harry N. Abrams Inc., 1990) p 164.

of ongoing, heated debate. The museum started as a glorified storehouse of objects of ideological or scholarly interest where methodology overruled all other concerns. Quickly the emphasis began to shift when it dawned on those in charge that the museum's objects were not just specimens but works of art that deserved consideration on their own merit. The resulting aestheticising of the object has proved unstoppable – Dominique-Vivant Denon's Louvre, Bode's Kaiser Friedrich-Museum, the already quoted 1928 report on the Elgin Marbles and Barr's Museum of Modern Art are but four examples illustrating this radical shift of emphasis.

Today it seems that curatorial practice is split between two opposing factions. On one hand there is the purely aesthetic school of thinking, where the work of art stands at the centre of all discourse. On the other hand one finds contextualising curatorship which strives to place the work within the political, social and economic circumstances under which it was created. The former strategy is epitomised by the Museum of Modern Art under Barr, and the latter by the Centre Pompidou in its heyday. Scholarly opinion has remained divided as to which approach is the more correct, and many curators have opted for a seemingly safe middle course between the two extremes or have chosen a practice which continually alternates between them.

To complicate matters further, over the last decades or so questions about the museum's own history have increasingly come to the fore. In an age obsessed with history and conservation it was only a matter of time before the museum and its historical displays were themselves being submitted to careful study and preservation: turning full circle, the museum has become its own subject.

The two most fascinating illustrations of this historicising trend are the update of the Louvre in Paris, which was carried out between 1984 and 1999, and the restoration of Bode's Museum Island, about to be undertaken in Berlin.

Because the Louvre had played such a pivotal role in the evolution of the museum concept and many displays had remained virtually untouched since inception, it seemed important, particularly from the present perspective, to retain as much of the historic fabric as possible. Some critics even went as far as to

advise preserving the museum in its current state, limiting restoration work to general cleaning and hardly noticeable upgrades of facilities (air-conditioning, lighting, utilities for visitors, etc.). In the light of growing numbers of visitors this was deemed insufficient: the museum, effectively unchanged since the nineteenth century, could no longer cope with the visitor numbers of the jet age. It was also noted that the Louvre had run out of space and that curators were unable to show an even remotely representative proportion of the museum's unrivalled collections, nor was it possible for displays to reflect the latest research. There was no room for special exhibitions, educational activities or administrative facilities. The museum had effectively come to a standstill.

President Mitterrand, clearly in an attempt to leave a personal mark on the same scale as Pompidou, made the Louvre the first of his *grands travaux*. Not content with one monument to himself, he also instigated the Opéra Bastille, the La Défense complex and the Bibliothèque Nationale, altogether the most extensive civic building programme in the French capital since Hausmann changed the city's layout in the 1870s. Following Pompidou's example, Mitterrand did not leave the Louvre project under the jurisdiction of the Ministry of Culture but set up a special independent government agency (Etablissement Public du Grand Louvre, EPGL) to carry out his ambitious plans.

Mitterrand's appointment of I.M.Pei as chief architect in 1983, and the architect's proposal of a glass pyramid in the Cour Napoléon set off a heated debate about the nature and wisdom of contemporary interference in historic settings.

The Louvre not only houses collections of great historical significance but is the setting for some of the most central episodes in French history. It is also one of the prime records of French architecture from the twelfth century to the Second Empire, from the reigns of Philippe Auguste, Catherine de Medici, Louis XIV (although during his reign the court moved to Versailles), to 'Le Nouveau Louvre', the Richelieu wing built under Napoleon III in the 1850s and 1860s. There are the foundations of Philippe Auguste's late twelfth-century fortress, traces of building work undertaken by Charles V. There was the Grande Galerie, effectively preserved in its eighteenth-century appear-

ance and that has become the model for picture galleries all over Europe, the seventeenth century interiors in the east wing, the opulent state apartments of Napoleon III in the Richelieu wing, the early nineteenth century displays of Greek and Roman art and the Egyptian galleries, in essence still laid out as they were by the father of modern Egyptology, Jean-François Champollion in the 1820s. Often it is not just the collection and its historic installation but also the original function of the former royal interiors that can coincide in a single space, resulting in a rich layering of historic references as well as reminders of past and present museal use. Few locations anywhere in the world are quite as hypercharged with so much national symbolism and institutional meaning.

To preserve the Louvre's unique interplay of architectural record and historic displays and at the same time accommodate today's museological requirements was the great challenge for architects, designers and curators alike. At the centre of it stood the question of how to best update displays without interfering in any way with the original fabric. The present had to coexist with the past, without one cancelling out or compromising the other. Architecture (the buildings' original function), historic displays (whole galleries, cabinets, etc.) and contemporary displays had to stand side by side – harmonious as an entity but without overpowering one another. As I. M. Pei's plans were beginning to emerge it became clear that he was certainly up to this daunting task.

Although all historic interiors were preserved, some areas, where the historic fabric had been damaged beyond redemption, are resolutely modern, yet Pei managed to do this without the overall cohesion of the museum being lost. Each historic layer can be viewed on its own merit: it is possible to progress through the galleries concentrating either on the collection or on the building's historic architecture. Once inside the period interiors, the first impression is that nothing has changed, until one realises this is not true at all and that present-day curatorial requirements have in fact been accommodated more thoroughly than in many purpose-built contemporary museums. This is particularly striking in the historic Egyptian galleries which had been designed originally in the 1820s under the supervision of Jean-François

Champollion and had hardly been touched since. They retain many of the original display cabinets as well as the extensive cycle of highly ideological wall paintings which manages to appropriate the entire course of Egyptian history for the goals of the Bourbon Restoration.[147] Architects and curators miraculously succeeded in turning these galleries into arguably the most up-to-date display of Egyptian art anywhere in the world, without compromising the historic setting or distracting from it at all.

Interestingly, Pei's concept worked least where there was little or nothing of the original interiors left. In this respect the galleries dedicated to French painting in the Richelieu wing are particularly uninspiring in their institutional blandness. Architecturally they are not bad, but neither are they particularly distinguished, their effect strangely echoing the galleries in the new Gemäldegalerie in Berlin.

Skilled at adapting historic settings to their best advantage, today's architects seem to be unable to create their own contemporary equivalent of the distinguished interiors of the past, instead taking refuge in pastiche and straight copy. Wherever Pei was given at least some residue of the historical fabric to work with he succeeded spectacularly, but on the few occasions where nothing remained, the result was disappointing. Luckily so much of the original substance had survived that only in a few instances did Pei have to work without any historical inspiration at all.

It was not just the issues of display and integration of historic fabric and modern use that Pei dealt with so well. The Louvre had a notorious reputation as far as its user-friendliness was concerned. In the past there was always the spectacle of hordes of tourists desperately circling the museum in an attempt to find their way in, and even then their trials were far from over: to get from A to B inside the museum was equally challenging, and the impression was often that most visitors were not looking *at* something but *for* something, restlessly shuffling from gallery to gallery. In addition there was also a total lack of basic amenities (rest rooms and restaurants), and the few available facilities were far apart, hard to find and in a state of disrepair. Pei took care of the needs of nearly four million annual visitors by introducing a central focus to the museum's sprawling expanse: his glass pyra-

47
See: Todd Porterfield, *The Allure of Empire, Art in the Service of French Imperialism 1798–1836*, Princeton, New Jersey: Princeton University Press, 1998) chapter 3: 'The Musée d'Egypte', pp 81–116.

mid was a bold and controversial proposal, introducing an unashamedly modern structure into the historical ensemble. The pyramid gave the museum a focal point, and the huge underground spaces that came with it provided visitors with shopping facilities and a wide choice of restaurants. Finally, the Louvre had a long needed and easily identifiable central entrance. Rather than having to struggle through miles of galleries, visitors are funnelled quickly from the central pyramid to the various departments without the danger of getting lost inside the museum's myriad corridors. A welcome side-effect of this is that galleries now feel less busy, less like the transit spaces they resembled in the past. Today it is possible for those in a hurry to do a quick thirty-minute tour, taking in highlights as diverse and located as far apart from each other as the Mona Lisa, the Venus de Milo and the Nike of Samothrace, while other visitors, more interested in an in-depth look at the various collections, can do so without disruption from milling crowds.

Pei's designs were proof that it was possible to 're-program' given architecture without having to annihilate the historic record in the process. The Louvre's example demonstrated that one could have various functions running concurrently and preserve layers of history simultaneously. Pei's Louvre project was the first undertaking of its kind, resulting in a new sensibility towards the restoration and adaptation of historic museum buildings. It was a timely discovery, with the long-awaited makeovers of the Prado in Madrid, the Hermitage in St Petersburg and the Museum Island in Berlin about to commence. As in the past, the Louvre had again become an object lesson in the latest museological practice.

In Berlin the debate about the future of the Museum Island – ongoing since reunification in 1989 – has been protracted and complex. As in Paris, the question of how to preserve the historic fabric without compromising modern-day needs stood at the centre of the argument. While the Louvre had survived nearly eight hundred years of tumultuous history if not unscathed then at least as an organic entity, the Museum Island, in less than a fifth of that time, had been built, expanded, altered and severely damaged. It is today no longer a cohesive whole but a fragmented and desolate shadow of its former self. If the Louvre is a monu-

ment to French history and national glory, the Museum Island is a much more ambiguous reminder of Germany's altogether more convoluted history, its imperialistic origins, Fascist self-destruction, national division and democratic rebirth.

The Museum Island, Bode's great model for museology during the first decades of the twentieth century, had barely survived the Second World War. The random split of the collections between East and West, the extensive destruction of its architecture, and the failure of the East German regime to safeguard the remains in more than just a perfunctory fashion, all make it a miracle that as much has survived as can be seen today.

Partly driven by ideological considerations but mainly held back by a shortage of funds, the Communists carried out only the most basic repairs. The Nationalgalerie, the Pergamon Museum, the Bode Museum and the Alte Museum reopened to the public in the course of the 1960s, barely functional and a far cry from Bode's original. The most badly damaged of the five museums, the Neue Museum, was intermittently threatened with destruction by the Communist regime, a fate only narrowly avoided thanks to the diligence and great bravery of successive generations of curators in charge. The Communists' attitude towards the Museum Island had been deeply ambiguous, and it is safe to assume that, had their economic situation been less strained, they would have pulled down all the buildings and replaced them with modern structures.

If the Louvre had to retain the full record of its architectural and collecting history, as well as accommodate contemporary display techniques and audience needs, all this was helped by the well-preserved unity of the entity: in Berlin matters were much more complicated.

On the Museum Island the balance between past function and present-day curatorial considerations was again a central issue, but the architectural unity of the ensemble had been literally torn apart, the fragments ranging from the roughly patched up to the barely recognisable. This fragmentary nature raised many questions regarding the status of half-finished buildings, war destruction and post-war reconstructions which themselves had become historical. On analysis, every building on the Museum Island revealed a complex history of botched genesis,

subsequent adaptations and changes, destruction and attempted restoration. Messel's plans for the Pergamon Museum, for example, had been endlessly altered for nearly a quarter of a century after his death. In the end, many aspects of the building were left unfinished: the architectural detailing was toned down, sculptural decorations were left off and the interiors streamlined. Most importantly, the colonnade that was to close off the entrance courtyard towards the Kupfergraben remained unbuilt, leaving a rather unsatisfactory state of affairs that will eventually need resolving. The Pergamon Museum is a building compromised during construction, by war destruction and half-hearted attempts at rebuilding. The Alte Museum is similarly blighted, Schinkel's original interiors gone and replaced with an unsophisticated variant of streamlined 'Socialist Classicism'. Of the Neue Museum only about half of the building's architectural fabric has survived, with important parts, such as the central staircase, completely destroyed: matters have been made worse by half a century of exposure to the elements and ham-fisted emergency conservation work carried out at various stages during the post-war period.

How to rescue the overall character of this wreck of a *'Gesamtkunstwerk* of European rank'[148] without creating a faux-historical re-rendering was the big challenge. In Berlin, besides the layers of history already noted in the Louvre project, there were two additional factors to consider: the rebuilt Museum Island was also to remain a record of its war destruction and a monument to its own post-reunification resurrection. Rather like the restoration of an old master painting, the scars of bombing and neglect were not to be rendered invisible but subtly blended in. As a result, it would be possible to get an overall impression of the architectural ensemble but at the same time remain fully aware of precisely which elements had been irretrievably lost.

Often, within the same building, there are interiors that are either fully preserved, more or less destroyed, or have completely disappeared. The complexity of the Berlin situation cannot be exaggerated: how is it possible to create unity in order to give an idea of the former cohesion of the complex, yet at the same time not deny its fragmentary nature? How is one to deal with the fact

148
Ernst Badstubner et al., op. cit., p 19.

that some of the original collections – apart from those that have been irretrievably lost – will not return to the Island in the foreseeable future? Much art is still in limbo in Russia, and European paintings, for example, will not return to the Island but remain housed at the Kulturzentrum at Tiergarten. And how are those parts of the collections to be integrated that had grown independently from each other during the half century of separation?

Even if a full reconstruction were a possibility, the question would arise as to which specific point in time such a project was to aspire to. Was there a particular moment, a *terminus ante quem*, when the Museum Island appeared particularly finished or perfect? It seems that from the outset the Museum Island was a place of evolving functions and changing uses, and Bode himself clearly thought that the institution in his charge could be forever expanded and improved upon.

A reconstruction that denied or underplayed this work-in-progress nature of the Island and instead opted for a particular point in time would be fictitious, not factual. It would introduce a static element into the equation that had not been there in the first place.

The restoration of the Museum Island is an exceptionally complex undertaking by any standards. Rarely had so many diverse agendas come together in a single museum project. Issues of town planning, questions of the nature of the audience and its needs as well as the curatorial and historical context had to be considered with great care. This involved urban archaeologists, art historians, architectural historians, museologists and curators in equal measure, with the choice of a suitable architect as the linchpin guaranteeing that the Museum Island was to regain its full function without losing any of its significance as a historic site. The appointment of David Chipperfield in 1996 was welcomed with great relief by many of those who had feared the worst for the Island's future. The restrained minimalism of Chipperfield's architecture and the clarity of his proposal will ensure that an overall cohesion is regained, without the fragmentary nature of the ensemble being underplayed. Chipperfield's work will guarantee that the historic record will be preserved without the new parts being 'in denial' or pretending to be anything but clearly contemporary, allowing the Museum Island once again to

take its place amongst the great museums of the West. It will combine a full awareness of its historicity with up-to-date curatorial practice. Like the Louvre, it will accommodate large numbers of visitors, fulfil present-day requirements of scholarship and conservation and at the same time unify what is currently fragmented, without having to fall back on a full-blown, faux-authentic reconstruction. The reborn Museum Island will be the product of urban archaeology and distinguished contemporary architecture in equal measures. It will be a place simultaneously home to the myriad works of art on display and monument to both the museum's own past and German history, of which it has become such an enduring symbol.[149]

This careful preservation of the historic record, its full integration into the day-to-day functioning of museums, is a relatively new concept. In the 1950s and 1960s the question of historic and contemporary function would often have been dealt with by removing period interiors or by simply covering historical details – the boarding-up of the Duveen Gallery at the Tate Gallery in the 1950s has already been mentioned. Today, as far as curators are concerned, such historic spaces, rather than being considered a distraction, actually offer a welcome side-effect. They are a subtle reminder to visitors not to take the interpretative stress of displays at face value but to recognise them for what they are, a contemporary and often partisan rereading of the past.

Like the strata on an archaeological site, the museum today displays the various layers of its own history. At the core is the collection, surrounded by the vestiges of former modes of display as well as the architecture's own history (sometimes, but not always, the two are identical), its former function, gradual evolution or, in the case of the Neue Museum in Berlin, destruction and subsequent renewal.

The stories of the Louvre and the Museum Island are exceptional in so far as both museums house collections that are amongst the greatest assemblies of Western art anywhere in the world. At the same time both museums are deeply bound up with the histories of their nations. They are national treasure houses, symbols of their peoples' political aspirations and cultural self-understanding, their triumphs and tragedies. In addition, both institutions played central parts in the development of

149
As of writing (March 1999) the Museum Island project is stalled because the future organisation of all Berlin museums is again under review. Until a satisfactory new administrative structure has been agreed no building work will be carried out.

the museum concept and were benchmarks of their kind, setting scholarly examples and standards that to this day determine how museums are looked at and understood.

Yet the question of how best to utilise existing or purpose-designed buildings, how to adapt them to changing audience and curatorial needs, is not limited to museums on a Berlin or Paris scale. This issue of adaptability to changing curatorial circumstances and, in the case of contemporary art museums, artistic practice, has quite recently become a central concern for all museums.

8.
Modes of Display

Now that the museum boom of the past two decades has run its course, the question is how to deal with existing buildings and how to keep them up-to-date. This is an issue that does not affect only historic museum architecture but also a surprisingly large number of more recent structures. It is relatively easy to put up a headline-grabbing, spectacular new museum or wing. The real challenge to curators starts when the novelty has worn off. How to maintain an institution's place in the limelight, keep visitors coming and sponsorship (as well as public funding) flowing, is in the end a much more complex issue than building work, requiring elaborate and inventive strategies.

After two decades of unprecedented growth and expansion it is beginning to dawn on curators that bigger museums are not automatically better museums. Limits to physical growth are imposed by the amount that even the most diligent and observant visitor can take in. As to the argument of expansion in order to accommodate growing audience numbers, it is now clear that expanded museums, like road planning in the past, do not ease congestion but merely create more traffic. As a result of this realisation the curatorial emphasis has shifted from quantity to the quality and nature of displays.

It is not just the visitors' physical limitation that has come into focus but also the fact that there is a limit to institutional growth itself. The idea of the universal, all-encompassing museum, conceptually tied to a master narrative, has in the present, post-modern cultural climate, increasingly appeared to be an unrealistic and outdated notion. As the gap between material and interpretation widened during this century, the limitations of the historical models of museum organisation became painfully clear.

As a result, displays have shifted from the static towards the dynamic. The transition arguably marked the greatest revolution

the museum concept had undergone in its entire history. Curatorial displays were no longer writ in stone as in the past but subject to continuous revision and turnover. To keep a collection alive was no longer just a matter of adding to it, but became a question of combining objects in forever changing and unexpected permutations in order to explore their myriad meanings. This transition from the static-monolithic to the dynamic-temporised museum has taken place over the course of the last two decades.

Rather than presenting the museum, as in the past, as a storehouse of cultural prototypes instilled with the authority and normative power that such a concept implies, the museum is now much more involved in a two-way dialogue with its audience. It relies more on interpretation and less on absolute truths. The new, 'open' museum reflects the dynamics and multicultural nature of late twentieth century society, with its questioning approach and insatiable appetite for novelty.

The effect of these developments is particularly marked in museums dedicated to modern and contemporary art. From the days of MoMA-cloning and a predominantly historical-chronological approach, a shift has occurred towards two new curatorial models, both of which are the complete antithesis of what went before. Within a relatively short period of time both these modes of presentation have come to dominate the display of twentieth-century art: they can be described respectively as ahistorical and monographic in character.

Ahistorical installations forego chronology and evolution. In their place they stress aesthetic affinities that may run counter to more traditional ways of classification. Whilst this strategy, most ardently proposed by Rudi Fuchs, Jan Hoet and Harald Szeemann in the 1970s and 1980s, may appear to deal with the increasingly doubtful issues of master narrative, chronology and style, its implicit tautology raises just as many questions as it answers. By taking a work of art out of both its cultural and historical context, ahistorical installations put it into an interpretative vacuum in which it may be virtually impossible for the viewer to gauge the artist's original intentions. To point out affinities between two widely diverse cultural artefacts does not automatically generate meaningful information in regard to either, and to measure their degree of divergence *per se* does not mean very much either.

In the end there is the suspicion that ahistorical installations are elitist by stealth. They are meant for the initiated only, who already know all there is to know about a specific object's historical and stylistic context, all of which is rendered practically invisible by this particular mode of installation. Instead of providing the visitor with as many facts as possible, ahistorical curating is based on the assumption that the visitor is already fully aware of what is pertinent. For those not 'in the know' the result may be merely baffling. Ahistorical curating is in danger of obfuscating instead of informing. Rather than initiating new audiences to the museum, ahistorical curating may actually drive them away.

Although the concept may be centrally flawed, today it is often used for smaller displays of a less scholarly but more playful nature, as a way of putting certain works on display without having to unfold the full curatorial apparatus around them. At the Tate Gallery in London recently a series of small exhibitions, entitled 'Dangerous Liaisons' has been initiated, pairing two artists whose works are often historically far apart. The first of these juxtapositions, Fuseli and Bacon, followed by Gainsborough and Hockney, were disappointing, merely demonstrating that you cannot construe meaningful affinities where the connections are tenuous to begin with.

The validity of the ahistorical model is doubtful in many respects: for the layman its underlying strategies are hard to make out. However astute and insightful, it often remains in the realm of the purely subjective and speculative. As far as the museum's educational mandate is concerned, the ahistorical model hardly delivers at all.

It is therefore not surprising that it is the second, monographic model that has gained much wider currency, to the point where monographic installations are now the norm in most museums. Today it has become the preferred way of showing museums' collections, replacing previous curatorial concepts based on chronology, nationality, school, style or typology. In the process it has also influenced acquisition policies. Instead of acquiring single works by the widest possible range of artists, museums now often attempt to assemble extensive groups of works by a limited number of artists. The monographic model has also had an impact on what kind of exhibitions are seen:

monographic shows, an exception in the 1950s and 1960s, are now the most prevalent exhibition type.

Of course there had always been monographic blocks of works in museum collections. Wilhelm Bode's Kaiser Friedrich-Museum was anchored by large groups of paintings by Rembrandt, Rubens and Van Dyck, while the Museum of Modern Art in New York is to this day effectively arranged around the twin axes of Matisse and Picasso. Another example is the Kunstmuseum in Basel where the collection has always focused on large monographic holdings by, amongst others, Holbein, Cézanne (drawings), Picasso, Léger and Hodler. The core of the Kunstsammlung Nordrhein-Westfalen is its Klee collection and the Hessische Landesmuseum in Darmstadt is dominated by the Beuys block. The Tate Gallery collection of modern art since the early 1970s has had at its heart substantial holdings of works by Alberto Giacometti and Mark Rothko, and since then representative groups of paintings and sculptures by other artists have been built up. It is interesting to note – but not entirely surprising – that many of these groups in various museums originated with private collectors (La Roche, Thompson, Ludwig, Stroher, for example) because they were never affected or constrained by concepts of 'completeness', 'even-handedness' or 'balance'. Instead personal preferences could be indulged without apology, resulting in collections that are admired today precisely because of their audacious self-restriction. Artists have also preferred this model, and large groups of works were donated to museums by artists such as Henry Moore, Picasso, Rothko[150] and Still, to name only a few. Artists clearly understood that the monographic way of collecting is conceptually closest to the studio process, and that judiciously selected groups of works may give a deep insight into how ideas evolved over time.

In recent years the concept of monographic collecting and installing has dominated curatorial practice, particularly in museums dedicated to modern and contemporary art. Arguably the four most influential examples of the monographic collection, again all privately owned or financed, have been the Panza Collection in Varese, the Dia Centre for the Visual Art in New York, the Crex Collection in Schaffhausen and the Saatchi Collection in London.

150
Moore gave extensively to the Tate Gallery in London and the Art Gallery of Ontario; Picasso donated large groups of work to the Museu Picasso in Barcelona, the Musée Picasso in Antibes and the Musée d'Art Moderne in Paris.

Over the decades the Panza Collection has acquired nearly mythical status, with Giuseppe Panza di Biumo having followed monographic collecting principles long before the term was actually coined. Panza started his collection in the late 1950s with groups of works by Mark Rothko, Franz Kline and Robert Rauschenberg (most of which are today in the Museum of Contemporary Art in Los Angeles). If this was not already a historical achievement, a decade later he changed tack and rapidly put together one of the most comprehensive collections of minimalist and conceptual art in the world. Encompassing large, often site-specific installations, and representing individual artists with sometimes more than twenty works each, the Panza Collection set new standards for a collector's commitment to contemporary art. Although a generous lender to exhibitions, the collection has rarely been displayed in full, if only because it is too large. The 1988 showing of a relatively large selection of works, including substantial groups by Bruce Nauman, Dan Flavin, Donald Judd and Robert Morris, over two floors of the Reina Sofia Museum in Madrid was a particularly memorable occasion.[151]

Panza's example has inspired a number of collectors, the most prominent of whom may be the German industrialist Josef Froehlich, whose collection, limited to the work of eighteen German and American artists, has been on extended loan to the Tate Gallery in London since 1996.[152]

Another example that inspired Froehlich is the Crex Collection in Schaffhausen. Under the directorship of Urs Raussmüller it has concentrated its collecting activity on a small number of minimalist, conceptual and arte povera artists (Andre, Judd, Mangold, Merz, Nauman, Ryman, etc.). It has preserved the privileged air of an extensive private collection in which the work of art has taken centre stage and all other considerations are secondary. The generational and stylistic closeness of the artists included gives the collection exceptional cohesion. As if to reinforce this point the Crex Collection's building in its matter-of-fact starkness subtly echoes the kind of architecture the artists on display were the first to explore as studios, living spaces and showrooms. Semi-permanently installed on three floors of a former textile factory, the Crex Collection is close in spirit to Donald Judd's dicta about art and architecture. Its sensitive and

151
In 1989 the Solomon R. Guggenheim Foundation in New York acquired most of the collection.

152
Monique Beudert and Judith Severne, *The Froehlich Foundation: German and American Art from Beuys and Warhol* (London: Tate Gallery Publishing, 1996).

understanding display of contemporary art is much admired by artists and curators alike, and has been hugely influential.

The third example, the Dia Foundation in New York, was set up in 1975 by Heiner Friedrich and his future wife, Philippa de Menil, the daughter of John and Dominique de Menil, to help contemporary artists realise large-scale projects. Friedrich's and de Menil's generosity was legendary: Donald Judd's Marfa project was one of the first recipients of Dia's largesse, as were Walter de Maria's ambitious installations in New Mexico and Manhattan. Dia's funding also allowed it to purchase works of art on an unprecedented scale, including Warhol's complete *Shadows* series (1978), as well as large groups of works by Dan Flavin, Cy Twombly, John Chamberlain and installations by Joseph Beuys (the first American institution to do so). So large had Dia's ongoing commitments become that in 1984 they precipitated a major financial crisis. It resulted in the departure of Friedrich and de Menil and a subsequent reorganisation of Dia's activities. Dia turned from being a sugar daddy for artists towards more display- and exhibition-orientated activities. Many artists, suddenly set adrift financially, reacted with anger and frustration, and Donald Judd went as far as to file a lawsuit against the foundation.

Besides maintaining a number of permanent, site-specific installations, particularly Walter de Maria's *Lightning Field* (1977) as well as his *New York Earth Room* (1977) and *Broken Kilometer* (1979), Dia's activities today are focused on a programme of changing one-person exhibitions at its West 22nd Street headquarters which opened to the public in 1987. On view for approximately twelve months and installed in close consultation with the artists, Dia offers artists virtually ideal conditions under which to show their works, and many have responded by realising their most ambitious, site-specific installations. Dia's example has been an important antidote to the frantic pace of the New York art world, giving visitors a rare opportunity to revisit works and exhibitions over an extended period of time. Its pared down, slick, late modernist architecture has also influenced the way commercial galleries in Manhattan look, to the point where today most of them are virtual clones of the Dia spaces. Dia's architect, Richard Gluckman, has become the architect of choice for most commercial galleries.

The fourth example of an influential monographic model is the Saatchi Collection in London.

When the Saatchi Collection opened in 1984 it instantly set a new standard for the display of contemporary art. Located in a factory building converted by the minimalist architect Max Gordon, it provides 30,000 square feet of pristine, skylit exhibition space. The gallery's sparseness is enhanced by the fact that it is half-hidden: passing through the discreet, grey front gate, nothing prepares the visitor for the sheer expansiveness of the space inside. Works of art are displayed sparingly to great effect, and the large galleries often contain only a handful of works at a time. Exhibitions are either monographic[153], pairings[154] or groupings of no more than five or six artists[155].

Charles Saatchi (initially in collaboration with his first wife, Doris) collects in depth the artists in which he is interested. Often individual groups include up to twenty works, a kind of mini-survey of a particular artist's career. This in itself is not novel (it was Philip IV of Spain who could be described as the first monographic collector, before the term was coined: he assembled a group of no less than forty Titian paintings, besides large holdings of works by Rubens, Van Dyck, Velásquez and many others) but there is nobody else today who does it quite on Saatchi's scale. Had Saatchi not sold large parts of his collection over the years it would today stand as the most comprehensive record of art after 1960 anywhere in the world.[156]

Saatchi's example was widely noted and may indeed have inspired a number of museum curators to pursue monographic acquisition policies. The opening of Boundary Road in 1985[157] had wide implications for the London art scene. It showed the neglect public institutions had suffered for so long. Its ambition and uncluttered expansiveness stood in stark contrast to most other London institutions who at that point were beginning to suffer severely from the effects of the financial restrictions put in place by Margaret Thatcher's Conservative government. Boundary Road introduced a whole generation of art students to important work that was rarely seen in London in such depth. Saatchi's example to some degree gave the students a sense of what was possible and desirable. In this way Boundary Road influenced the emergence of a new generation of British artists at the end of

153
Duane Hanson, April to August 1997; Alex Katz, January to April 1998.

154
Anselm Kiefer and Richard Serra, September 1986 to July 1987; Robert Mangold and Bruce Nauman, April to October 1989; Fiona Rae and Gary Hume, January to April 1997.

155
The opening show was Donald Judd, Brice Marden, Cy Twombly and Andy Warhol, March to October 1985. For a full list of exhibitions at Boundary Road see: Jenny Blyth (ed), *The New Neurotic Realism*, [exhibition catalogue] (London: Saatchi Collection, 1998).

156
This selling may be an admission that comprehensive collecting is an impossibility. One could argue that Charles Saatchi's actions are just an updated and accelerated variant of what Barr initially envisaged for MoMA.

157
During the first year viewing was by appointment only but during its second year the collection opened to the general public on two days of the week.

the decade, of whom in turn Saatchi became the main patron in the 1990s.[158]

From being the exception, the monographic principle quickly became the norm. The Tate Gallery, in order to overcome space constraints, was the first museum that applied the concept on a grand, institutional scale. In 1989 it instigated an annual rehang along monographic lines. Initially, the result was a great success. Dedicating galleries to single artists, or groupings of two or three at most, and giving individual works breathing space had an extraordinary effect. It showed that the Tate Gallery's collection, despite widely held assumptions to the contrary, had immense breadth. At their best the rehangs have offered a succession of monographic displays of great clarity, underpinned, from room to room, by at least the vestiges of a chronological narrative. The rehangs worked particularly well when quite a large proportion of the Tate Gallery's indisputable masterpieces was on display.

Only now, after nearly ten years, a certain ennui has set in as it is becoming obvious that the areas of true strength in the collection have been exhausted. Instead of creating meaningful juxtapositions as at the outset, there is today sometimes a sense of reshuffle just for the sake of it. Recently some of the proposed connections appeared tenuous and far-fetched, bordering on the pure speculative-subjective that has dogged ahistorical curating. As time passes the juxtapositions have become occasionally quite obscure (if not whimsical) and it is increasingly hard to follow curatorial reasoning. At their worst they have presented a muddled succession of eccentric pairings which, rather than rescuing marginal figures from obscurity, left the visitor with the feeling that such obscurity was in fact well deserved.

The annual rehang of the entire collection is extremely demanding on curators and support staff. With the limits of the principle becoming obvious it could be argued that a more gradual approach might be more effective: instead of changing all displays simultaneously, certain galleries could be reinstalled from time to time, allowing for a higher proportion of the key pictures to remain in situ. It would also reduce the sense of semi-closure that permeates the Tate at the height of the annual rehangs, giving the museum a rather unkempt and chaotic feel.

8
ce: *Sensation: Young ritish Art from the Saatchi ollection* [exhibition talogue] (London: Royal cademy of Arts, 1997).

Yet on balance, and judging by the attendance figures, the rehangs have been an unquestionable success that has turned the Tate Gallery's space restrictions to an advantage.

The advantages of the rotating monographic principle are obvious. It allows an in-depth look at an artist's work and, at the same time, over a period allows for the display of a much larger proportion of the permanent collection. On the downside, the display can appear without thread or theme and the most common complaint is that specific works, which are central to the collection, are often not on view. The Tate Gallery has responded to this criticism (which affects tourists and out-of-town visitors who do not go to the museum at regular intervals) by making sure that a high proportion of key works is always on display. In any event, this will no longer be a problem once Bankside opens in 2000 and the Tate Gallery will effectively double its display area on the two sites.

The monographic principle seems to be best suited to the complex nature of today's audiences. It could be argued that it is no longer necessary to offer a basic introductory course in modern and contemporary art. Museum audiences have become extremely knowledgeable and sophisticated over the last decades. For a high proportion of audience members museum visits are no longer a once-in-a-decade experience: visitors return much more frequently. Their willingness to revisit is a further indication of the already mentioned temporalisation of the museum. If this leaves the first-time visitor with little or no prior knowledge at a disadvantage, the expanded educational facilities and related programmes make up for this shortcoming. Hampered by space constrictions and the physical impossibility of putting the entire story of modern art on display at one time, rotating monographic displays seem to be, for the time being at least, the most efficient model available.

9.
Bouvard and Pécuchet: Epilogue

During the dark ages of the museum in the 1950s and 1960s, it would have been impossible to predict on the available evidence that only two decades later a museum culture was to emerge, which repositioned the institution right at the centre of all cultural discourse, setting off an institutional renaissance that was to far surpass all past experiences and expectations, in terms of both numbers of new museums and attendance figures. In the process, art (and particularly contemporary art) has made the transition from being a marginal field of specialist interest to 'Modern Art in the Common Culture', to quote the title of Thomas Crow's recent book,[159] and the museum is the place on which this transition is focused. Twenty years ago there was not the slightest indication that something as momentous as this was about to happen. Today, museums again play a central role in Western culture, the way they used to for most of the nineteenth century.

This unpredictability may be a warning to those who wish to foretell the future of the museum. Art, like all cultural trends, evolves in strange ways. What seems chaotic and directionless tends with hindsight to appear logical and extremely focused, and what appears from one perspective outdated and of no interest, in a different light takes on new weight and significance.

This is not to say that it is impossible to make any predictions at all about the future. The present renaissance of the museum has already created its own set of problems of which those in charge are increasingly aware, and it is surely safe to say that these issues will dominate the agenda for the foreseeable future. As in the past, the museum's changing circumstances have simultaneously created their own critique as well as a backlash. The shape of the museum debate for the next decade or so is already emerging in outline.

Having embraced free market principles – or rather having been forced by politicians to do so – museums were set on a

159
Crow, op. cit.

course of unprecedented growth and expansion. Initial fears that larger audiences would mean a corresponding lowering of standards – a kind of museal dumbing down – have mercifully proved unfounded. There has been the odd slip-up, but it was usually punished with instant critical panning, thereby discouraging future repetition.

To their intense relief, museum officials have discovered that their audiences, instead of being passive and susceptible to curatorial spoon-feeding, are smart, knowledgeable, and demanding. The audience knows what it likes, is aware when it is being manipulated, and is quite willing to stay away when necessary. The boom of the last twenty years has resulted in a new kind of highly-informed visitor who understands what a delicate construct the museum is. Audiences have not only grown in numbers but have become, on the whole, much more sophisticated, not only able but eager to explore the cultural and interpretative strategies that define institutions. From the position of barely tolerated intruder, the visitor has progressed to being at the centre of the intellectual construct that is the museum.

In other respects the record is less encouraging. The museum has not escaped today's political correctness. It is the great curse and temptation of our age to approach all history with hindsight and to judge the past with our own standards and norms. In the harsh light of our hypersensitive times the past tends to become a terrible trail of omissions, wrongdoings, misdeeds, slights, ideologically motivated misrepresentations, thoughtlessness, wanton cruelty and outright lies. Yet the benefit of radical historical revisionism is questionable. It results in such great distortions that the emerging picture bears no resemblance to the reality it supposedly reflects, and there is indeed a real danger that too zealous an approach could in the end render any reading of history utterly meaningless.

It is now understood that the museum is not the neutral place it has so long been assumed to be. It is accepted that this insight does not automatically discredit the entire museum concept or disqualify any knowledge gained from its application. Instead, there is a new awareness of the museum's conceptual boundaries: by factoring in its systemic distortions and limitations, one is able to make allowances for their possible effect.

Self-analysis and -critique are today an integral part of museum practice, and should equally condition the visitor's approach. To passively expect an untainted and impartial representation would be naive, and the active, critical visitor is no longer the occasional exception but the norm:

> Reject impossible things [...] *Take into account the skills of forgers and the personal apologists and calumniators [...] Because one cannot say everything, there must be some choice. But in choosing documents a certain spirit will prevail, and as it varies according to the writer's condition, history will never be fixed.*[160]

In a way this new awareness of the nature of the museum and its limits promises more than ever before that the museum could indeed become, at least conceptually, a neutral space, not automatically so but as a result of complex calculations that allow for its conceptual limitations.

Flaubert's last and unfinished novel, *Bouvard and Pécuchet*, published posthumously in 1881, is about two copy-clerks who meet on a park bench in Paris. After an unexpected inheritance falls to one of them, they decide to give up work, move to the country and explore the world of ideas. In the process they take up the study of biology, agriculture, chemistry, physiology, anatomy, geology, archaeology, the list goes on and on. Whichever subject they turn to, the outcome is always the same. The more they know about a subject, the more contradictory the information appears. Theory and practice, learning and knowing, knowing and understanding seem to be irreconcilably at odds. Bored and frustrated they move on, but in the end not even religion offers respite. Flaubert's novel could be read as a parable on the irresolvable contradiction at the centre of the modernist and, by inclusion, the museum project.[161] The museum is an attempt to homogenise the heterogeneity of the world: to interpret, order, classify. Its allure is irresistible, so much so that the mechanism of classification can become more important than the classified object and, in a wider sense, the world it stands for.

The museum is a machine for producing meaning, a machine propelled solely by the belief that the museum has ordering propensities. Like a machine, its function depends on motion: ultimately, a motionless machine is meaningless. It is not the acquired knowledge but the perpetual acquiring of knowledge

)
aubert, op. cit., pp 123–4.

ouglas Crimp's
terpretation of the novel
clusively as a parable of
e museum seems to be
o narrow a reading and
t entirely born out by the
ctual evidence: Crimp,
. cit., pp 50–54.

that is the key to the museum's success. In the end, Bouvard and Pécuchet's frustration indicates nothing less than their loss of faith in the machine's ordering power.

In order to keep up the fiction that it can create meaning out of chaos, the museum has to come up with constant rereadings and reorderings of its material. This is why every object added requires a rearranging of the whole, and why mistakes strike such terror in the curator's heart: the slightest error or omission could render the whole meaningless. Errors and lacunae are the spanners in the museum's works:

> *To judge impartially they would have to read all the histories, all the memoirs, all the journals, and all the manuscript documents, for the slightest omission may cause an error which will lead to others ad infinitum.* [Bouvard and Pécuchet] *gave up.*[162]

And:

> *Let us hope that there will be no more discoveries, and the Institute even ought to draw up some sort of canon to prescribe what is to be believed.*[163]

In place of 'institute' read 'museum', its curators drafting and redrafting that canon, sometimes trying to stem the flow of new discoveries by keeping them, temporarily at least, out of the museum's halls and galleries. Flaubert's fragmentary novel is one of those rare prophetic books that have hardly dated at all, to the point where the directness and contemporariness of its message can be startling. Predating both Samuel Beckett and the Frankfurt School by nearly a century, Flaubert shares Beckett's deep scepticism – and sometimes his matter-of-fact language – about the human condition. Flaubert's realisation of the irresolvable contradiction at the centre of the modernist proposition (and the museum) was confirmed a century later by the philosophers of the Frankfurt School.

As it became over the last two or three decades increasingly impossible to deny the inherent contradictions of the museum project, they have been thematised within the institutional framework. The already noted shift from the static to the dynamic museum is the result of this realisation: by subjecting the institution to constant change and review, the issue of its normative power is side-stepped, no longer claimed but not quite fully surrendered either. Today's curator has not given up, as is

162
Flaubert, op. cit., p 121.

163
Flaubert, op. cit., p 123.

often alleged, he has merely moved the goalposts to make allowances for the increasingly obvious. Post-modernity, paired with an inevitable end-of-the-century need to chalk up and revise the record, has created a climate of unprecedented museal relativity. At the centre of all curatorial activity now stands a desire to continuously reshuffle and rethink the history of modernism, if not all art history. Revisionism, more than anything else, is the name of today's curatorial game.

If the museum can no longer be all-inclusive, then it should at least have the potential to be so, and temporisation is the most successful strategy yet to achieve this goal. Although temporisation is a relatively recent development, with hindsight it is possible to look back through the institution's history and chart various related strategies to preserve the museum's universality: exclusion, specialisation and Malraux's *musée imaginaire* are only three inevitable steps towards temporisation.

From the outset, and all through the nineteenth century, the curator's ambition was to make his displays as complete as possible, but 'completeness' was achieved by the deceit of declaring whole areas outside the museum's brief. Intermittently during the nineteenth century all-inclusiveness seemed to be a real possibility but the exponential growth of knowledge and collections made it increasingly unattainable, yet the idea retained its appeal. It was taken up by Bode in Berlin at the beginning of the century, by Barr in mid-century and again at the Centre Pompidou in the 1970s and during the early 1980s.

Malraux formulated the concept as his 'museum without walls' from the 1950s onwards in many of his writings.[164] For Malraux the solution was on the one hand a reliance on photography and on the other hand the issue of 'style'. Photography would render everything the same and make it comparable. Arguably even more important than photography was the concept of 'style' as the great unifier (the German term *Kunstwollen*, the will to make art, may cover Malraux's meaning even more precisely). 'Style' was something shared by every object he introduced into his *musée imaginaire*. 'Style' was the great equaliser that united the most diverse cultural products. The question as to what the knowledge that everything shares 'style' meant, Malraux ominously left unanswered.

4
ndré Malraux, *Museum Without Walls* (London: ecker & Warburg, 1967). lso: André Malraux, *icasso's Mask* (New York: a Capo Press, 1994).

Another important question was avoided just as conspicuously by Malraux: by introducing everything, every work of art, into his imaginary museum without walls, what was actually gained? If the modern museum – born, after all, at the same time as Diderot's *dictionnaire* and sharing certain traits with it – was an attempt to order the world, to instil reassuring homogeneity and order where heterogeneity and chaos ruled, what would happen if one suddenly admitted all objects under the guise of 'style'? The museum's reliance on classification, chronology and single-strand narrative attest to its purpose to overcome, at least temporarily or theoretically, the disorder that is the world. By admitting everything, Malraux does nothing less than conceptually short-circuit the museum: he replicates the chaos of the world within the museum. His museum no longer establishes order but merely mirrors the chaos it is supposedly clarifying.

Malraux's dream, always in the realm of the speculative, has turned into the post-modern nightmare. It seems that the museum has become the predominant mode of looking at the world, an observation born out by the amazing proliferation of new museums everywhere. Today, any subject and any historical period can become the subject of a museum. Museological perspective is the post-modern equivalent of Malraux's fundamentally modernist insistence on style. And as Malraux's *idée fixe* of the all-embracing universal museum is at its most persuasive in theory, so the concept of a museum culture works best as a model. Once put into practice both ideas deliver ever diminishing returns. The more museums there are, and the larger individual institutions become, the less they seem to be able to convey an idea of what the world is. The more the concept is implemented the more tautological – and useless – the result becomes: taken to its logical conclusion, the world becomes the museum, at which point one would have to come up with a new idea of how to grasp this museum world.

It is not just the growing number of museums that attests to this dilemma but also the spirit and nature of individual institutions. Growth in this context is not merely a function of the consumer society of which the museum is a part or a reflection of a political agenda that has been forced onto the museum, but indicates a wider, underlying cultural dilemma.[165] Post-modernism

165
On the connection between the growth of museums and the mechanisms of consumer culture see: Russel W. Belk, *Collecting in a Consumer Society* (London: Routledge, 1995), particularly chapter 4 on institutional collecting.

has done away with modernist systems of structure, hierarchy and classification. The post-modern goal – and the curator's dearest desire – is to establish a new hierarchy that is both hierarchical and non-hierarchical at the same time. Once this dilemma has been resolved, post-modernism will cease. As to what will take its place – and how the museum of the future will look – one cannot say.

As far as temporalisation is concerned, it is only the latest and, for the time being, the most radical strategy to preserve the museum's power. It was preceded by other strategies each of which worked for at least some time. No doubt temporalisation will ultimately share their fate and will be supplanted by other, more advanced organisational models.

Besides these pressing theoretical questions there are other, equally important practical issues which concern curators.

It seems that many museums are reaching a natural plateau as far as their attendance figures are concerned. As much as large audiences are desirable – they attest to the democratic spirit of the museum and are irrefutable arguments for funding – how to accommodate ever-growing numbers of visitors is a question that is worrying curators more and more.

Is it possible to bridge the gap between people's desire to see certain works of art and the physical limitations inherent in those very objects? In this respect the Johannes Vermeer exhibition at the National Gallery of Art in Washington DC and at the Mauritshuis in The Hague is a particularly illuminating example.[166] The show included only twenty-three paintings, two thirds of Vermeer's known oeuvre, the majority of which were tiny in format. Unless one was privileged enough to gain after-hours access to the exhibition,[187] it was virtually impossible to spend more than a few seconds in front of each picture, hemmed in and pushed from all sides by other visitors jostling for space. This was not an exceptional occurrence but is today the rule with most popular exhibitions. Is the visitor being short-changed? What kind of experience is the museum advocating and is it really worth the risk it subjects works of art to? However carefully packed and handled, each journey causes a further, minute deterioration of the objects in question, a process rather euphemistically described by restorers as 'erosion'. As more and more exhibi-

36
'Johannes Vermeer', National Gallery of Art, Washington DC (November 2, 1995, to February 11, 1996) and Royal Cabinet of Paintings, Mauritshuis, The Hague (March 1 to June 2, 1996).

37
After-hours attendance was often nearly as heavy as during official opening times.

tions are organised and works of art are taken to more and more destinations, the cumulative effect of this slow deterioration process, although virtually immeasurable on individual occasions, will become apparent in the end. If at each destination nothing more than a been-there-seen-it-worn-the-T-shirt experience takes place, a kind of museum train-spotting, is it really justifiable to move fragile works of art in the full knowledge that this might jeopardise their long-term survival? How can a satisfactory balance be reached between the audience's legitimate desires and the obligations of the custodians?

As to how artworks can be displayed, there are obvious limitations imposed by their physical scale, but could not new modes of display be developed which makes the experience of looking both more pleasurable and meaningful for the audience? How can one accommodate the many without turning the experience into an undignified scrum?

Some of the large museums have grasped the nettle and instead of expanding further have set on a course of consolidation, attempting a balance between displays, building capacities and visitor numbers.

If the answer to all these questions is indeed that the museum is a resource of a limited kind, how does one decide who is let in and when, and on whose authority and invitation, without the place turning into an elite facility? The notion of limited access runs against precedent and curatorial instinct.

The issues of audience growth and funding are intimately linked and maybe one can only be resolved by carefully considering the other.

The present funding model is based on expansion: growing collections, endowments, public and private funding, attendance figures and new buildings have become the *sine qua non* of museum activity. Private and public funding is justified exclusively in terms of growth, and although this is a relatively recent concept, it is virtually impossible for curators to argue their case along any other lines.

The inherent dangers of this are obvious: instead of creating a financial equilibrium within which an institution can operate, the growth model creates ever expanding monetary needs. The Guggenheim Museum is the most extreme example of this, but

to a degree all museums are affected by the dilemma. This results in institutions that are increasingly becoming preoccupied with administration, fundraising and expansion at the cost of all else, leaving less room for curatorial and scholarly activities. With attention so diverted, there is a real danger that curators might lose touch with progress in their own disciplines, artistic developments or more general aesthetic shifts, resulting in monolithic museums that have lost their ability to reflect such trends with reasonable speed and precision.

At its root this is more a political than an institutional issue. To resolve the conflict a fundamental political change of attitude would be required. If political thinking about the museum was shifted away from the concept of the institution as part of the leisure industry back to its old educational-scientific definition, change would follow very quickly. It is ironic that it is museums, of all places, that are still run according to hard line neo-conservative principles, long tempered in most other areas of policy.

How does new information technology affect the museum?

Rash predictions that the internet would make the museum obsolete have not been borne out. The integration of information technology into museum displays has so far been limited to non-art museums. Interactive displays, for example, are largely a domain of science museums, and where information technology has reached art museums it is hardly ever deployed in the galleries but mostly in specially designated areas away from displays.

The advances of printing and electronic technology have at least partially freed the museum from one of its more mundane tasks. It is conceivable that in future visitors will read up on museum objects beforehand and that visits may become more of a purely aesthetic exercise. As to the diversity of museum visitors, advanced information technologies will allow museums to meet myriad demands more easily by enabling them to finely calibrate information according to specific needs. Rather than having to make do with one wall-panel and running the risk of being either patronisingly over-simplistic or talking right over visitors' heads, it is now feasible to provide a whole range of graded options. This gives the visitor a chance to select the information level he feels most comfortable with, from the most straightforward to an in-depth analysis of the subject at hand.

It seems that information technology has not sidelined the museum but has, in fact, further increased the public's interest. Rather than being content with looking at the 'virtual Louvre', for example, the internet might actually increase the desire to visit the real thing.

May it not be that we have a natural affinity for the three-dimensional object because it mirrors our own physicality? If this is the case, information technology will make the museum even more of a popular destination. As more and more aspects of our lives become virtual, our fetishist fixation on the museal object may grow in accordance.

The new museology that has evolved over the last two decades has widened the horizon of the museum immensely. It has brought in new audiences and new models of display. It has changed the outlook and attitude of curators. As a result the museum has become the centre of a lively and vital discourse in which more and more people wish to participate.

One of the dangers curators are now faced with is complacency in the light of these remarkable achievements. Self-critique can easily slip into navel-gazing, and new conventions, when applied mechanically and unthinkingly, are as stifling and leaden as their historic precursors. With the museum's success seeming so guaranteed, it could be tempting to apply the present curatorial models dogmatically, without giving true consideration to particular circumstances. The result would inevitably be a new fall from grace, this time a failure born from excess.

It is impossible to predict the long-term future of the museum, but looking back at its history, it is worth observing that the museum has proven – despite appearances to the contrary – extremely flexible and adaptable to changing conditions. At the core it remains the place where the encounter between works of art and audiences is facilitated, and this encounter seems to become increasingly important for more and more people.

If anything can be learnt from the museum's history it is the fact that it is no good to make the present an unbending rule or measure for the future. It would only mean replacing the dogmas of the past with the dogmas of the present. We have to allow museums institutional flexibility, and not forestall future devel-

opments by making irreversible decisions today – or by declaring the present state of affairs 'the best' and trying to preserve it at all costs. We have to remain as open-minded as possible towards new developments, even if it means that we may have to surrender cherished myths in the process.

Whatever the future holds, the museum remains an exceptionally adaptable cultural construct, both deeply vulnerable to outside interference yet of awesome robustness at the same time. It is the perennially open university, combining pleasure and learning unlike any other institution in modern society. The museum's openness and flexibility, its broad appeal and versatility, its transparency and ultimate incorruptibility make it one of democratic society's greatest assets. It is an institution and a principle worth defending at all costs, if only in order to facilitate change of a magnitude we may not even dream of today.

The best thing about museums may be that they are forever changing.

<div align="center">August 1998 – March 1999</div>

III

1.
Democracy of Spectacle:
The Museum Revisited

The present order is the disorder of the future.
Saint-Just [168]

There is nothing more easily destroyed than the equilibrium
of the fairest places.
Marguerite Yourcenar [169]

Since *The Curator's Egg* was first published nine years ago much
has changed in the museum world. While the historical facts
remain the same, the current trends and debates that I set out
and the conclusions I drew at that time require elaboration, cor-
rection and update. As always, when trying to predict the future
one can only extrapolate from the present. Yet reality moves in
strange and unpredictable ways, as is the case here. The cultural
landscape has altered greatly since the turn of the millennium.
What then seemed vague trends are now established truths. The
public and professional debate about museums, already shrill
a decade ago, has since become even more aggressive, partisan
and often self-serving and dogmatic. It would be no exaggera-
tion to describe it as a battle for the life and soul of the muse-
um. The battle lines are drawn between, on the one hand, those
who align themselves with the new museums as a great success
story, over-run with visitors, the latest entrant in the 'cultural-
industry' league, and, on the other, the keepers of the flame, the
defenders of an old museum ethos, invoking primarily scholar-
ly and educational goals. At one point, it seemed, this conflict
could be sketched out by comparing Tate Modern in London on
one side of the Atlantic and the Museum of Modern Art in New
York on the other. This was a seductive pairing and made for
noisy discussion because it allowed each side to denounce the
other as destructive and vulgar or elitist and out-of-touch. The
ready-made simplicity of this black-and-white argument has

rman Hampson,
nt-Just (Oxford: Basil
ckwell Ltd, 1991).

rgaret Yourcenar,
moirs Of Hadrian
* Reflections of the
nposition of Memoirs
ladrian (London:
guin, 1986), p 288.

been irresistible for many authors and critics. Yet, like all simplistic readings, it does not reflect reality and has obscured the complexities of the issues at stake. In the end, this is not a conflict between the keepers of the flame and the new barbarians. It is about what kind of role the visual arts are to play in our culture and, by extension, what role culture is to play in our society. It is nothing less than a debate about one of the fundamentals of democracy.

The notion that museums should somehow pay for themselves (either by charging visitors or by way of private and corporate sponsorship) has long been commonplace in the United States. This was, in part, a logical extension of the concept of private individuals taking responsibility, a characteristic of the North American museum landscape from its inception. The idea is relatively novel as far as European institutions are concerned. It was first propagated in the United Kingdom, without subtlety and to dreadful effect, under the Thatcher government in the 1980s. Elsewhere in Europe, though this shift seems increasingly inevitable, it is still met with widespread professional and political resistance. If, initially, this change seemed to entail no more than a switch of paymaster (from public to private), it has since become obvious that it has had profound effects on the outlook and ethos of museums. It is generally agreed that a historic tipping point has been reached,[170] though not all would concur with the art critic David Carrier's recent claim that we are seeing 'the end of the modern public art museum'.[171]

In the past, the concept of the museum arose from the principle of making an elite culture available to all, in order to educate to the highest possible standard and provide the greatest enjoyment. This model of the museum emerged from much the same Enlightenment mould as notions of democracy and education. The idea of the museum as egalitarian enabler has never lost its allure; and elitism for all, a notion of glorious and radical ambition, simultaneously naïve and highly potent, steered the museum for the better part of 200 years. By and large, the balance between utopian dream and everyday reality held remarkably well.

Today, it seems that curators have lost faith in the democratising power of the institution and that these revolutionary ideas no longer hold any appeal. Museums have forgotten their revolutionary origins and their extraordinary history. In the new

170
The most spirited recent defence of the museum is contained in a series of lectures given by, among others, Philippe de Montebello, Glenn D. Lowry and Neil MacGregor, reprinted in James Cuno (ed), *Whose Muse? Art Museums and Public Trust* (Princeton and Oxford: Princeton University Press, 2004).

171
See: David Carrier, *Museum Skepticism. A History of the Display of Art in Public Galleries* (Durham and London: Duke University Press, 2006), pp 181–207.

museum, the individual visitor is no longer considered, and no credence is given to the idea of elite culture being offered to all. The new museum has no time for such delicate complexities. In its fixation on numbers (box office or, to use the language of retail, 'footfall'), together with its fear of either underestimating or overestimating the audience's capacity to understand, the new museum has sidelined its old utopian ideals, which are now deemed to be pitfalls. In the process, art for all has given way to the 'democracy of spectacle': an ambition to be attractive to the greatest number of people at all costs. This has become the new museum's blanket justification and its strongest defence.

If mass appeal is the best defence apologists for the new museum can muster, it is also the crudest. It is crude because it can be used to parry any sort of criticism, above all the dreaded charge of elitism. It deliberately muddles the issues (above all, the distinction between elite culture for all and culture for an elite) and closes off any discourse about the nature of the fundamental changes that the new museum proposes. As for the mass appeal of the new museum, it is a questionable argument for its validity. As the philosopher Theodor Adorno has observed, 'the culture industry piously claims to be guided by its customers and to supply them what they ask for [...] The culture industry not so much adapts to the reactions of its customers as it counterfeits them.'[172] Adorno was referring primarily to the film industry, but his observation also holds true for the new museum. By turning itself into another branch of the culture industry, the new museum has not just suspended its old guiding principles but has, as we shall see, turned them upside down. It has, in the process, let go of its historical roots and its intellectual purpose. Shifting the emphasis from education to entertainment, it has changed the ground rules – only without, alas, alerting its visitors. By this sleight of hand, the old museum's politicised citizen and visitor has become the new museum's passive consumer, simultaneously manipulated, disempowered and infantilised.

Rosalind Krauss was the first to observe this new trend in her celebrated essay 'The Logic of the Late Capitalist Museum' (1990). She spelled out its consequences presciently: the new museum would 'forgo history in the name of a kind of intensity of experience, an aesthetic that is not so much temporal (historical) as it is

orno, Theodor. *Minima ralia: Reflections on a maged Life,* (London and w York: Verso, 2006) ɔo.

now radically spatial'.[173] This goal would be achieved by reversing all the guiding and defining principles of the old museum. Quantity would supersede quality. Diffusion would displace concentration. Chronology would be replaced by revival, memory by amnesia, authenticity by copy, order by chaos. Instead of focus there would be distraction and history would be sacrificed for novelty. In lieu of preservation there would be disposal, and sensation and spectacle would take the place of contemplation and experience.

For Krauss, the artistic model for this shift was Minimalism or, more precisely, the 'articulated spatial presence specific to Minimalism'.[174] Viewing an exhibition of works from the Panza Collection at the Musée d'Art moderne de la Ville de Paris in 1983, Krauss observed that, more than the art on display,

> it is the museum that emerges as [a] powerful presence and yet as properly empty, the museum as a space from which the collection has withdrawn. For indeed the effect of this experience is to render it impossible to look at the paintings hanging in those few galleries still displaying the permanent collection. Compared to the scale of Minimalist works, the earlier paintings and sculpture look impossibly tiny and inconsequential, like postcards, and the gallery's take on a fussy, crowded, culturally irrelevant look, like so many curio shops.[175]

The implication of Minimalism here has since become something of a critical cliché and I will discuss the validity and limits of this line of argument later. For Krauss, the new museum had substituted the erstwhile experience of the viewer, *contemplative and framed by personal knowledge*: 'In place of the older emotions there is now an experience that must properly be termed an "intensity" – a free-floating and impersonal feeling dominated by a peculiar euphoria.'[176] In other words, the museum offers an experience akin to a visit to a department store. Krauss had no doubts about the ultimate outcome of this gradual shift. In her view, the 'industrialised museum will have much more in common with other industrialised areas of leisure – Disneyland, say – than it will with the older, pre-industrial museum. Thus it will be dealing with mass markets, rather than art markets, and with simulacra experience rather than aesthetic immediacy.'[177]

173
Rosalind Krauss, 'The Logic of the Late Capital Museum', in: Claire J Farago and Donald Preziosi (eds), *Grasping the World: The Idea of The Museum* (Aldershot: Ashgate, 2004) p 604.

174
Krauss, op.cit., p 601.

175
Krauss, op.cit., p 602.

176
Krauss, op.cit., p 610.

177
Krauss, op.cit., pp 611–6

178
That this should occur at a time, post-1989, when the capitalist free market model became ubiquitous is no coincidence.

...expectedly, given
historic policy of
engagement from
...balisation, France has
...erged in the vanguard
...European countries
...plementing the 'Krens
...ctrine'. Both the Louvre
...d the Centre Pompidou
... due shortly to open
...tennes within France
...d both institutions have
...ently engaged in plans to
...erate Guggenheim-style
...nchises abroad. Thus
..., the Pompidou's hopes
...gaining a foothold in
...a have suffered several
...backs, though
...gotiations to open a
...ellite museum in
...anghai are ongoing.
...2005 the Louvre entered
...hree-year collaboration
...h the High Museum
...Art, Atlanta, lending
...museum (in which the
...uvre now occupies its
...n wing) some of its most
...zed treasures in return
...a fee of Euro 13 million.
...d in 2007 the French
...vernment signed a
...ntract with the United
...ab Emirates whereby, for
...s totaling over 1 billion,
...Louvre's name, its
...ators' expertise and
...rks from its collection
...d those of other French
...seums will be loaned
...museum to be built in
...oil-rich emirate of Abu
...abi, as the centrepiece
...ongside, inevitably,
...roposed Guggenheim
...seum) of a major tourist
...velopment on Saadiyat
...nd. The scheme has
...n attacked by many
...ior figures in the French
...seum world; see:
...itorial, 'A Desert Folly',
...e Burlington Magazine,
...y 2007, p 295.

When Krauss wrote her essay the trends she described were only beginning to emerge and, to many observers at the time, her conclusions seemed unduly alarmist and wildly exaggerated. In fact, reality far surpassed even her darkest predictions. The concept of the late capitalist museum has since been implemented step by step, with astonishing rapidity and against little critical resistance, suggesting it was the only outcome historically possible.[178] To begin with, this trend was contained largely within the Guggenheim Museum in New York and its various international satellite projects. Thomas Krens, the Guggenheim's director from 1988 to 2008, became the poster boy of the new museum, its most outspoken defender and ardent practitioner. Before long his model gained wide currency. Today, many museums all over the world are run, if not in name at least in spirit, according to what might be termed the 'Krens doctrine'.

That the new museum should seek its salvation in commerce highlights an historical paradox, for the idea of the museum as a non-commercial sphere was programmatic from its inception. For the founders of most nineteenth century museums in the English-speaking world, they were the anti-realm of their own commercial activities, a place where money could transmutate into something higher. The museum's unprecedented authority in cultural matters was the result of this particular division. In complete reversal of this reality, the 'Krens doctrine' is an attempt to square the circle, to turn the museum into a cultural industry without surrendering its authority and to commercialise it without jeopardising its special status. Although several of Krens's most ambitious projects have failed to materialise – proposals for Guggenheim franchises in Taiwan, Rio de Janeiro and Mexico have all been shelved – his doctrine has nonetheless become a powerful dogma, embraced, to varying degrees, by museums the world over.[179] Like all powerful dogmas, it is rarely questioned and never fully explained. For a whole generation of museum directors and curators, it has become the sole guarantor of institutional survival and legitimacy. While some adherents go so far as to say that museums are nothing but specialist businesses active in the field of high culture, others talk more delicately about the need to run their institutions in a business-like fashion.

There is no denying that, for a while, this new approach brought spectacular results: museums were the great cultural success story of the late twentieth century. New ones opened seemingly every month; old ones were expanded or reconfigured. Audiences grew, collections were built, and major exhibitions circulated to an ever widening range of venues. Museums became the new civic status symbols, much as theatres and opera houses had been in the immediate post-War period.

But this approach has not proved the panacea its promoters imagined. What seemed at first an effective medicine has begun to reveal some troubling side effects. These can best be summarised as the creation of moral and ethical ambiguities that had hitherto been absent from the museum sphere. The inherent contradiction at the centre of the 'Krens doctrine', the conflict between corporate ambition and cultural status, has not yet been resolved. Increasingly, it seems that it never will be. The majority of museum officials (directors, curators, trustees) remain in denial, but the chorus of discontent grows ever louder.[180]

It is a hallmark of late capitalism that capital and power have been rendered strangely invisible – that is to say, their presence is undeniable, but their source is obscured and their directional flow hard to chart. A corporation wields power, yet how it is constituted and from where it emanates is difficult to pinpoint. The same holds true of the museum in its new cultural-industry incarnation. A myriad group of contributors make up the institution's power. From within, there are the director, chief executive, trustees, curators and those responsible for marketing and public relations. From outside, architects, artists, consultants and guest curators are called upon to reinforce the institutional message. From time to time, politicians and sponsors choose to interfere. This no longer amounts to a classic power pyramid; and it would be futile to attempt to describe or analyse the institutional structure as such. How decisions are arrived at and how they are finally implemented – the what, why, where and when of this process – have all been rendered opaque and, as a result, the new museum, like its corporate model, has become strangely unaccountable for its actions. Within an institution, contributors to this intricate web of power and influence hide behind one another. Decisions are described as 'collective', even when they are not.

180
See: Cuno (ed), op. cit.

When things go awry, blame for 'bad' decisions is instinctively placed with others, preferably outside the institution: mimicking corporations, the new museum likes to cite market forces, political circumstances and changing times (shifting markets, global trends, competition) as the trigger for its actions, in the process giving them an almost Biblical inevitability that is safely beyond review or criticism.

Ultimately, it is irrelevant how decisions are arrived at or who drives and implements them. For the sake of the present argument, it is sufficient to look at the results. What has the late-capitalist museum, post-Krauss and post-Krens, become? What are its hallmarks? What are its particular qualities and weaknesses? I will focus my analysis on the three areas where almost all museum activity is now concentrated: architecture, permanent collections and temporary exhibitions and displays. How have the politics and demands of the new museum affected architecture, collecting policies and exhibition-making? How has the desire to attract large audiences impinged on these core areas? How has the escalating need for non-public income (sponsorship and box office) shaped museum agendas? What are the positive and the negative results of the paradigmatic shift set in motion over the last two decades? What bearing have these changes had on the museum's standing in the wider cultural and political context? And how will all this determine our future understanding of and attitude to museums?

Architecture

Architecture and location have always been the visible calling cards of the museum. They are a public statement of its cultural ambition. A prominent geographical location marks the museum's exalted civic status, its central place in the fabric of a city in particular and of a nation in general. By locating the national museum in the former royal palace, the French revolutionaries in 1792 set a precedent that has been followed ever since: the choice of place signified both the exceptional status and the centrality of the new institution in national discourse. If the choice of location remained important, so did the choice of architectural

language. The exterior of the building prepared the visitor for what to expect inside. Architecture left no doubt about what the museum was about, articulating the cultural hierarchy upheld within. Consequently, variations on classical models remained a hallmark of museum architecture well into the twentieth century. Even high-modernist buildings, such as Mies van der Rohe's Neue Nationalgalerie in Berlin (1965–1968), were loaded with classical references. This remained the rule, more-or-less, for nearly two centuries.

However, something strange seems to have happened to museum architecture over the last two decades: buildings have become autonomous, by severing the link, first, between exterior and interior and, secondly and even more problematically, between interior and content. It is tempting to place Frank Gehry's Guggenheim Museum in Bilbao (1993–1997) at the beginning of this trajectory; but, with hindsight, the Neue Pinakothek in Munich (1977–1981) and James Stirling's Staatsgalerie in Stuttgart (1981–1984) are the true precursors, their conceptual radicalism masked by nineteenth century references (to Schinkel's 1825–1828 Alte Museum in Berlin in particular). In this respect, Stirling's well-known quip at the opening of the Staatsgalerie that it would have looked better without art, was prescient. Since then, architects have increasingly taken liberties and created buildings that pay less and less attention to the requirements of art and artists. Gradually, museum architecture has emancipated itself from its function. If, in Bilbao, Gehry made at least half-hearted concessions to the needs of the museum and shoe-horned, albeit uncomfortably, relatively conventional galleries into the folds of his baroque exterior, more recent architects seem to be no longer willing to make even such basic allowances. Daniel Liebeskind's Jewish Museum in Berlin (1997–1999) is a building that has been much complimented for its eloquent symbolism, but this held true only as long as the museum remained empty. Once the curators installed their exhibits, the interiors became a claustrophobic, cluttered mess: content and envelope were aggressively at odds.[181]

The result is not always as disastrous, and in the majority of cases the mismatch is merely irritating. At Tate Modern (1996–2000), Herzog and de Meuron's curious lack of willingness to consider the

[181]
The same happened more recently in San Francisco at the new De Young Museum (by Herzog and de Meuron, opened 2005).

basic requirements of the museum continues to interfere with the art on display. Their insistence on installing fluorescent lighting has been one of the most frequently discussed faults of the building, as has their insistence (against all professional advice) of laying raw oak flooring that was to acquire a patina through use over time. The result is an interior that looks forever gloomy and grubby. Another example of this disregard for function is Tadao Ando's Fort Worth Art Museum (1999–2002), a building so severely modernist that works of art within it merely play a supporting role. In the opening displays, a Warhol self-portrait at the top of the main staircase appeared like ornamentation – a detail – the sole purpose of which, it seemed, was to throw the architecture into higher relief. More recently, Zaha Hadid's Museum of Contemporary Art in Rome (begun in 2005) is a building that seems to have been commissioned with no other brief in mind than the creation of a landmark, a museum without collection, exhibition programme or declared purpose.[182] The exterior has finally taken over at the expense of all else. If anything, this trend has accelerated over recent years: a recent traveling exhibition 'Museums in the 21st Century: Concepts, Projects, Buildings' documented about two dozen current projects (including Hadid's Rome museum), every one of unprecedented theatricality, as if an entire generation of architects was suddenly inspired solely by German Expressionist cinema.[183] Centrifugal, exploding, expanding, dynamic, throbbing, pulsating, pivoting, sculptural, operatic, delirious, high-octane, futuristic, narcissistic – this is only a small catalogue of the adjectives useful in describing the latest crop of museum projects. These are buildings in which art plays a secondary part and, at the most extreme, is done away with altogether. For example, in the Museum of the Hellenic Word in Asia Minor, in Athens (currently under construction), Anamorphosis Architects 'translate the context to be depicted – the history of Hellenistic Asia Minor, from beginnings to the present day – into spatial experience, or, as they themselves call it, a three-dimensional monument'.[184] Their 'anti-object concept of exhibitions is, in the first place, *a criticism of the collecting and purchasing activities of museums* [...] Secondly it is a criticism of architecture that mutates into an advertising medium.'[185] A new generation of architects, it seems, has appropriated Krauss's critique and adopted it as their credo.

182
The result will no doubt replicate what happened in Barcelona with Richard Meier's Museum of Contemporary Art, a museum forever in search of an identity and mission.

183
See: Suzabbe Greub and Thierry Greub, *Museums in the 21st Century: Concepts, Projects, Buildings* [exhibition catalogue] (Munich, Berlin, London and New York: Prestel, 2006) pp 138–139.

184
Greub and Greub (eds), *op.cit.*, p 138.

185
Greub and Greub (eds), *op.cit.*, p 138.

By and large, architects' accelerating claims to autonomy as far as the function of museums is concerned have gone unchallenged. One reason is, perhaps, that a museum's quest for funding is made much easier by presenting funders (public or private) with an emblematic landmark building. In this equation, conventional functionality is of little concern.

As for the dozen or so books on recent museum architecture, they too note the divergence between form and function only in passing. They are, without exception, authored by architectural historians or architecture critics and thus written from the architect's perspective. They comment on the emancipation of museum architecture from function but do not take issue with it. It is also noticeable that the majority of illustrations in these publications show buildings empty, devoid of art or visitors. To my knowledge, no museum director or curator has gone on record to criticise this disturbing development in museum architecture, recalling the fraught relationship between architect and client satirised by Tom Wolfe in *From Bauhaus to our House*.[186] Instead, curators muddle through at great cost and effort with buildings barely suitable for the function they were supposedly designed to accommodate.

The choice of architectural language, or the disconnection of form and function, is not the only problem; it is also the scale of many museums that brings buildings into conflict with the art on display. The most notorious example is the Turbine Hall at Tate Modern, a space that, as a matter of course, dwarfs any work of art shown within it, presenting artists with a challenge that they have rarely met successfully. The same holds true for the huge central atrium and the enormous gallery devoted to contemporary art in Yoshio Taniguchi's new Museum of Modern Art in New York (1995–2003) or the oversize special exhibition hall at the Guggenheim Museum in Bilbao.[187] The gigantic museum not only makes the art on display look unimportant, as Krauss observed, but it also leaves the visitor dissatisfied, lost in a labyrinth and unable to take it all in. (It is no coincidence that small, intimate museums remain so loved by the public).

As yet, no lessons have been learned from all of this. Tate Modern's proposed glass ziggurat South Tower (also by Herzog and de Meuron) seems to combine the worst of these twin

186
London: Jonathan Cape, 1982.

187
This was a battle in which the Guggenheim's curators finally conceded defeat. The hall is now filled with a large group of sculptures by Richard Serra, on display for an initial term of twenty-five years.

trends, excessive theatricality and gargantuan scale.[188] It is yet another stark example of the architectural narcissism now prevalent, another massive site-specific sculpture that will dominate and interfere with the scale of an existing building and dwarf both art and visitor.

It may appear some form of poetic justice that this new type of museum architecture as spectacle rises and falls by the same principle – the rule of its own inflationary aesthetic: one Guggenheim Bilbao may be exhilarating, a succession of clones is boring. As hyper-expressionist buildings have become the norm, they no longer register as exceptional landmarks but merely as predictable signifiers of a museum. Their originality has quickly turned banal. Their dysfunctional theatricality has become a debased currency, no longer able to sustain interest for long. The architecture is literally consumed by the onlooker, to be discarded as casually as last season's fashion accessory or the latest must-have technological gizmo. That, a mere six years after opening, Tate Modern felt it necessary to commission a landmark addition, gives a measure of this acceleration.

Financial circumstances permitting, it is easy to conceive of a future where museum buildings might be erected as temporary pavilions, ongoing displays of avant-garde architecture, raised up and torn down without much ado, with all institutional energy and care forever focused on the skin. That many of the new buildings seem to be conservation time-bombs may only reinforce such a trend: so technologically advanced and complex has contemporary architecture become, that long-term maintenance may no longer be a feasible option.

Exhibiting

If the democracy of spectacle favours an architecture that is theatrical and that turns the museum into a *locus per se*, a venue that is visited and experienced for its own sake, the way in which works are exhibited and the choice of what is displayed follows a similar logic.

Up until the late 1970s, while the permanent collection retained centre stage, temporary exhibitions were a comparatively

188
Since writing the plans have been heavily revised, the building is now brick clad.

rare occurrence in museums. This hierarchy has not only been gradually reversed, but has almost entirely dissolved: while temporary exhibitions have become the lifeblood of museums, permanent displays have become temporary, endlessly changing and evolving. It should follow that a much wider range of exhibits is shown, a broader canon is explored and a greater proportion of the museum's holdings is put on display, even if only in rotation. Yet oddly, this temporalisation of the museum has created the opposite effect: although the number of museums (and other exhibition venues) has grown exponentially, the canon of what is on view (both in temporary exhibitions or semi-permanent displays) has stagnated, if not actually shrunk. The need for box-office success has ensured this. It has made museums, as far as their display and exhibition policies are concerned, entirely risk-averse. Not only are curators no longer willing to take chances in their displays and exhibition programmes, they can no longer afford to do so. In their new expansionist and success-driven incarnation, like their counterparts in the film and publishing industries, museums have come to rely on the tried and tested. To do otherwise would be to commit commercial suicide. Just as the film industry counts on sequels to guarantee a box-office hit, and publishing conglomerates focus on bestsellers at the expense of more challenging literature, the risk-averse new museum, now a self-declared part of the cultural industry, focuses relentlessly on the iconic, the already famous, the perennial favourites: Impressionism, Post-Impressionism, the great artists of the twentieth century. Playing to the gallery, it favours an art that is literal (anything figurative), emotional (emotion is easier to appeal to than the intellect), issue-driven (yet never radically political). It champions whenever possible an art where autobiography and work are inextricably linked (Caravaggio, Van Gogh, Modigliani, Frida Kahlo, Diane Arbus, Tracey Emin). The new museum's media of choice are film, video and photography, easy to comprehend, easy to install and in many cases requiring only the most superficial engagement from the viewer. Video and film can turn entire enfilades of galleries into virtual multiplexes. The new museum prefers installations to single works, because it likes its visitor engulfed, caught up in the theatrics on offer, enraptured and overcome by spectacle.

For obvious reasons, exhibitions dedicated to fashion have become more frequent. If fashion signals the ultimate in consumer disengagement – its rationale no more than theatre and entertainment – its arrival in the new museum makes perfect sense: fashion's agenda of recasting content as style, re-inventing art object as ornamental back-drop and reducing history to a mere source for periodical revivals, meshes neatly with the new museum's own anti-historical inclinations and its goal to reposition art as entertainment. Conceptually and intellectually, the new breed of fashion exhibition takes the museum closer to *Hello!* than, say, *October* magazine. In place of critical distance – analysis of how fashion works, how it is arrived at and how it is disseminated – the new museum is content merely to capture or replicate fashion's theatricality. It suspends curatorial judgment and offers in its place something approximating to the spectacle and immediacy of an actual fashion moment. In this respect, fashion exhibitions have become hard-core. In 2005, the Metropolitan Museum of Art in New York staged the exhibition 'Anglomania', a meaningless romp through 200 years of British fashion.[189] Set in the museum's English period rooms against the backdrop of one of the world's greatest collections of English furniture, each room offered a different tableaux ('the gentlemen's club', 'the English garden', 'upstairs/downstairs'), mixing historic and contemporary clothing. The effect was one of de-historicisation, an intentional blurring of the line between original and copy, where the past was reduced to an open-ended resource for style choices and where questions of authenticity no longer mattered – Orwellian curating. A year later, the Museum of Fine Arts in Boston mounted 'Fashion Show'.[190] Focusing on the clothes from the current couture collections of nine Parisian fashion houses, the display consisted of mannequins dressed by each of the nine designers accompanied by the respective house's most recent promotional video. Nowhere near approaching the glamorous pitch of 'Anglomania', the exhibition was deeply disappointing to view, and turned out to be a box-office flop. Concurrent with this, the Metropolitan Museum opened 'Nan Kempner: American Chic' to show off the late socialite's stupendous couture wardrobe.[191] On the other side of the Atlantic, the Victoria & Albert Museum followed suit with 'Kylie Minogue:

glomania',
tropolitan Museum of
, New York (May 3 to
tember 4, 2006).

hion Show: Paris
lections 2006',
seum of Fine Arts,
ton (November 12,
6, to March 18, 2007).

n Kempner: American
c', Metropolitan
seum of Art, New York
cember 12, 2006, to
rch 4, 2007).

The Exhibition'.[192] Defending the show, a museum spokesperson half-heartedly declared that 'We hope this exhibition will attract students of fashion and stage costume design', while the academic Lisa Jardine (a trustee of the V&A), in a let-them-eat-cake moment, affirmed that 'It is certainly not our job to be elitist'.[193]

To accommodate the new museum's need for undemanding aesthetic spectacle, art history has had to be selectively re-written. In the case of Picasso, for example, the critical discourse of the last twenty years or so has largely focused on the biography-work dichotomy, as if his stylistic evolution were entirely prompted by changing personal circumstances, in place of a more formalist analysis of his *œuvre* – a bias reflected in numerous recent museum exhibitions dedicated to the artist. Meanwhile, Krauss's implication of Minimalism in the formation and politics of the new museum has been taken up by Hal Foster in his alarmingly entitled essay 'Dan Flavin and the Catastrophe of Minimalism'.[194] Foster appears to blame Flavin for a subsequent misinterpretation of Minimalism, which is about as reasonable as holding Mies van der Rohe responsible for every glass box erected since the opening of the Seagram Building. But both Krauss and Foster concede that it is in the rewriting of the history of Minimalism that the problem lies: an intentional misreading of the historic record by shifting the focus from the centre of the movement to the margins, where an art whose nature fits better with the requirements of the new museum is sited.

This shift may be illustrated by comparing the work of Flavin and James Turrell. Flavin's is an art of controlled rationality. The effect of his work (however beautiful or theatrical it may be) is counterbalanced by the open display of its source (the 'specific object'). Flavin's aim is to set up a dialectic between the specific object and the theatrical potential that is invoked, revoked and invoked again, *ad infinitum*. The theatrical potential upon which he touches is at its extreme a directionless emotional blurring, surpassing the realm of beauty and quickly entering, without warning, a zone of emotion evoked for its own sake; in short – kitsch – a faux spirituality, religiosity without religion, affect without object. Flavin is effectively playing with fire, but he does so consciously and, above all, he makes the viewer not only aware of his intention but participatory in the dialectic he has

192
'Kylie Minogue: The Exhibition', Victoria and Albert Museum, London (February 8 to June 10, 2007).

193
Quoted in: Vanessa Thorpe, 'V & A Under Fire Over Kylie Show', *The Observer*, February 2007, p 18.

194
In: Jeffrey Weiss (ed), *Dan Flavin: New Light* [exhibition catalogue] (New Haven, London and Washington DC: Yale University Press and National Gallery of Art, 2006), pp 133–15

set up. This 'reality check' does not occur in the work of Turrell. What this artist offers is the opposite: his is an art of old-fashioned illusionism. It is an art of effect that is entirely focused on the theatrical potential, its source rendered invisible. In lieu of Flavin's modernist rationality, Turrell presents the open-ended illusion of a synthetic spirituality and *ersatz* mysticism, a profusion without profundity, the illusion of emotion in place of true feeling and engagement. His elevated place in the pantheon of the new museum may be entirely at odds with his actual historic contribution, but it is commensurate with the important role he plays within the institution: he provides a fail-safe ride for the new museum theme park, easy on the mind and easy on the eye, visually compelling, all-engulfing and theatrical.

Another artist who has come to prominence in the new museum is Bill Viola. Liberally quoting Old Master references, Viola empties his religious subject matter of all meaning and recasts it as *objet de luxe*, the ultimate consumer object. His theatre of emotion finds its match in a hysterical viewer: when spectators cry on viewing his work, as they often do, they really only weep at their own tears. Conceived on a grand scale to the highest production standards, Viola's art is the video version of high-Victorian painting. If Turrell provides the new-age ride to the museum, Viola contributes its spiritual equivalent, a hollow emotion that is in the end undemanding, empty and disengaged.

The greatest difference between Flavin, on one hand, and Turrell and Viola, on the other, is where they leave their viewers. Flavin empowers his, makes them active participants in the constitution of the work. His audience is in charge and fully conscious, whereas Turrell's and Viola's viewers are disempowered, overwhelmed and emotionally manipulated. Running between active participant and passive consumer, this is exactly the same fault line that divides the old and the new museum.

Collecting

In the old museum, the collection was the main focus of curatorial attention, a permanent fixture towards which scholarship, research and acquisition policies were directed. The collection's

content and particular shape, its eccentricities, strengths and weaknesses, set the terms of reference for all the museum's other activities. Conceptually, permanent displays and the collection were perceived as one and the same. This is not the case in the new museum. Displays have gone from static to forever changing, to such a degree that they increasingly resemble temporary exhibitions. This obviously affects the way in which curators view the collections in their charge. For a new generation of curators, collections need to be constantly refreshed and are perceived merely as a resource, a pool from which temporary displays can endlessly be drawn and loans to other institutions granted, but no longer as an entity that adds up to more than the sum of its parts. This conceptual dematerialisation of the collection has become one of the hallmarks of the new museum. Since the collection is no longer thought of as an entity, it can no longer help set the points of reference for acquisition decisions. As a result, purchases have inevitably become random, either dictated almost exclusively by personal taste and inclination or, at the other extreme, fashion- and market-driven. As time goes by, the collection as a resource becomes a self-fulfilling prophecy: the long-term outcome is not a collection but a heterogeneous assemblage of objects.

When a museum's collection is no longer seen as an organic entity with a particular character and a history of its own, de-accessioning is the next logical step. Adopting euphemistic management speak (indicating at least a trace of shame about what it is proposing), the new museum justifies its actions by claiming that it is only 're-focusing its activities', 'rationalising its collecting activities', 'diversifying', 'maximising its assets' or 'strengthening its core mission'. ('Core mission' is a favourite buzz-word in new-museum speak.) The benefit to the long-term interest of the institution is always invoked. The deceptive simplicity and rationale of this language barely manages to hide the fact that, under its cover, acts of cultural vandalism are being performed against both the fabric and history of institutions. Not only do objects disappear, but institutional memory is erased into the bargain.

In recent years, de-accessioning has become more prevalent. In Europe, where the subject used to be taboo, it is now openly discussed by curators and politicians. In America, the practice

is no longer restricted to minor examples or duplicates from the print room, but is extended to major works of which any museum might be envious. In 2003, for example, the Museum of Modern Art sold three highly important paintings by Modigliani, Picasso and Pollock, in the process raising over $50 million. More recently, the Albright-Knox Art Gallery's decision to divest itself of a group of major works from its small historic collection in order to establish a contemporary art endowment fund, drew particularly harsh criticism. [195] It was not only the quality of the works consigned for sale that caused disquiet. Sotheby's (appointed to handle the sales) described the de-accessioned *Granite Figure of Shiva as Brahma* (tenth–eleventh century) as 'without question the greatest Indian sculpture ever to appear on the market', and the Roman bronze *Artemis and the Stag* (first century BC/ AD) as 'among the very finest large classical bronze sculptures in America'. [196] The idea that a museum was providing the market with such gems and that these works would inevitably end up in private hands – that *de facto* the privatisation of public cultural assets was taking place – struck many observers as deeply troubling. That this was done in order to purchase contemporary art did not help matters: was the museum not in fact entering an already overcrowded niche market with too little cash, too late? Significant works by the most coveted contemporary artists are rarely available, fiercely fought over and often very expensive.

If the de-accessioning trend continues, it will have major repercussions for the future of museum collections. Ultimately, it will debase the concept of perpetual public ownership – the main justification for generous tax concessions in the United States and public and charitable grants in Europe. These concessions will obviously become vulnerable to scrutiny. If de-accessioning evolves into an acceptable practice, it will lay museums open to politically motivated raids of their collections, as happened for the first time in the UK in 2006 when Bury Metropolitan Council sold at auction for £1.1 million a painting by L.S. Lowry from the collection of Bury Art Gallery and Museum in order to balance the council budget. Such actions will inevitably deter donors from giving their works to museums since the future fate of their gifts is no longer guaranteed, however exceptional their quality. It will also make museums susceptible to many more

e, for instance: Tom Freudenheim, 'Shuffled f in Buffalo', *Wall Street urnal*, November 15, o6; and Christopher ight, 'Cashing in or ling Out?', *Los Angeles nes*, January 14, 2007.

:heby's press release, vember 10, 2006. *emis and the Stag* sold following June for $25.5 llion, the highest price r paid at auction for a lpture.

restitution claims by nation states, since the present defence of perpetual public ownership for the public good could no longer reasonably be invoked.[197]

Ambivalence about the museum on the part of curators, visitors, artists and politicians is not a new phenomenon. The history of museums demonstrates that each constituent group has, at various times, raised different objections and expressed all kinds of dissatisfaction and doubts about the systems in place. The difference now is that the disquiet the new museum is causing is almost universal. What is worrying is that, in the end, every participant in the new museum feels short-changed, frustrated or disappointed. By the measure of its own standards and declared intentions, the new museum has not lived up to its promise. Having recast the visitor as a consumer, it has elicited the response of a consumer: never satisfied and always on the lookout for more. However much visitors may be attracted to the spectacle of the new museum and however much they may be conditioned by it, they still expect the museum to deliver all the qualities of the old museum as well. They continue to believe in the institutional superiority, impartiality and the guarantee of the highest quality. In the visitor's mind the museum is still synonymous with an educational mission of high culture. Visitors still have absolute trust in the museum's integrity and its ability to deliver. And their disappointment is twofold: they are dissatisfied that the spectacle on offer – exhibitions, architecture, services – is not bigger, more theatrical, more spectacular; and they are disillusioned that their trust in the institution has been betrayed – they are beset by the nagging suspicion that they have been offered sub-standard fare.

Curators are also unhappy with their role. Their curatorial independence has gradually been eroded. They are no longer the specialist scholar-curators of the past, who stood at the centre of the institution. In the new museum, they find themselves at the nexus of an exhibition industry in which their role is reduced to administrator and where exhibitions do not benefit from their scholarship but are staged from purely financial motives. The curator's mandate is now to provide, above all, commercially viable entertainment. As for choices of exhibitions and displays, these are no longer exclusively the curator's, but are dictated by

197
Private restitution claims have already become much more frequent, actively supported by specialist lawyers and supply-starv auction houses.

commercial imperatives and institutional politics. There is no room any more for the curious, the neglected, the adventurous, the eccentric; no place for the untried or untested. Most worryingly, there is no room for scholarship. There is no call for it either, because scholarship, by the logic of the new museum, does not serve an identifiable purpose – it does not contribute to the financial bottom line. As a result, art history has retreated from the museum to the university. For the first time, the vast majority of new art-historical research is now taking place outside museums.[198]

Artists' attitudes towards the museum have also grown more ambivalent. In the past, artists could rely on a life-long support stream, with input from various interested parties at different points in their career – support from adventurous young dealers and collectors at the outset, followed by exhibition invitations from small museums and Kunsthalles, then interest from blue-chip collectors, big museums, secondary-market dealers and auction houses, and finally the offer of a retrospective in a major institution. This trajectory gave artists the time and means to develop their ideas. Today, all interest groups fish in the same pond simultaneously, creating instant market bubbles and hysteria wherever the attention turns. After 2002, for example, photography became ubiquitous for two or three seasons, to be abruptly replaced, first by New German painting, then by contemporary Chinese art. The pressure on artists to seize the moment and serve these demands has never been greater.

When an artist's work is put on display in the new museum, it is subsumed by the general theatre of the venue, interpreted, branded and homogenised. Artwork is no longer considered on its own merit, but becomes a variable in the overall equation of the democracy of spectacle. It is not read in isolation but as part of a chain of stimuli selected and calibrated to keep the client-visitor amused: the artist's autonomy is sacrificed to the institution's overreaching corporate ambition. In this scenario, the museum has lost the privileged place it held for artists as an intellectual sanctuary, where their rights were protected and their wishes respected above all else. The new museum no longer constitutes a special, safe realm but is part of an encroaching and all-consuming malaise: on one hand the market place, where artists' work is

198
The relationship between these two branches of art history is explored in: Charles W. Haxthausen (ed), *The Two Art Histories: The Museum and the University* (London and New Haven: Yale University Press, 2002).

literally consumed, on the other hand, the museum, where the consumption is metaphorical, where their art is offered as diversion and entertainment. Carsten Höller seemed to have been commenting ironically on this development in his Turbine Hall commission at Tate Modern in 2006, when he filled the space with a series of slides. An irresistible attraction for tens of thousands of screaming children, the slides promptly swept Tate Modern to the top of that year's UK museum attendance table. Yet, in the end, Höller merely highlighted a dilemma without suggesting a solution to it, and one suspects that his installation may have been less critique than resigned collaboration. In the new museum, the artist finds himself reduced to mere content provider, a handmaiden to corporate dreams. The artist's role, previously at the centre of the museum, has become, like everyone else's, marginal.

Over time, the new museum has manoeuvred itself into a precarious position. It has adopted the circular, inescapable logic of the corporate market place with its overreaching fixation on expansion, competition and growth, a logic that has quickly come to over-rule every other institutional consideration. It has bred a generation of visitors who are, as far as their entertainment expectations are concerned, endlessly demanding. New buildings, major exhibitions, forever expanding services, all pander to these expectations at an ever-escalating cost. Yet, however much the museum likes to see itself as a corporate entity, in reality it is not. Unlike big business, museums cannot tap into the capital markets to finance their capital projects and they cannot borrow to deal with temporary shortfalls or unforeseen reversals. Most cannot even run a deficit legally. There is no mechanism for the deferment of financial pressures by means of taking out overdrafts or issuing bonds. Unlike corporations, museums do not run reserves; they are zero-sum businesses – that is to say, income is immediately spent (this is why museums can sincerely claim to be perennially under-funded, irrespective of how successful they are). There is no room for error, and thus the pressure to attract huge crowds (if not paying then at least spending) is so relentless that it over-rides all other considerations. The precariousness

of the situation became clear a few months after the terrorist attacks on September 11, 2001, when museums on both sides of the Atlantic faced major financial difficulties following a steep drop in tourism.[199] Fortunately, the downturn did not last long, but it was an unwelcome reminder of how vulnerable most institutions have become.

The reliance on large attendance figures, combined with an expansive mindset, has created its own irrefutable logic: in order to survive, the new museum has to keep expanding. This self-justifying logic is flawless and is the reason why politicians are so weary of museums' incessant demands for funding: they are by nature open-ended and limitless.

To meet these financial demands, the new museum acts more and more like a business and less and less like a museum. Fundraising activities become increasingly aggressive, no commercial opportunity is left unturned, no ruse to earn money passed up. In the process, museums are moving further and further away from the ideals of their past. A blind eye is turned to the agenda of those signing the cheques. Ann Drew, Head of Sponsorship at UBS for Europe, the Middle East and Africa, recently explained the bank's involvement in art sponsorship as follows: 'We have a number of different deliverables around our sponsorship investments: to create brand awareness, favourable opportunities for client entertaining and networking and, of course, bringing our employees with us and, where appropriate, our community partners.'[200] Never mind the language (I particularly like the cryptic 'where appropriate, our community partners', by which I imagine is meant the museum's general audience), it is quite clear that this is no longer sponsorship but a business transaction that returns to sponsors the exact benefit equivalent of their cash contributions, an exercise in mutual, bank–museum brand enhancement. This is not sponsorship; it is renting out a museum as a glamorous networking venue.

All of the new museum's activities are first considered from a financial perspective. The museum's public-interest mandate is interpreted in ever narrower ways, ultimately only to serve the institution's self-interest. Other museums are no longer viewed as colleagues but as cash cows from which origination fees for exhibitions and, increasingly, fees for loans of works of art can

199
The Guggenheim Museum found itself in particularly dire straits, but many other American and European museums (including the British Museum and Tate Modern) were likewise affected.

200
Karina Robinson, 'Banking Matters: Banks Getting Deeper into the Art World', *International Herald Tribune*, January 1, 2007.

be milked. Whenever there is a conflict between the financial demands of the new museum and the old museum ethos, financial demands inevitably take precedence, because financial concerns have to be addressed immediately while questions of ethos can be debated forever, compromised, obfuscated or ignored.

The great danger in behaving like a business is that ultimately one will be treated like one. It is conceivable that, over time, the entire special status of the museum may be lost: state-funding, tax concessions, public trust – everything that made museums possible – might one day be denied by a politician who could justifiably claim that no difference exists between a museum and any other commercial enterprise. In a crisis, having traded the hard currency of public trust for corporate dreams, the museum may no longer be offered help but will be taken at its own word and allowed to fail – just like any other business that doesn't live up to market expectation. At this point, it will be too late to invoke the special pact between museum and public. Everybody will have forgotten.

Do so many problems, so much discontent, so much unease, not point to a more fundamental flaw at the heart of the new museum and the democracy of spectacle it espouses? I believe that the democracy of spectacle is, in fact, a contradiction in terms, an oxymoron. Born out of radical revolutionary politics, the public museum is vested with extraordinary powers and weighty responsibilities: to establish and uphold the cultural framework that provides the backdrop of all social and political discourse. To exercise these powers responsibly, ethically and for public benefit is the museum's central aim. It needs to encourage informed, empowered, independent-minded participant-visitors, who in turn are willing to be informed further, to have their knowledge expanded, their horizons opened and their curiosity affirmed. This is the pact between the museum and its visitors and, by extension, between the museum and society. To discharge its duties and retain the public trust should be the museum's main goal, the single consideration that over-rules all others.

There should be no limit on the intellectual ambition the museum has for its audience. Spectacle, however, relies on a passive consumer who is offered ever-escalating stimuli, yet nonetheless remains disengaged, bored and dissatisfied. Spectacle, in

the final analysis, is anti-democratic (and it is no coincidence that it plays such an important role in totalitarian society: it trains passivity and propagates ignorance). This is where the democracy of spectacle in the museum collapses. It perverts the museum's original idea by placing the institutional interest above the visitor's. It eschews public responsibility and holds itself accountable to no one. It is an abdication of the museum's historic duty and it will ultimately lead to its downfall. But it is not yet too late. Public trust is frayed but has not been completely eroded. In order to stop the rot, directors must set aside their corporate fantasies, abdicate their dreams of eternal growth and limitless expansion, renounce their big-business swagger. It is time for architects to put works of art first and architecture second; time for trustees to reign in their CEO directors and call them to account; time for politicians to stop insisting that museums serve social or political purposes (be they economic or regenerative) instead of supporting institutions for their own sake.[201] It is time for curators to follow their scholarly instincts and to reclaim their power (vested in them by the public). It is time for museums to return to their true business: preserving what lies in their care, and furthering knowledge. It is time for museums to empower, challenge, thrill and uplift their visitors, without compromise or shortcuts, always remaining aware of their duty and mindful of their privileged status in society. Lisa Jardine is wrong when she says: 'It is certainly not our job to be elitist'. It is the museum's *raison d'être*: to be elitist for everybody.

September 2008

201
See: Tony Blair's speech on the arts, given at Tate Modern, London, on March 6, 2007, as reported in: Charlotte Higgins, 'Blair Reminisces about Labour's "Golden Age" of the Arts', *The Guardian*, March 6, 2007, p 18.

Bibliography

dorno, Theodor. *Minima Moralia: Reflections on a Damaged Life,* .ondon and New York: Verso, 2006

.lexander, Victoria D. *Museums nd Money: The Impact of Funding n Exhibitions, Scholarship and Management,* Bloomington, Ind.: ndiana University Press, 1996

.ltshuler, Bruce (ed). *Collecting the Jew: Museums and Contemporary rt,* Princeton: Princeton University ress, 2005

.nderson, John. *Art Held Hostage: he Battle over the Barnes Collection,* ondon and New York: W. W. Norton, 003

adstubner, Ernst (et al). *Das Neue Museum in Berlin: Ein denkmal-flegerisches Plädoyer zur ergänzenden Wiederherstellung,* Berlin: Senats-erwaltung für Stadtentwicklung nd Umweltschutz, 1994

arker, Emma (ed). *Contemporary Cultures of Display,* New Haven and ondon: Yale University Press, 1999

arr Jr., Alfred H. *Defining Modern rt: Selected Writings of Alfred H. Barr r.,* New York: Harry N. Abrams, 1986

arringer, Tim and Flynn, Tom ds). *Colonialism and the Object: mpire, Material Culture and the Museum,* London and New York: outledge, 1998

arron, Stephanie (ed). *'Degenerate rt': The Fate of the Avant-Garde in Jazi Germany* [exhibition catalogue], os Angeles and New York: Los ngeles County Museum and Harry . Abrams, 1991

Becker, Christoph. *Vom Raritäten-Kabinett zur Sammlung als Institution: Sammeln und Ordnen im Zeitalter der Aufklärung* [Deutsche Hochschulschriften, Vol. 1103], Egelsbach, Frankfurt and St Peter Port: Hansel-Hohenhausen, 1996

Bedford, Steven McLeod. *John Russell Pope: Architect of Empire,* New York: Rizzoli, 1998

Beier-De Haan, Rosemarie. *Erinnerte Geschichte – Inszenierte Geschicht. Ausstellungen und Museen in der Zweiten Moderne,* Frankfurt am Main: Suhrkamp, 2005

Belk, Russel W. *Collecting in a Consumer Society,* London and New York: Routledge, 1995

Bennet, Tony. *The Birth of the Museum,* London and New York: Routledge, 1995

Beudert, Monique and Severne, Judith (eds). *The Froelich Foundation: German and American Art from Beuys and Warhol* [exhibition catalogue], London: Tate Gallery Publishing, 1996

Blyth, Jenny (ed). *The New Neurotic Realism* [exhibition catalogue], London: Saatchi Collection, 1998

Borsdorf, Ulrich, Grütter, Heinrich Theodor and Rüsen, Jörn. *Die Aneignung der Vergangenheit. Musealisierung und Geschichte,* Bielefeld: Transcript, 2005

Bosse, Dagmar (ed). *Der Ausstellungs-katalog. Beiträge zur Geschichte und Theorie,* Cologne: Salon Verlag, 2004

Bruderlin, Marcus, *Fondation Beyeler,* Munich and New York, Prestel, 1997

Buddensieg, Andrea and Weibel, Peter (eds). *Contemporary Art and the Museum: A Global Perspective,* Stuttgart: Hatje Cantz, 2007

Button, Virginia. *The Turner Prize,* London: Tate Gallery Publishing, 1997

Carbonell, Bettina Messias (ed). *Museum Studies: An Anthology of Contexts* (Malden, Mass, Oxford and Victoria: Blackwell, 2004

Carrier, David. *Museum Skepticism: A History of the Display of Art in Public Galleries,* Durham and London: Duke University Press, 2006.

Caygill, Marjorie. *The Story of the British Museum,* London: British Museum Publications, 1981

Caygill, Marjorie and Date, Christopher. *Building The British Museum,* London: British Museum Press, 1999

Chadwick, Alan and Stannett, Annette (eds). *Museums and the Education of Adults,* Leicester: NIACE, 1995

Clair, Jean. *Malaise dans les musées,* Paris: Flammarion, 2008

Conn, Steven. *Museums and American Intellectual Life, 1876–1926,* Chicago and London: Chicago University Press, 1998

Cooke, Lynne and Wollen, Peter (eds). *Visual Display: Culture Beyond Appearances* [Discussions in Contemporary Culture, No.10], New York: The New Press, 1995

Coplans, John. *Provocations,* London: London Projects, 1996

Crimp, Donald. *On the Museum's Ruins*, Cambridge, Mass. and London: MIT Press, 1993

Crow, Thomas. *Modern Art in the Common Culture*, New Haven and London: Yale University Press, 1996

Cuno, James (ed). *Whose Muse? Art Museums and Public Trust*, Princeton and Oxford: Princeton University Press, 2004

Cuno, James. *Who Owns Antiquity? Museums and the Battle Over our Ancient Heritage*, Princeton, NJ and Oxford: Princeton University Press 2008

Danto, Arthur C. *After The End of Art, Contemporary Art and the Pale of History: The A W Mellon Lectures in the Fine Arts, 1995* [Bollingen Series XXXV: 44], Princeton: Princeton University Press, 1997

Daston, Lorraine and Park, Katharine. *Wonders and the Order of Nature 1150–1750*, New York: Zone Books, 1998

Dean, David and Edson, Gary. *The Handbook for Museums*, London and New York: Routledge, 1994

Dube, Wolf-Dieter, et al. *Gemälde-galerie, Berlin: The New Building at the Kulturforum*, Berlin: G+H Verlag, 1998

Duncan, Carol. *Civilising Rituals: Inside Public Art Museums*, London and New York: Routledge, 1995

Farago, Claire J. and Preziosi, Donald (eds). *Grasping the World: The Idea of the Museum*, Aldershot: Ashgate, 2004

Fisher, Philip. *Making and Effacing Art: Modern American Art in a Culture of Museums*, Cambridge, Mass. and London: Harvard University Press, 1991

Flaubert, Gustave. *Bouvard and Pécuchet*, London: Penguin, 1976

France, Peter. *The Rape of Egypt: How the Europeans Stripped Egypt of its Heritage*, London: Barrie & Jenkins, 1991

Frick, Symington and Sanger, Martha. *Henry Clay Frick: An Intimate Portrait*, New York, London and Paris: Abbeville Press, 1998

Gaehtgens, Thomas W. *Die Berliner Museumsinsel im Deutschen Kaiserreich*, Berlin and Munich: Deutscher Kunstverlag, 1992

Glanton, Richard E., et al. *Great French Paintings from the Barnes Foundation* [exhibition catalogue], New York: Alfred A. Knopf in association with Lincoln University Press, 1993

Goodrow, Gerard A. (ed). *Neue Lösungen für Museumsmarketing und Museumsfinanzen*, Munich: Verlag Christian Mueller-Straten, 2004

Goodrow, Gerard A. (ed). *Museen und Kulturerbe in einer globalisierten Welt*, Munich: Verlag Christian Mueller-Straten, 2007

Greenberg, Reesa, Ferguson, Bruce W. and Nairne, Sandy (eds). *Thinking About Exhibitions*, London and New York: Routledge, 1996

Greenfield, Jeanette. *The Return of Cultural Treasures*, Cambridge: Cambridge University Press, 1990

Greub, Suzanne and Thierry. *Museums in the 21st Century: Concepts, Projects, Buildings* [exhibition catalogue], Munich, Berlin, London, New York: Prestel, 2006

Hanulla, Mika (ed). *Stopping the Process? Contemporary Views on Art and Exhibitions*, Helsinki: The Nordic Institute for Contemporary Art, 1998

Hampson, Norman. *Saint-Just*, Oxford: Basil Blackwell Ltd, 1991

Haskell, Francis. *The Ephemeral Museum: Old Master Paintings and the Rise of the Art Exhibition*, New Haven and London: Yale University Press, 2000

Haxthausen, Charles W. (ed). *The Two Art Histories: The Museum and the University*, London and New Haven: Yale University Press, 2002

Hickey, Dave. *Air Guitar: Essays on Art and Democracy*, Los Angeles: Art Issues Press, 1997

Hooper-Greenhill, Eilean. *Museums and the Shaping of Knowledge*, London and New York: Routledge, 1992

Hooper-Greenhill, Eilean. *Museums and their Visitors*, London and New York: Routledge, 1994

Hooper-Greenhill, Eilean (ed). *Museum, Media, Message*, London and New York: Routledge 1995

Hopps, Walter, et al. *La Rime et la Raison, Les Collections Menil (Houston–New York)* [exhibition catalogue], Paris: Editions de la Réunion des Musées Nationaux, 1984

Hoving, Thomas. *Making the Mummies Dance*, New York and London: Simon & Schuster, 1993

Hunnekens, Annette. *Expanded Museum: Kulturelle Erinnerung und Virtuelle Realität*, Bielefeld: Transcript, 2002

Jacob, Mary Jane and Brenson, Michael. *Conversations at the Castle: Changing Audiences and Contemporary Art* [Arts Festival of Atlanta 1996], Cambridge, Mass. and London: MIT Press, 1998

Jaffé, Michael. *The Devonshire Collection of Italian Drawings, Tuscan and Umbrian Schools*, London: Phaidon Press 1994

Jenkins, Ian. *Archaeologists and Aesthetes in the Sculpture Galleries of the British Museum 1800–1939*, London: British Museum Press, 1992

Johnson, Paul. *The Birth of the Modern: World Society 1815–1830*, London: Phoenix, 1992

Kantor, Sybil Gordon. *Alfred H. Barr Jr. and the Intellectual Origins of the Museum of Modern Art*, Cambridge, Mass. and London: MIT Press, 2002

Kaplan, Flora E. S. *Museums and the Making of 'Ourselves', The Role of Objects in National Identity*, London and New York: Leicester University Press, 1996

Kirshenblatt-Gimblett, Barbara. *Destination Culture: Tourism, Museums, and Heritage*, Berkeley, Los Angeles and London: University of California Press, 1998

Lorente, J. Pedro. *Cathedrals of Urban Modernity: The First Museums of Contemporary Art 1800–1930*, Aldershot, Brookfield USA, Singapore and Sydney: Ashgate, 1998

Lowenthal, David. *The Heritage Crusade and the Spoils of History*, Cambridge: Cambridge University Press, 1998

Maki, Fumihoko (ed). *The Architecture of Yoshio Taniguchi*, New York: Harry N. Abrams, 1999

Malraux, André. *Museum Without Walls*, London: Secker & Warburg, 1967

Malraux, André. *Picasso's Mask*, New York: Da Capo Press, 1994

Marincola, Paula (ed). *What Makes a Great Exhibition?*, London: Reaktion Books, 2007

Marquis, Alice Goldfarb. *Alfred H. Barr Jr.: Missionary for the Modern*, Chicago: Contemporary Books, 1989

Marwick, Arthur. *The Sixties: Cultural Revolution in Britain, France, Italy and the United States 1958–1974*, Oxford: Oxford University Press, 1998

McClean, Daniel and Schubert, Karsten (eds). *Dear Images: Art, Copyright and Culture* London: Ridinghouse and Institute of Contemporary Art, 2002

McClellan, Andrew. *Inventing the Louvre*, Cambridge: Cambridge University Press, 1994

McLean, Fiona. *Marketing the Museum*, London and New York: Routledge, 1997

McShine, Kynaston. *The Museum as Muse: Artists Reflect* [exhibition catalogue], New York: Museum of Modern Art, 1999

Mellon, Paul (with Baskett, John). *Reflections in Silver Spoon*, London: John Murray, 1992

Möntmann, Nina (ed). *Art and Its Institutions*, London: Black Dog Publishing, 2006

Montaner, Josep Maria. *Museums for the 21st Century*, Barcelona: Editorial Gustavo Gili, 2003

Muchnic, Suzanne. *Odd Man In: Norton Simon and the Pursuit of Culture*, Berkeley, Los Angeles and London: University of California Press, 1998

Naredi-Rainer, Paul von. *Entwurfsatlas Museumsbau*, Basel: Birkhäuser, 2004

Newhouse, Victoria. *Towards a New Museum*, New York: Monacelli Press, 1998

Nicholas, Lynn H. *The Rape of Europe*, New York: Alfred A Knopf, 1994

Norman, Geraldine. *The Hermitage: The Biography of a Great Museum*, London: Random House, 1997

O'Brien, Ruairi (ed). *Das Museum im 21. Jahrhundert*, Dresden: Tudpress 2007

O'Neill, Paul (ed). *Curating Subjects*, London: Open Editions, 2007

Ostrower, Francie. *Why the Wealthy Give: The Culture of Elite Philanthropy*, Princeton: Princeton University Press, 1995

Pearce, Susan (ed). *Museum Economics and the Community* [New Research in Museum Studies: An International Series, Vol. 2], London and Atlantic Highlands, N.J.: Athlone Press 1991)

Petzinger, Renate. *Donald Judd Räume/Spaces* [exhibition catalogue], (Stuttgart: Cantz Verlag, 1993)

Pick, John. *The Arts in a State*, Bristol: Bristol Classical Press, 1988

Porterfield, Todd. *The Allure of Empire, Art in the Service of French Imperialism 1798–1836*, Princeton: Princeton University Press, 1998

Prior, Nick. *Museums and Modernity: Art Galleries and the Making of Modern Culture*, Oxford and New York: Berg, 2002

Reid, Donald Malcolm. *Whose Pharaos? Archaeology, Museums and Egyptian National Identity from Napoleon to World War I*, Berkeley, Los Angeles and London: University of California Press, 2002

Reitlinger, Gerald. *The Economics of Taste*, London: Barrie and Rockliff, 1962 [Second edition, New York: Hacker Art Books, 1982]

Renfrew, Colin. *Loot, Legitimacy and Ownership*, London: Duckworth, 2000

Rewald, John. *The Paintings of Paul Cézanne: A Catalogue Raisonné*, London and New York: Thames and Hudson, 1996

Riley, Terence. *The International Style: Exhibition 15 and the Museum of Modern Art*, New York: Columbia University Press and Rizzoli, 1992

Roberts, Lisa C. *From Knowledge to Narrative, Educators and the Changing Museum*, Washington DC and London: Smithsonian Institution Press, 1997

Ross, Barbara (ed). *Imagining the Future of the Museum of Modern Art* [Studies in Modern Art, Vol 7], New York: Museum of Modern Art, 1998

Russell, John Malcolm. *From Nineveh to New York*, New Haven and London: Yale University Press, 1997

Savoy, Bénédicte (ed). *Tempel der Kunst: Die Entstehung des Öffentlichen Museums in Deutschland 1701–1815*, Mainz: Von Zabern, 2007

Sayah, Amber. *Museumsinsel Berlin: Competition for the New Museum*, Stuttgart, Berlin and Paris: Avedition, 1994.

Schubert, Hannelore. *Moderner Museumsbau*, Stuttgart: Deutsche Verlags-Anstalt, 1986

Schultz, Bernd (ed). James *Simon: Philanthrop und Kunstmazen*, Munich: Prestel, 2006

Serota, Nicholas, *Experience or Interpretation: The Dilemma of Museums of Modern Art*, London and New York: Thames and Hudson, 1996

Silver, Nathan. *The Making of Beaubourg*, Cambridge, Mass. and London: MIT Press, 1994

Silverman, Deborah. *Selling Culture: Bloomingdale's Diana Vreeland and the New Aristocracy of Taste in Reagan's America*, New York: Pantheon Books, 1986

Simpson, Elizabeth (ed). *The Spoils of War*, New York: Harry N. Abrams, 1997

Spalding, Frances. *The Tate Gallery: A History*, London: Tate Gallery Publishing, 1998

Spalding, Julian. *The Poetic Museum*, London and Munich: Prestel, 2004

Staniszewski, Mary Anne. *The Power of Display: A History of Exhibition Installations at the Museum of Modern Art*, Cambridge, Mass. and London: MIT Press, 1998

St. Clair, William. *Lord Elgin and the Marbles*, third revised edition, Oxford: Oxford University Press, 1998

Storrie, Calum. *The Delirious Museum. A Journey From the Louvre to Las Vegas* (London and New York: I B Tauris, 2006

Thomkins, Calvin. *Merchants and Masterpieces: The Story of the Metropolitan Museum of Art*, London and Harlow: Longman, 1970

Thomson, Keith. *Treasures on Earth: Museums, Collections and Paradoxes*, London: Faber & Faber, 2002

Traill, David A. *Schliemann of Troy: Treasure and Deceit*, London: John Murray, 1995

Vail, Carol P. B. (ed). *Peggy Guggenheim: A Celebration* [exhibition catalogue], New York: Guggenheim Museum Publications, 1998

Vergo, Peter (ed). *The New Museology*, London: Reaktion Books, 1989

Vermeule, Cornelius C. *Greek and Roman Sculpture in America*, Berkeley and London: University of California Press, 1981

Walker, John. *Self-Portrait with Donors: Confessions of an Art Collector*, Boston and Toronto: Atlantic Monthly Press, 1974

Weil, Stephen E. *A Cabinet of Curiosities, Inquiries into Museums and their Prospects*, Washington DC and London: Smithsonian Institution Press, 1995

Weiss, Jeffrey (ed). *Dan Flavin: New Light* [exhibition catalogue], New Haven, London and Washington D.C.: Yale University Press and National Gallery of Art, 2006

Weitzenhoffer, Frances. *The Havemeyers: Impressionism Comes to America*, New York: Harry N. Abrams, 1986

Wilson, David M. *The British Museum, Purpose and Politics*, London: British Museum Publications, 1989

Wiseman, Carter. *I. M. Pei: A Profile in American Architecture*, New York: Harry N. Abrams, 1990

Witlin, Alma S. *The Museum, Its Task in Education*, London: Routledge & Kegan Paul, 1949

Wright, Gwendolyn (ed). *The Formation of National Collections of Art and Archaeology* Washington DC: National Gallery of Art, 1996

Yourcenar, Margaret. *Memoirs Of Hadrian and Reflections of the Composition of Memoirs of Hadrian*, London: Penguin, 1986.

Zimmerman, Michael F., et al. *Berlins Museen: Geschichte und Zukunft*, Berlin and Munich: Deutscher Kunstverlag, 1994

Index